HISTORIC PHOTOS OF
CHICAGO CRIME
THE CAPONE ERA

TEXT AND CAPTIONS BY JOHN RUSSICK

TURNER
PUBLISHING COMPANY
NASHVILLE, TENNESSEE PADUCAH, KENTUCKY

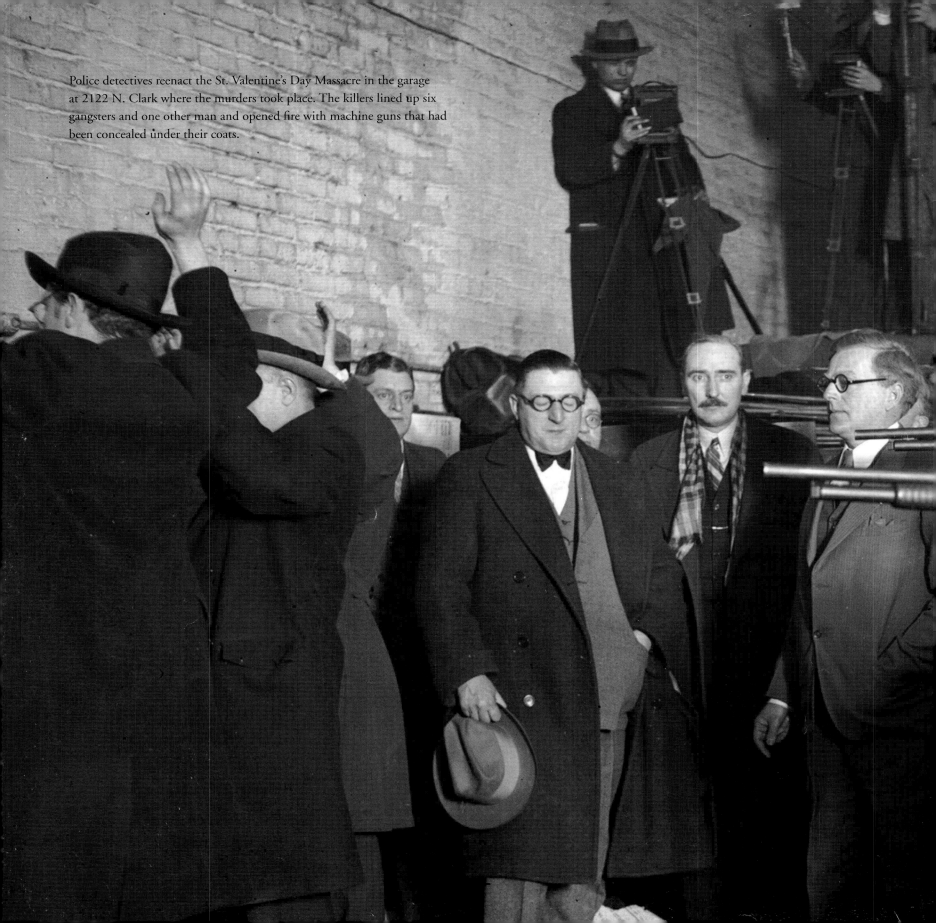

Police detectives reenact the St. Valentine's Day Massacre in the garage at 2122 N. Clark where the murders took place. The killers lined up six gangsters and one other man and opened fire with machine guns that had been concealed under their coats.

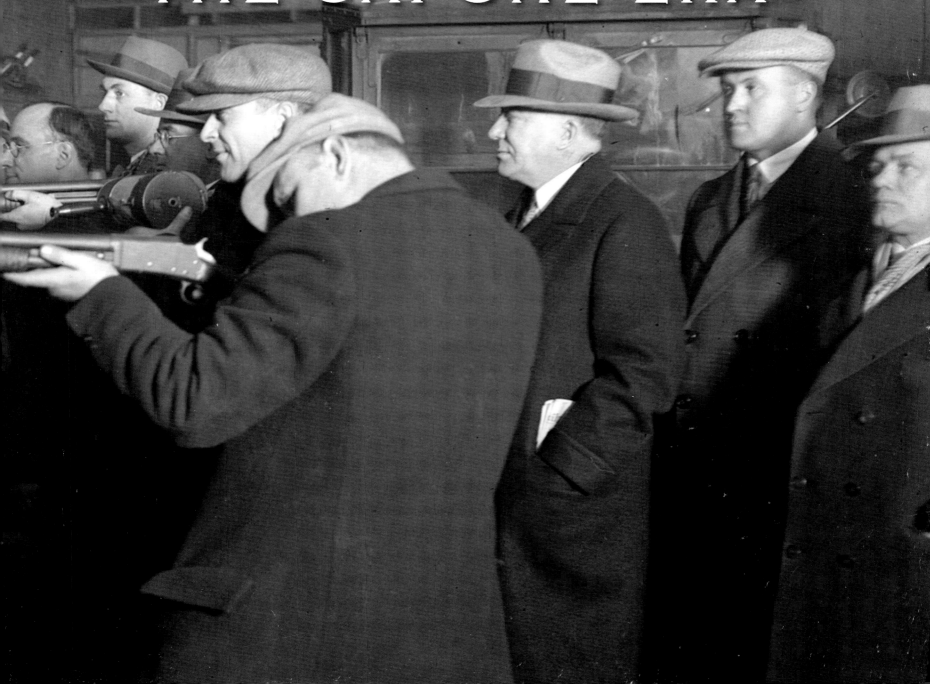

HISTORIC PHOTOS OF
CHICAGO CRIME
THE CAPONE ERA

Turner Publishing Company
200 4th Avenue North • Suite 950 412 Broadway • P.O. Box 3101
Nashville, Tennessee 37219 Paducah, Kentucky 42002-3101
(615) 255-2665 (270) 443-0121

www.turnerpublishing.com

Historic Photos of Chicago Crime : The Capone Era

Library of Congress Control Number: 2007933765

ISBN-13: 978-1-59652-387-6

Printed in the United States of America

07 08 09 10 11 12 13 14—0 9 8 7 6 5 4 3 2 1

CONTENTS

Captain Joseph Goldberg examines contraband beer and booze found in a raid. Prohibition and the subsequent illegal trade in alcohol was a catalyst for the gang wars during Capone's time.

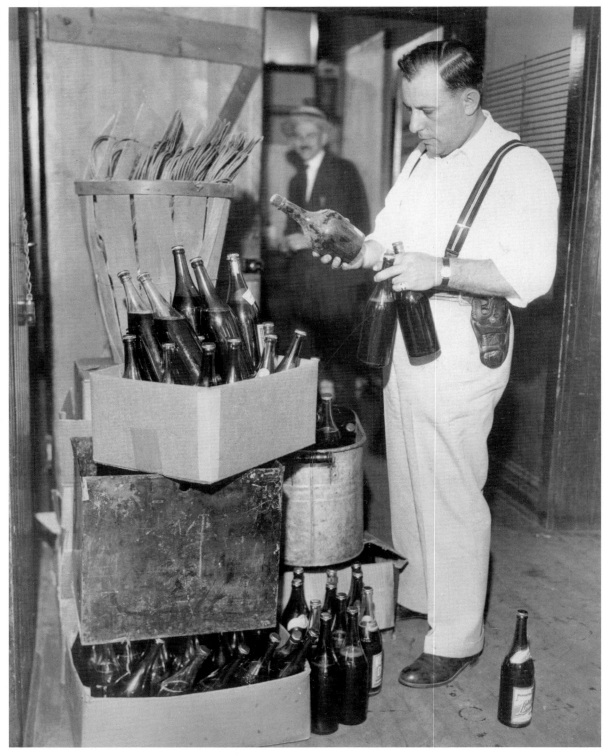

Acknowledgments

This book would not be possible without the assistance of two talented researchers, Cortney K. Tunis and Isabella J. Horning. They worked under extremely tight deadlines to review original source materials and investigate image dates, places, and names.

I want to thank the Chicago History Museum staff members who helped reproduce all the images for this volume, specifically Debbie Vaughan, Director of Research and Access and Chief Librarian; Rob Medina, Rights and Reproductions Coordinator; Bryan McDaniel and Erin Tikovitsch, Rights and Reproductions Assistants; John Alderson, Senior Photographer; and Jay Crawford, Photographer.

Last, I want to thank Gary T. Johnson, President, and Russell Lewis, Executive Vice President and Chief Historian, of the Chicago History Museum for giving me the opportunity to write the text for this book.

———————

For Susan, Leo, and Sofia

INTRODUCTION:
CHICAGO IN THE CAPONE ERA

It is quite a challenge to caption photographs about the Chicago underworld in the 1920s, a place inhabited by characters who wished to remain anonymous, who concealed their true identities and masqueraded as simple businessmen or even defenders of the poor, and who conducted their illicit trade behind closed doors to protect both themselves and their customers.

Pictures of cloaked figures in trench coats and fedoras, and policemen raiding speakeasies, breaking up beer barrels, and smashing stills, tend only to reflect how the gangs behaved when they were out of the shadows, and how the policemen looked when they were aware of the presence of cameras. A collection of these images alone might fail to reveal anything but the theater the public was meant to see.

Chicago in the Roaring Twenties was more than just a violent playground for the gangs. The U.S. census in 1920 revealed that for the first time in American history more people lived in the nation's cities than in rural areas. Cities like Chicago experienced a tremendous influx of people from across America searching for a better life. Laborers, musicians, social activists—and gangsters—all came. They brought with them energy, ambition, and determination to "make it" in Chicago.

Perhaps no other decade in American history conjures more romantic notions than the 1920s. Too often the realities of the corruption, greed, gang violence, racial prejudice, and gender inequality that shaped the decade are lost in the seductive image of the flapper, the allure of speakeasies and forbidden nightclubs, or the brilliance of an original Louis Armstrong solo. It must be remembered that the flamboyant and independent flapper emerges after more than a half-century-long struggle for equality by American women. Speakeasies were run by ruthless gangsters and hoodlums who dared defy the Volstead Act and defended their turf in violent gun battles. And Louis Armstrong is a symbol of the great flood of African Americans who left the South in search of a better life and freedom of expression in the nation's northern cities.

This book tries to paint a rich portrait of Chicago when gangsters, such as George "Bugs" Moran, John Torrio, Dean O'Banion, Earl "Hymie" Weiss, and "Scarface" Al Capone, operated multi-million-dollar illegal operations, used intimidation, extortion, and bribery to get their way, and regularly killed one another to satisfy their greed or their egos. It is hoped that this collection of photographs will provide some clarity and insight into Chicago's complex relationship with the gangs of the Capone era.

—*John Russick*

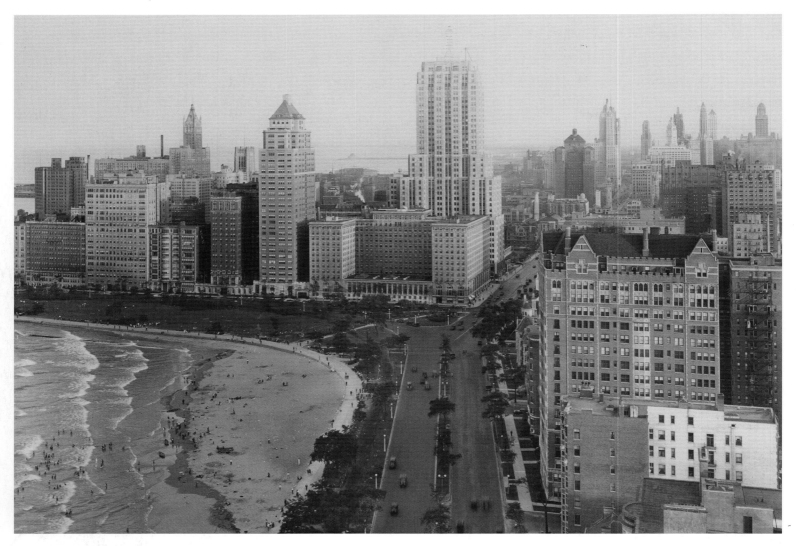

Facing south toward north Michigan Avenue. The scene is dominated by the Palmolive building, an art deco masterpiece designed by Holabird and Root and completed in 1929. At the top of the building stood the Lindbergh beacon, named for Charles Lindbergh the American aviator who flew solo across the Atlantic Ocean in 1927 and became an international celebrity.

Chicago in the Roaring Twenties

(1900–1920s)

The 1920s was a time of great change and experimentation in America. In the first decades of the twentieth century the country was transformed from a nation of small towns and farms, to one in which the majority of its citizens lived in cities like Chicago.

From a distance, Chicago offered freedom, equality, and opportunity. Young people, women, immigrants, and African Americans saw the promise of a better life there. They soon discovered that racism, ethnic isolation, labor unrest, corruption, and greed thrived there too. This mixture of people, ambition, opportunity, and conflict fueled Chicago in the jazz age and gave rise to a new American icon, the gangster.

Chicago had gangs and vice well before the 1920s. In fact, Chicago's Levee, or red-light district, an area just a few blocks south of downtown, was run by pimps and madams and celebrated for its brothels. Chief among them was the Everleigh Club at 2131 S. Dearborn Street. It was run by, and named for, the Everleigh sisters, Ada and Minna. In 1911, reformers forced Mayor Carter Harrison to close down the Levee. Prostitution, however, proved more resilient. Driven by the ambition of James "Big Jim" Colosimo, his wife, Victoria Moresco, and "Big Jim's" protégé, John Torrio, a new way of organizing vice emerged— more dispersed, more discrete—and its success attracted the attention of vice lords as far away as Brooklyn, New York.

In 1919, the United States Congress adopted the 18th Amendment to the U.S. Constitution. It became law the following year. The Volstead Act, as it was called, prohibited "the manufacture, sale, or transportation of intoxicating liquors" in the United States. Prohibition took what had been a widely used substance, alcohol, and turned it into contraband. It made every American who took a drink a criminal and put every saloonkeeper out of business. Chicago's gangs, already fiercely competing for the market in prostitution and gambling, suddenly had a new, more acceptable product to provide. They built alliances, networks, and carved up the city into territories they could control and defend, and they supplied alcohol to anyone with money to pay for it.

For many Chicagoans, the gangsters were seen as a necessary evil. The public came to rely on the gangs to get what the government denied them. It was an uneasy relationship, but it lasted for more than a decade, and it helped define Chicago in the Roaring Twenties.

America was changing dramatically in the first decades of the twentieth century and so was Chicago. Conservative voices were concerned that the rapid movement of people from rural America into the nation's cities would undermine traditional American values. Progressives, as if to fulfill this prophecy, found the mood in American cities ripe for advancing new ideas, such as the right to vote for women and protections for the poor and new immigrants.

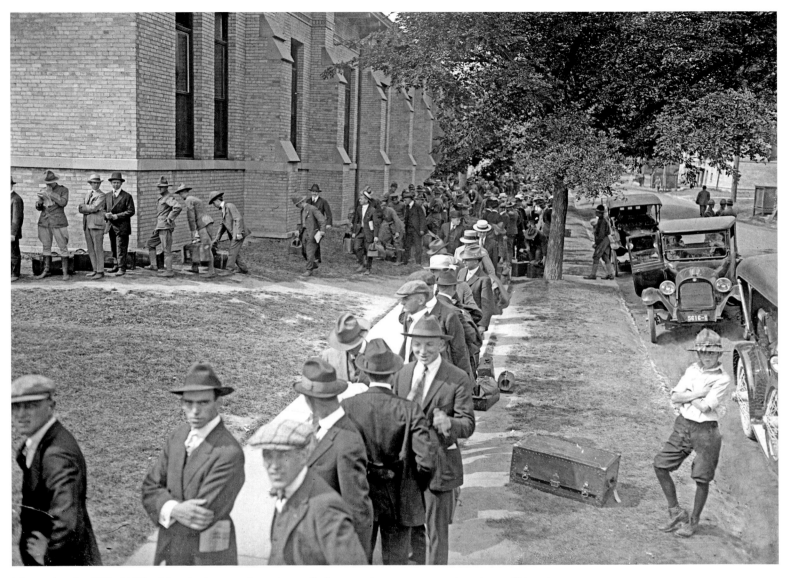

The outbreak of World War I inspired romantic notions of adventure in many young Americans. Taken in 1917, this photograph depicts men arriving for officers' training at Fort Sheridan, just north of Chicago. During the First World War, Illinois provided more than 300,000 recruits for the military. Many young men came home from the war less optimistic, disillusioned by the carnage they had witnessed.

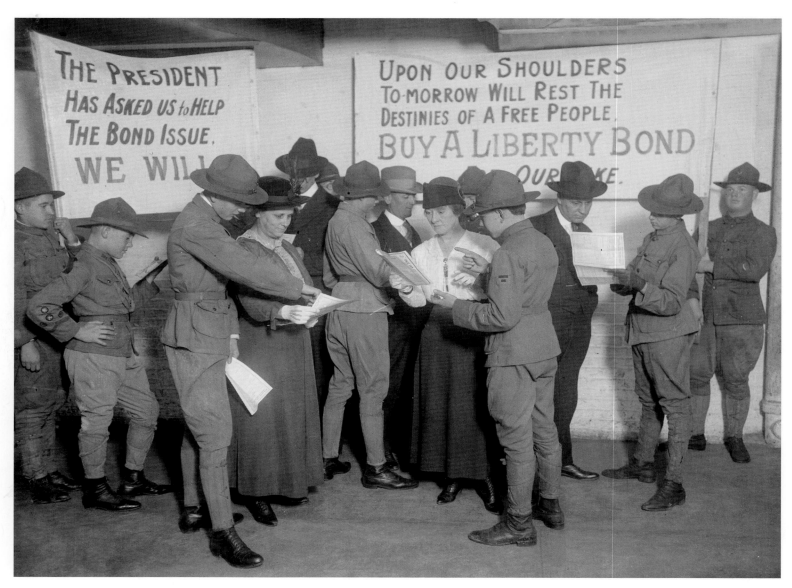

In this 1917 photograph, Boy Scouts in U.S. Army uniforms sell Liberty Bonds, which supplemented taxation to pay for the war. Bonds could be bought for $50, $100, $500, and $1,000 at 3.5 percent interest and had 15-year to 30-year maturation periods. It was considered one's patriotic duty to buy bonds.

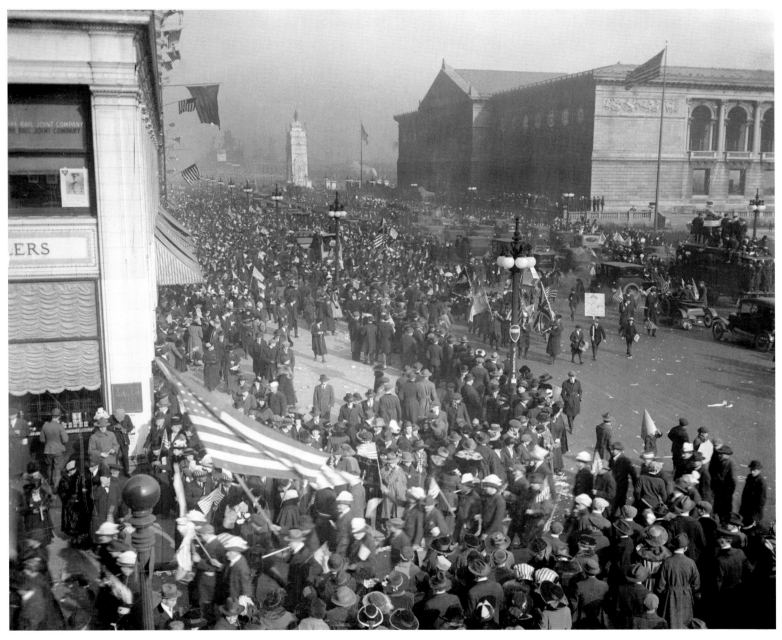

On Armistice Day large crowds marched down Michigan Avenue in celebration of peace.
Here, crowds gather in front of the Art Institute of Chicago.

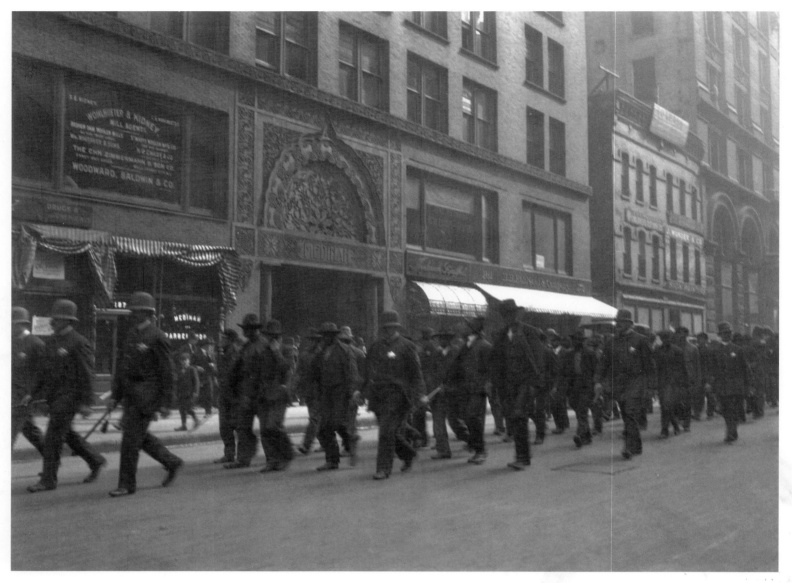

Workers engaged in the transport of commodities, better known as Teamsters, began to organize labor unions in 1900. The International Brotherhood of Teamsters (IBT) sided with striking workers at Montgomery Ward Co. in 1905. In the battles with replacement workers that ensued, 105 people were killed.

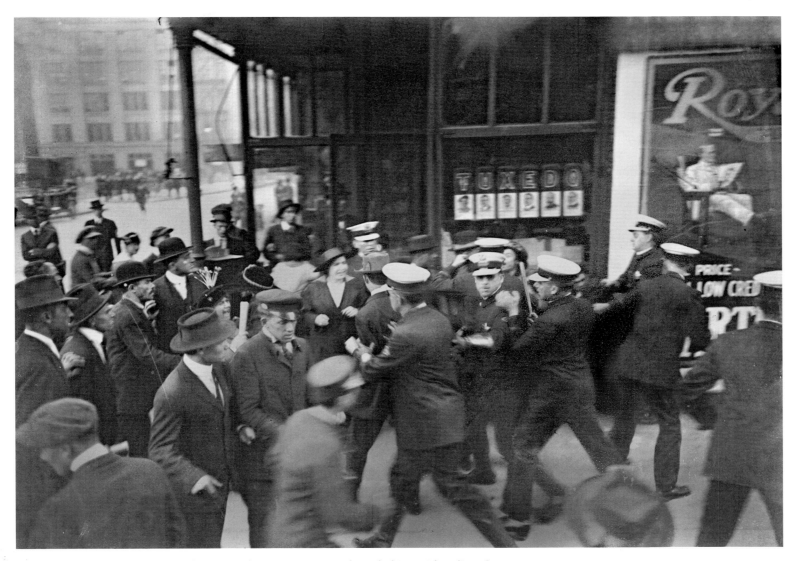

This photograph, taken in December 1915, depicts garment workers clashing with police. Garment manufacturing was one of Chicago's largest industries until the 1930s and was heavily involved in labor politics. Strikes in 1909 and 1910 led to the foundation of men's Amalgamated Clothing Workers of America (ACWA) and expansion of International Ladies Garment Worker Union (ILGWU). In 1919, the ILGWU claimed a membership of 6,000, or two-thirds of the women's clothing work force.

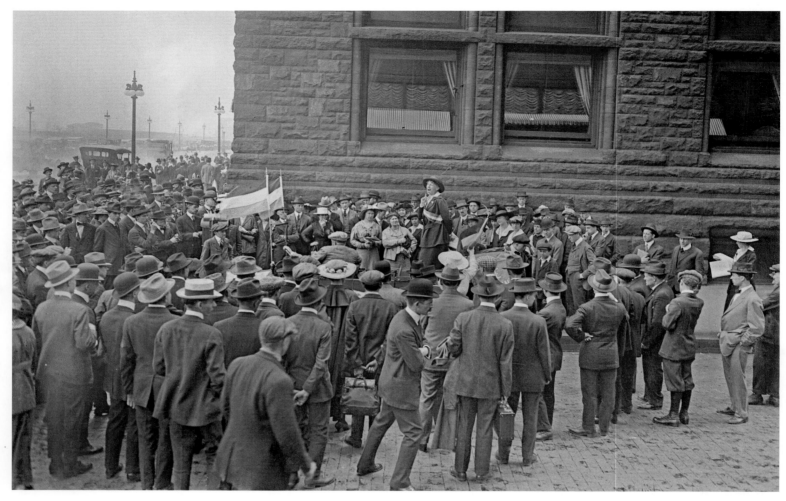

A pro-suffrage gathering in downtown Chicago at the corner of Van Buren Street and Michigan Avenue, June 16, 1916. The women's suffrage movement lasted from roughly the 1860s to 1920. Many progressive women involved in the movement for suffrage also championed the abolition of alcohol.

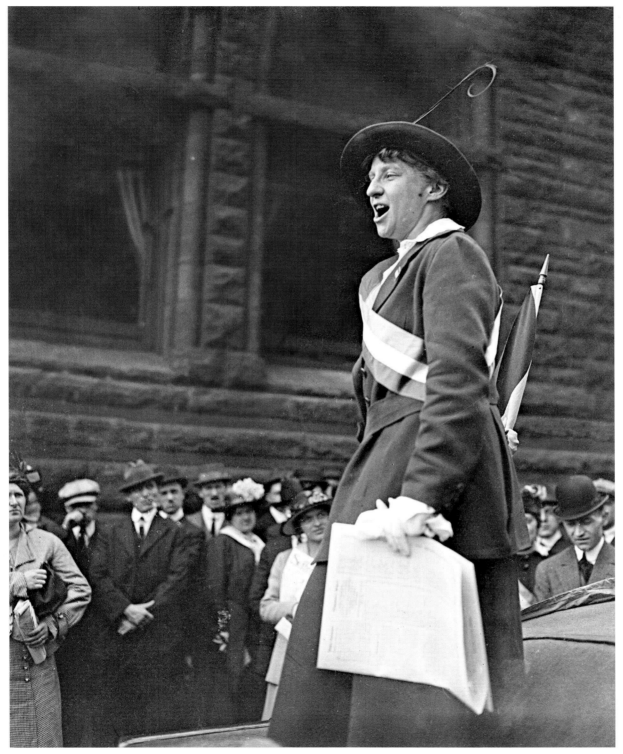

Suffragist Mabel Vernon speaks to a crowd in Chicago, June 16, 1916. The Illinois legislature granted women the right to vote in local and national elections in 1914, and 15,000 women registered. Universal suffrage was not granted nationally until 1920.

The original Juvenile Court Building and Detention Home near the corner of Halsted and Des Plaines streets. Chicago was the first city in the United States to establish a separate court to cater to the specific needs of juvenile offenders.

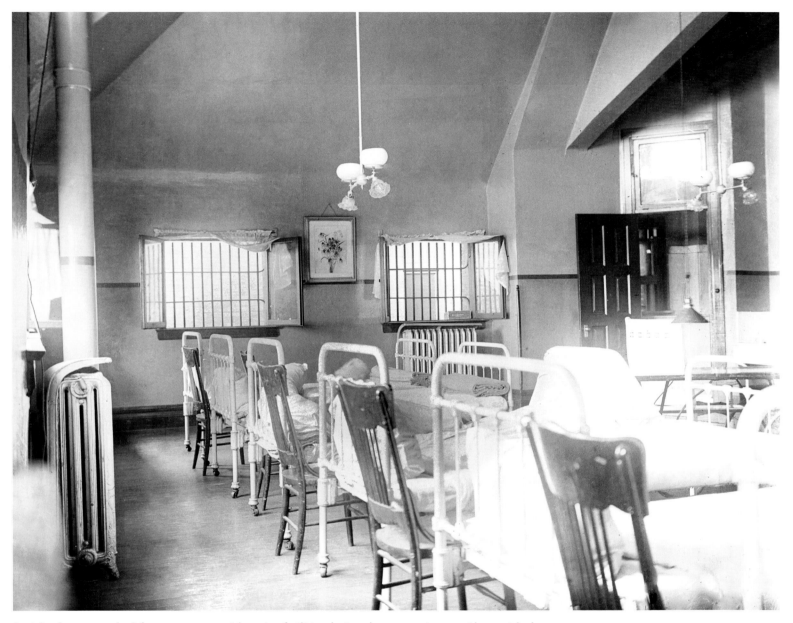

Social reformers pushed for many new social service facilities during the progressive era. Along with the creation of juvenile law services, hospital facilities were added in the Cook County Jail.

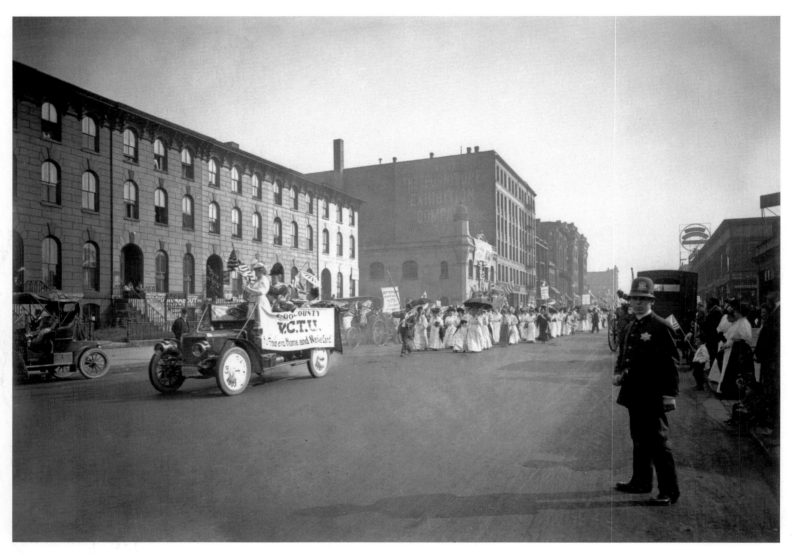

This photograph, taken on September 26, 1908, depicts a Temperance parade. The banner on the automobile reads "Cook County WCTU" (Woman's Christian Temperance Union). Temperance is as old as the city itself. The first local temperance organization was founded in 1833, before the city was officially incorporated. By 1909 two-thirds of Chicago precincts were dry thanks to the temperance movement's political influence. Illinois ratified the 18th Amendment, Prohibition, in 1919.

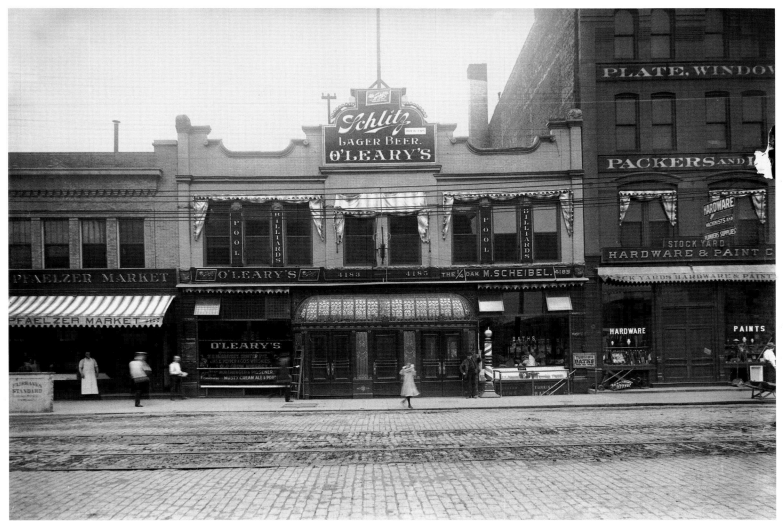

This saloon was located at 4183 S. Halsted Street. Prior to prohibition, saloons served as community centers, especially in areas of the city were literacy rates were low, and where social drinking was common and widely accepted. In Chicago, German and Irish immigrants converted saloons into cultural enclaves. Breweries controlled saloons and rented to barkeeps. As the price of licenses increased due to the growing influence of the temperance movement, saloonkeepers began to rely on gangs to support their businesses.

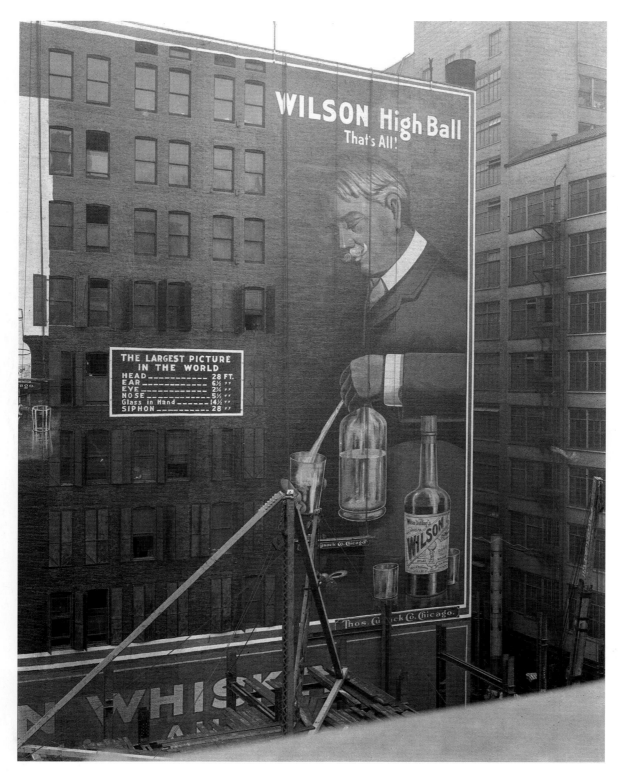

This colossal advertisement for Wilson whiskey was painted on a wall near the corner of Madison Street and Wabash Avenue. The temperance movement was gaining ground at this time in Chicago and nationwide; alcohol consumption, however, was still a common and accepted activity across the city's social strata.

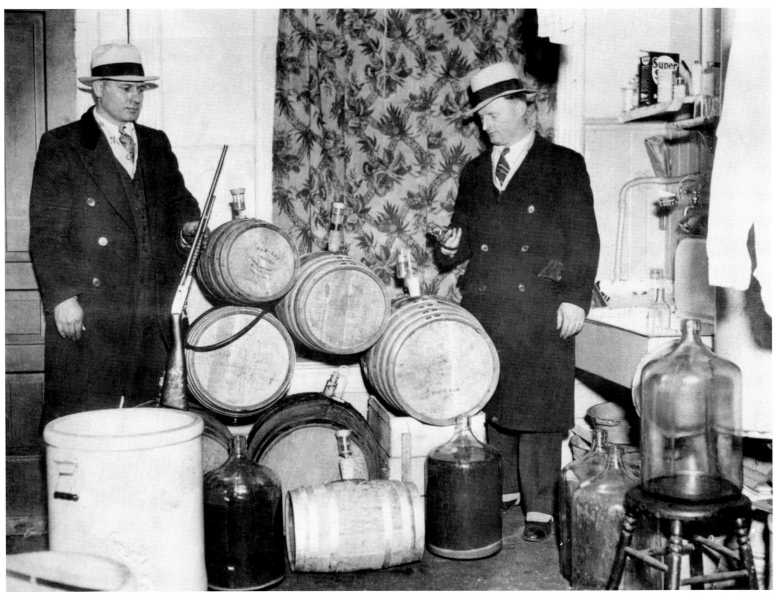

Police officers with distilling equipment. The U.S. Commissioner of Prohibition reported that, in the twelve months between July 1929 and June 1930, agents seized more than 16,000 distilleries and more than 8,000 stills, nationwide.

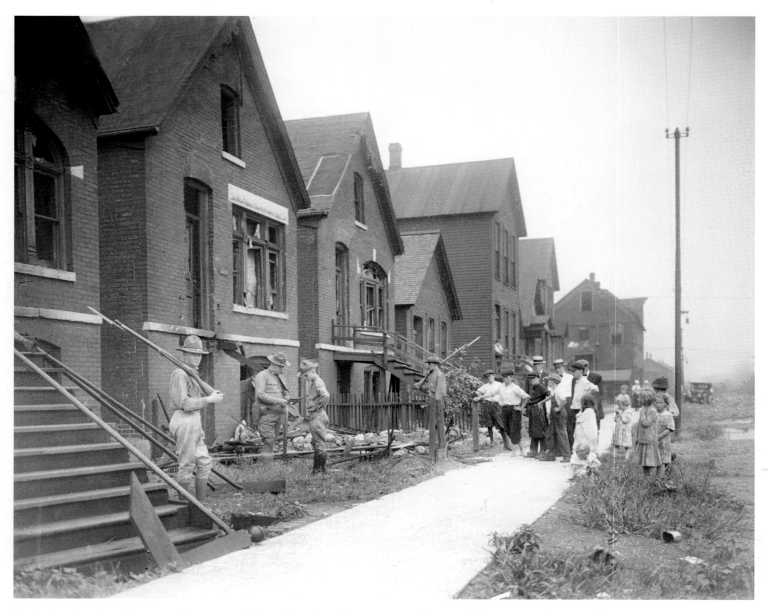

In the first decades of the twentieth century, African Americans began to move from southern states to the cities of the North in what came to be known as the Great Migration. Increasing numbers of African Americans were forced to live in a few overcrowded, segregated neighborhoods in the city. Heightened racial tensions boiled over on a hot day in 1919. Precipitated by the drowning of a black youth by whites at a segregated beach, a race riot broke out and raged across the city from July 27 until August 3. This image depicts soldiers in front of a vandalized house.

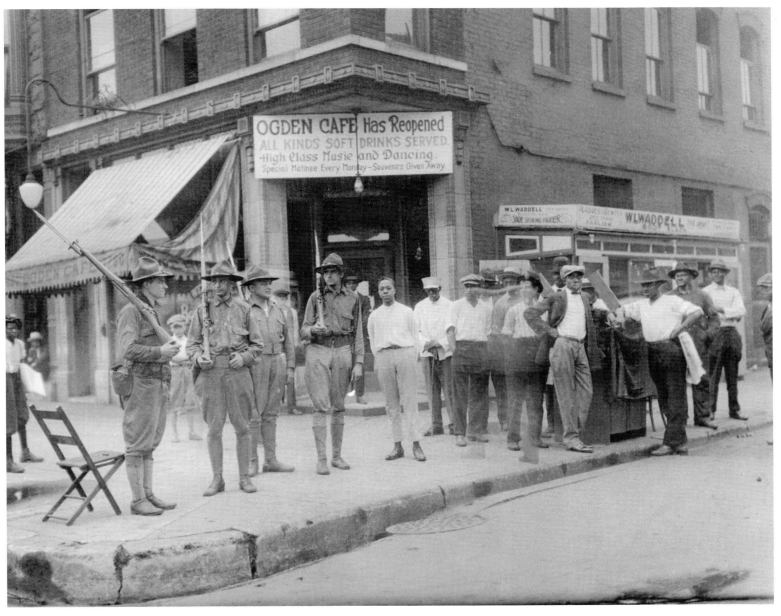

During the race riot, Chicago's mostly white police force proved to be ineffectual, and only the state militia and a subduing rainfall quelled the violence.

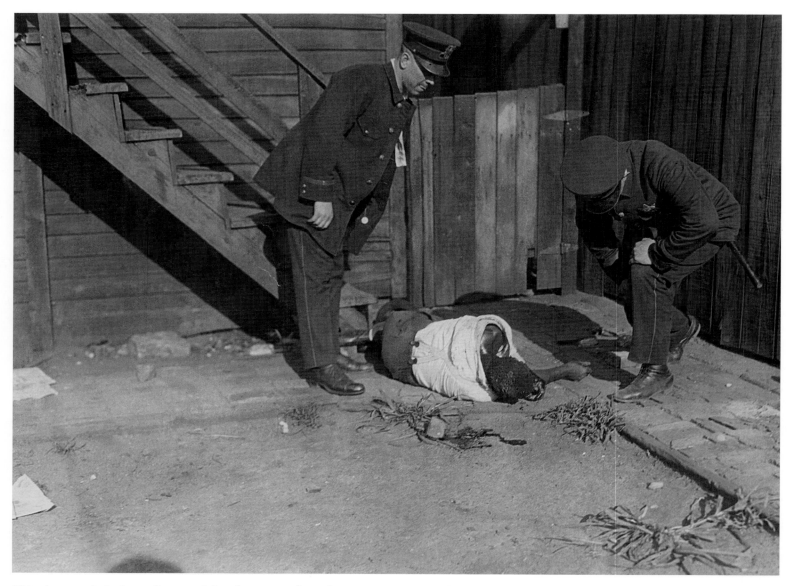

This photograph depicts police examining the corpse of an African American man who had been stoned and beaten to death. The riots resulted in the deaths of 15 whites and 23 blacks and an additional 537 people injured. The riot ended, but Chicago's race equation changed little, if it all.

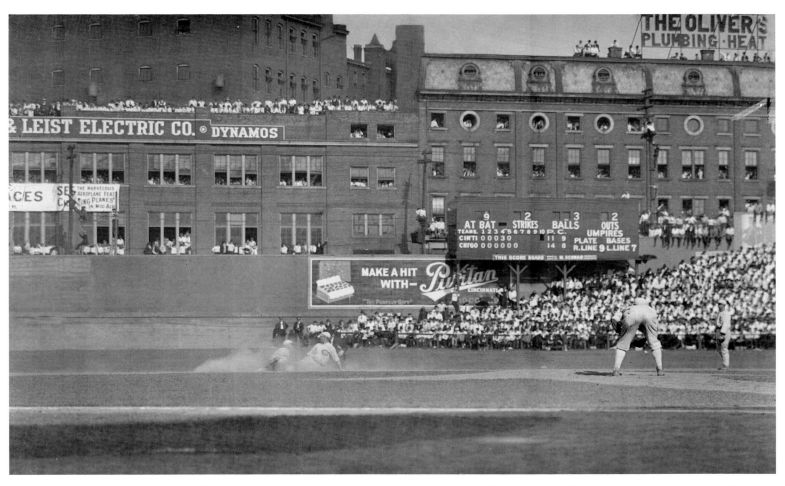

Chicago had a reputation as a city where the "fix was in," long before Al Capone arrived. At the dawn of the new decade, a professional baseball team added to the city's infamy. The Chicago White Sox, considered at the time to be one of the best baseball teams ever, surprised fans everywhere by losing the opening game of the 1919 World Series to a very mediocre Cincinnati Reds team. They went on to lose the entire series 5 games to 3. In 1920 it was revealed that eight team members had conspired with a gambling syndicate, headed by Arnold Rothstein, to throw the game. The incident became known as the "Black Sox Scandal."

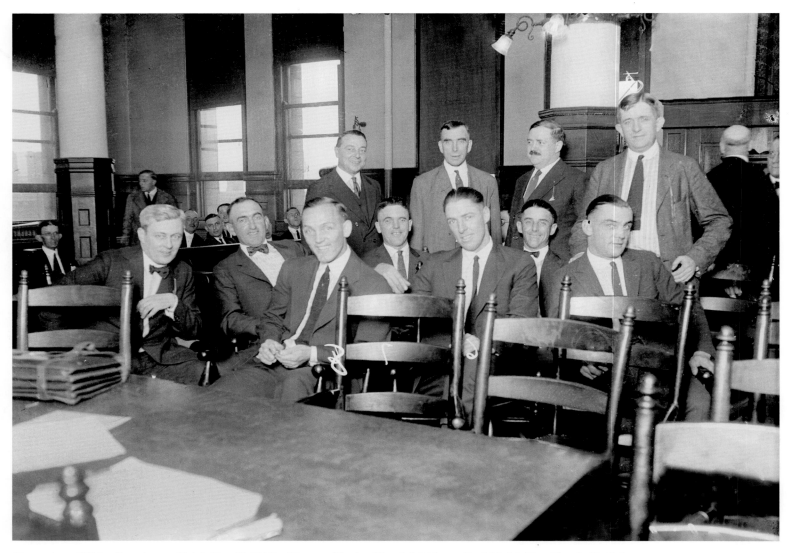

Shown here, White Sox players Chick Gandil, Eddie Cicotte, Charles "Swede" Risberg, Fred McMullin, Claude "Lefty" Williams, George "Buck" Weaver, "Shoeless" Joe Jackson, and Oscar "Happy" Felsch were charged with conspiracy to defraud the public, to commit a confidence game, and to injure the business of owner Charles A. Comiskey. The trial lasted 14 days, and on August 2, 1921, the players were found not guilty, despite the fact that many of them had confessed to knowing of, or participating in the scheme.

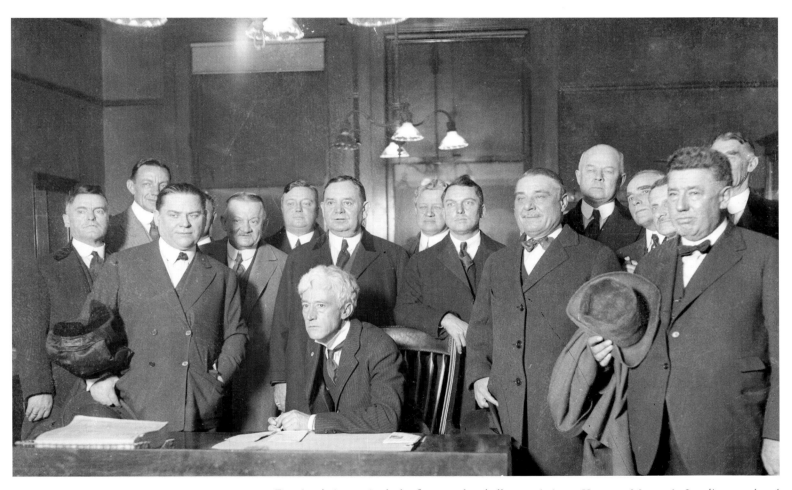

Despite their acquittal, the first-ever baseball commissioner Kenesaw Mountain Landis, seated and surrounded by baseball franchise owners, expelled all eight players from Major League Baseball to reassure the public as to the purity of America's beloved pastime. The Black Sox scandal contributed to Chicago's reputation for corruption and vice.

During the first decade of the twentieth century, Chicago was home to 28 automobile manufacturers who produced 68 models of cars. Although seen as a luxury item by many, automobile sales grew steadily through the 1920s. The speed of travel and the level of independence offered by private motor vehicles changed the nature of life in the city.

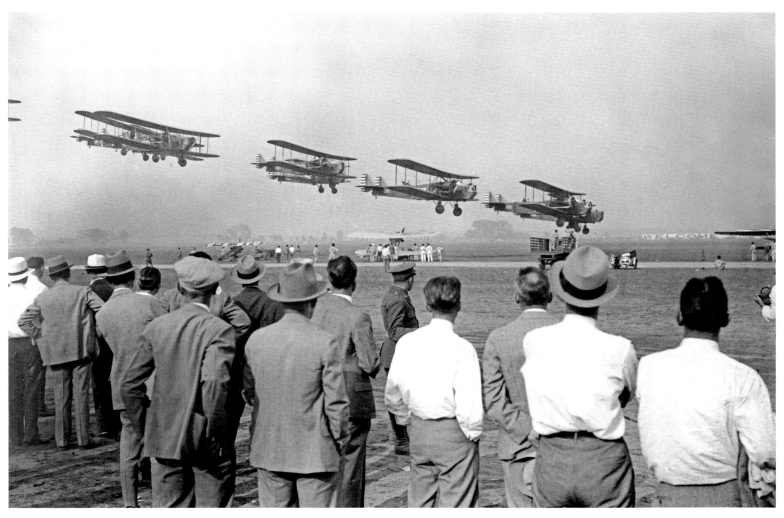

At the dawn of the 1920s, few people had ever flown in an airplane. In the few years between the Wright brothers' first flights and the emergence of the image of the dashing World War I flying ace, flight had captured the imagination of America. After the war, air shows, barnstorming acts, and wing-walking became wildly popular, and Charles Lindbergh's nonstop, solo flight across the Atlantic in 1927 symbolized the freedom, technological advances, and the possibilities of the era.

Aviators such as Charles Lindbergh and the Italian Francesco de Pinedo (pictured here), were welcomed in Chicago as heroes. When de Pinedo landed in Grant Park in 1927, throngs of people came out to see him including Al Capone, who attended the welcome party.

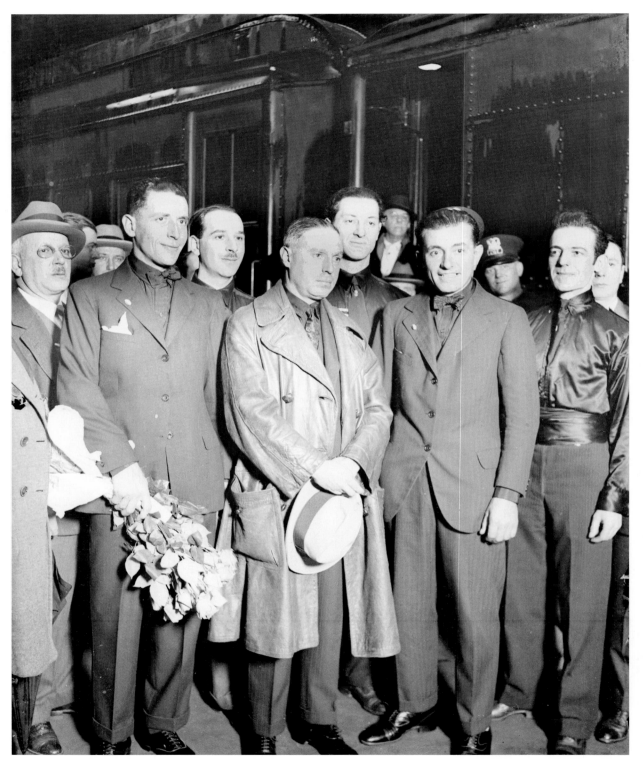

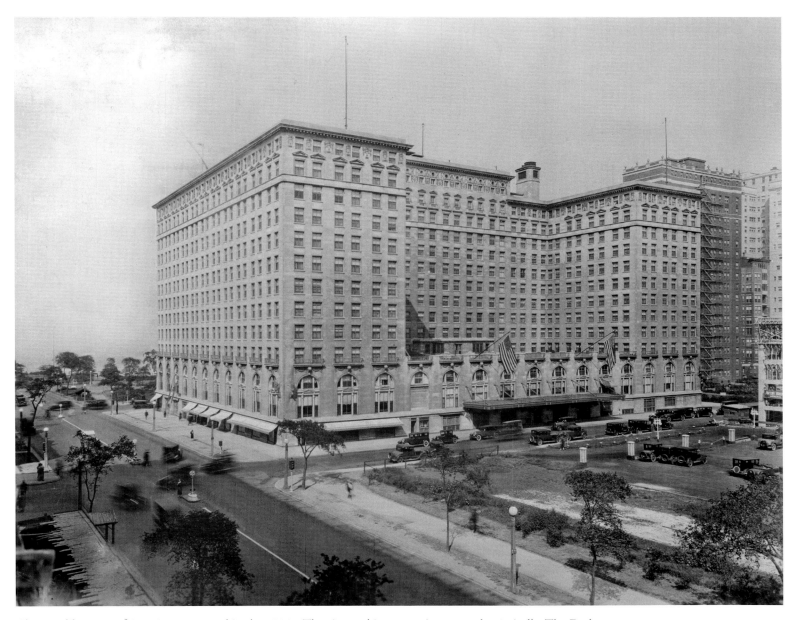

Chicago, like most of America, prospered in the 1920s. The city, and its reputation, grew dramatically. The Drake Hotel, owned by brothers Tracy and John Drake and designed by architects Marshall and Fox, opened on New Years Day 1920 and hosted Chicago's elite throughout the 1920s.

Economic prosperity in Chicago stimulated growth and development and helped establish Chicago as a destination, not merely a stopover for east-bound or west-bound trains. The luxurious Allerton Hotel opened in 1924 in the North Michigan Avenue area. It was part of a national chain of specialty hotels that provided hotel service and the social features of a private club.

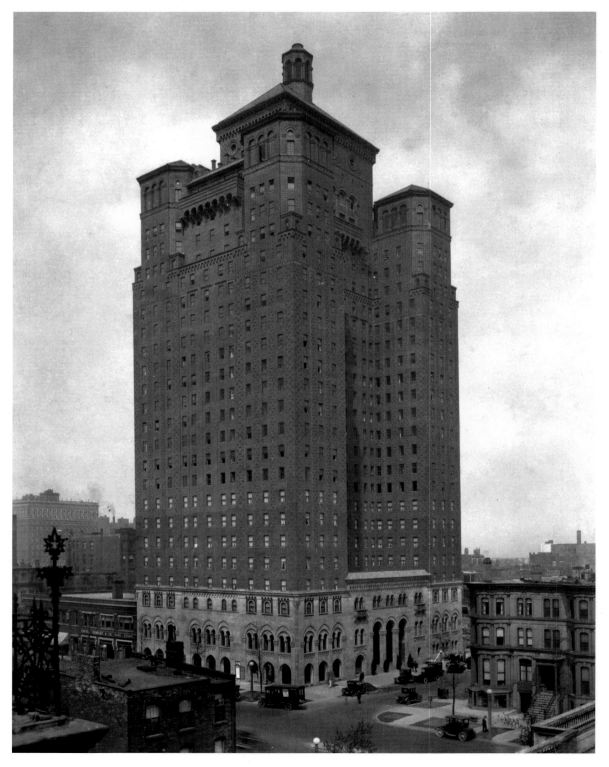

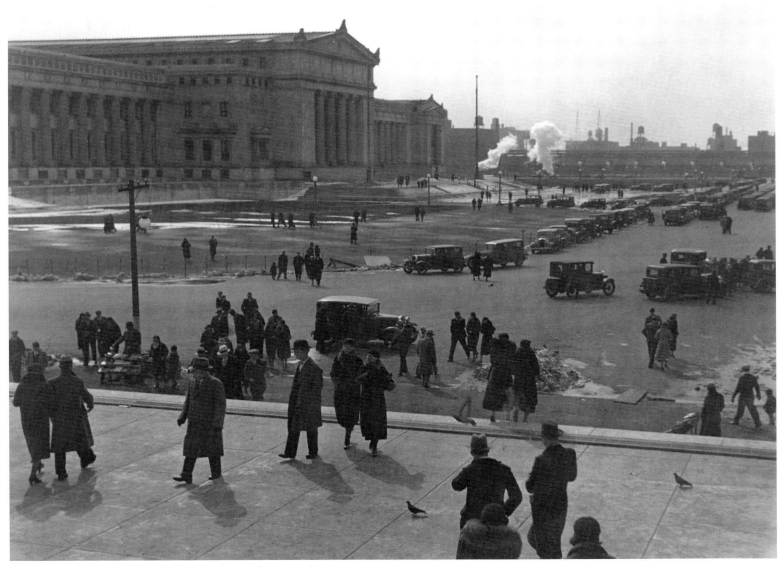

Founded in 1893 by one of Chicago's richest men, Marshall Field, the Field Museum's first incarnation was part of the World's Columbian Exposition Palace of Fine Arts in Jackson Park. After the fair, plans were drawn up to move the Field collection to its current home in Grant Park. World War I delayed the opening of the Field Museum, shown here, and the building was converted to a hospital for soldiers. Eventually construction of the museum was completed, and on May 2, 1921, the *Chicago Tribune* announced that the $6,750,000 facility would open the next day.

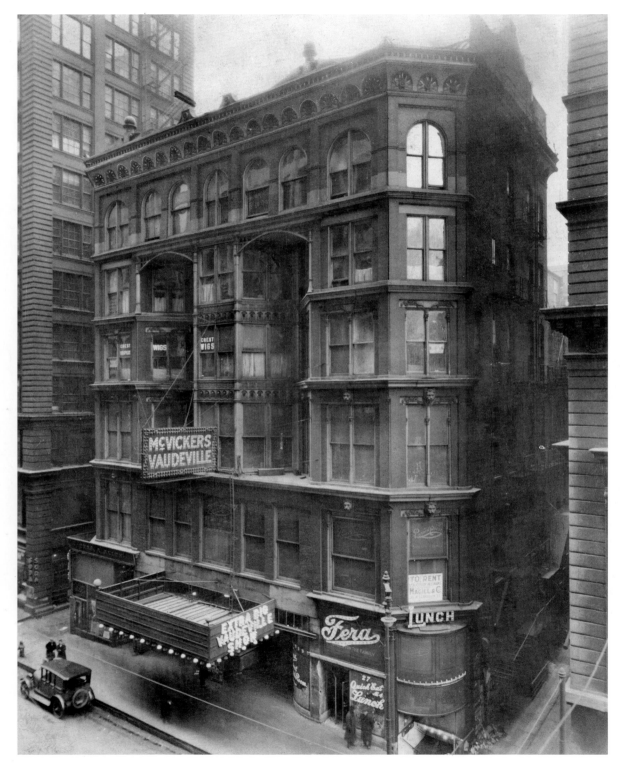

From its inception in 1857, McVickers theater, located at 25 W. Madison Street, featured high-drama live theater in which women and men performed in a manner consistent with Victorian attitudes toward courtship and romantic love. In the 1920s, in contrast, McVickers became famous for its bawdy vaudeville entertainment. McVickers next became a movie theater, evolving with the times and its preferred forms of entertainment.

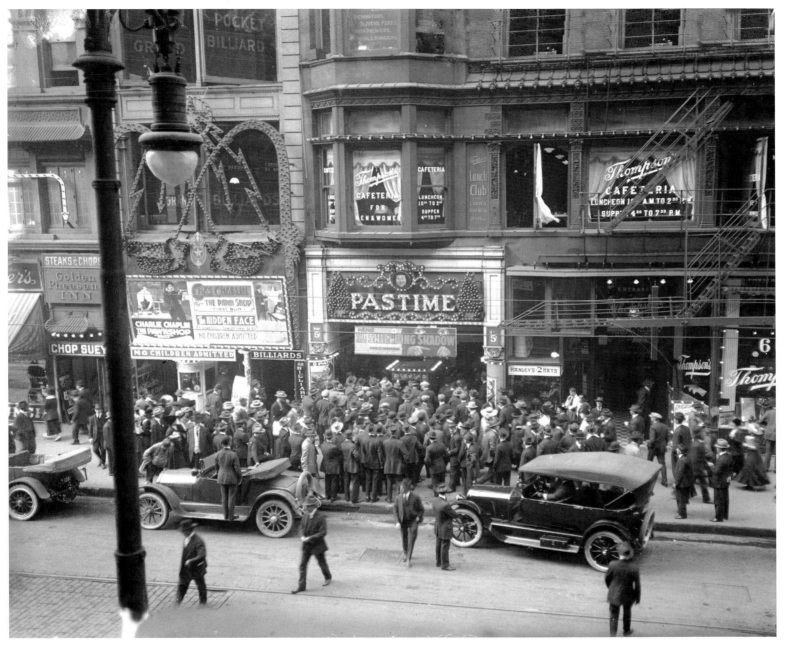

The Pastime Theater, located at 66 W. Madison, housed traveling Broadway shows, vaudeville acts, and popular exotica. During the first decades of the century, Chicago established itself as a theater hub, and venues like the Pastime and McVickers, with their elaborate sets and lavish decor, attracted visitors and big-name entertainers to the city.

The Chilton & Thomas dance team, shown here in the late 1920s, were Charleston dancers. New flamboyant and suggestive dances such as the Charleston and the Black Bottom became wildly popular in Chicago's prohibition-era nightclubs. The 1924, all-black musical revue, *Runnin' Wild,* is credited with inspiring the Charleston craze.

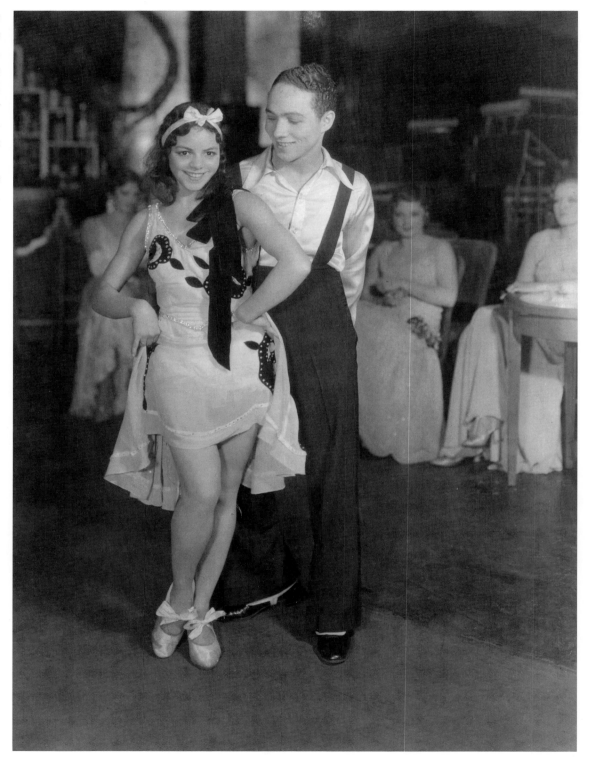

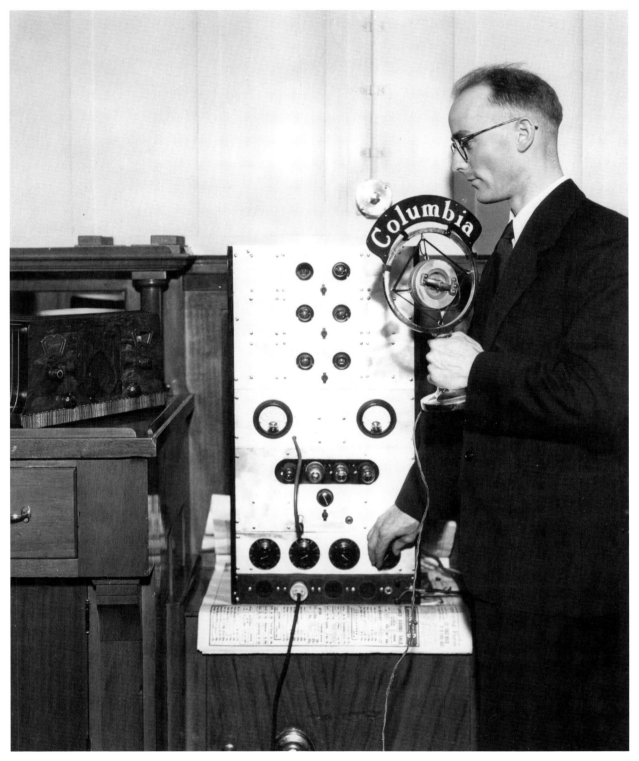

Chicago's first radio broadcast occurred in 1921. Until then most literate Chicagoans received information about events in the rest of the nation and the world through newspapers. Others, through word of mouth. The city's location made it a convenient broadcasting center and switching point for transcontinental broadcasts. Radio soared in popularity during the 1920s and the industry grew in Chicago. Most programs were musical comedies, but Chicago birthed the popular "soap opera" genre.

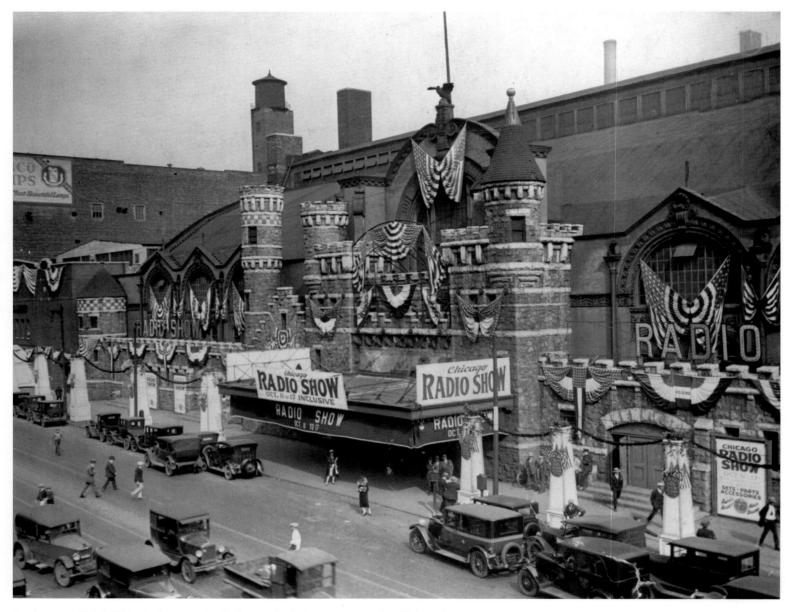

Located at 1513 S. Wabash Avenue, the Coliseum, built in 1899, served as Chicago's primary indoor arena until the 1930s and was often used for radio broadcasts with live audiences.

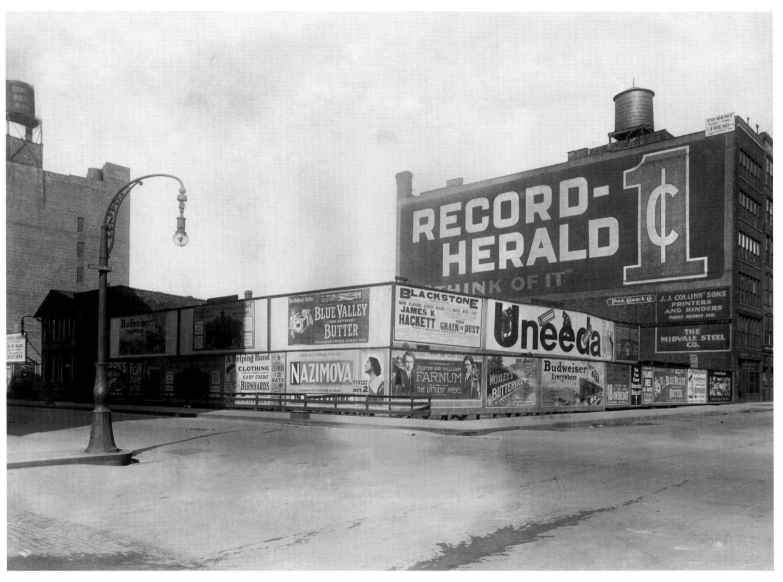

As radio progressed in the 1920s, advertisers took to the airwaves too. Traditional forms of advertising, however, remained popular.

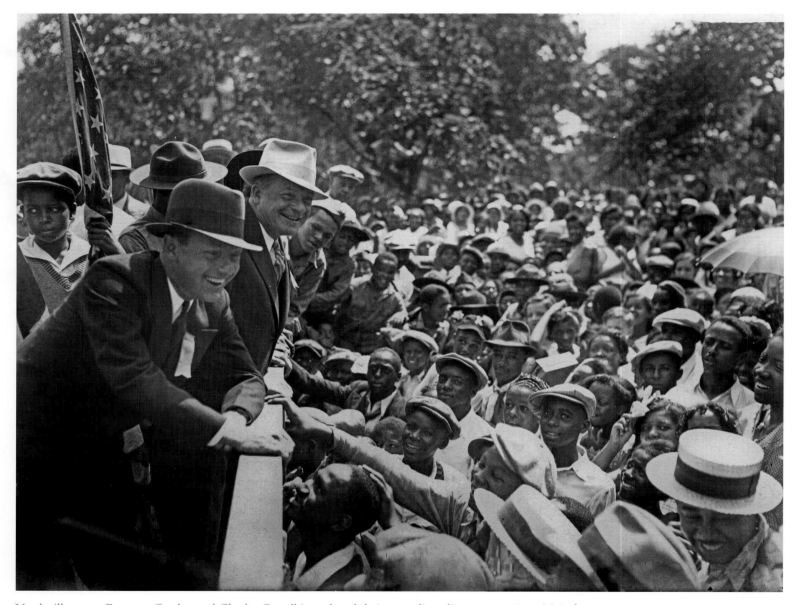

Vaudeville actors Freeman Gosden and Charles Correll introduced their comedic radio program *Amos 'n' Andy* on WGN in 1926, and it became radio's first sensational hit. The often stereotypical portrayal of the lives of black southerners in Chicago drew controversy but was also widely popular with white and black audiences alike.

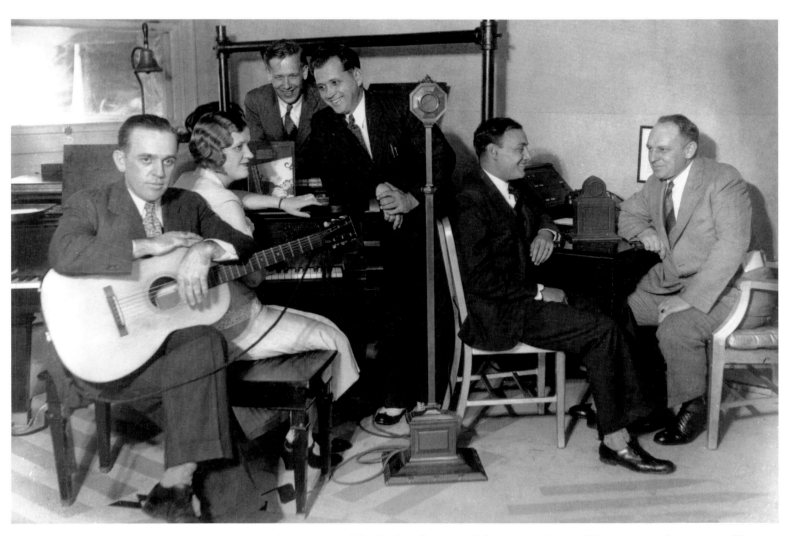

Marion (seated at piano) and Jim Jordan (foreground, leaning on piano) of Peoria were radio pioneers. They got their start in Chicago in 1924. After their show *Farmer Rusk and his Farmers,* the Jordans went on to create the widely popular *Fibber McGee and Molly* show on WMAQ, which aired nationwide beginning in 1935.

Women soldering radio chassis at Belmont Radio in 1922. From the left are Lottie Frys, Mildred Tessar, Helen Carpenter, Viola Davis, Bernice Siwy, and Dolly Chiero. World War II wasn't the first time women were sent into the work place. A labor shortage during World War I required many American women to perform jobs traditionally handled by men. After the war many women left these jobs, but some stayed and others followed.

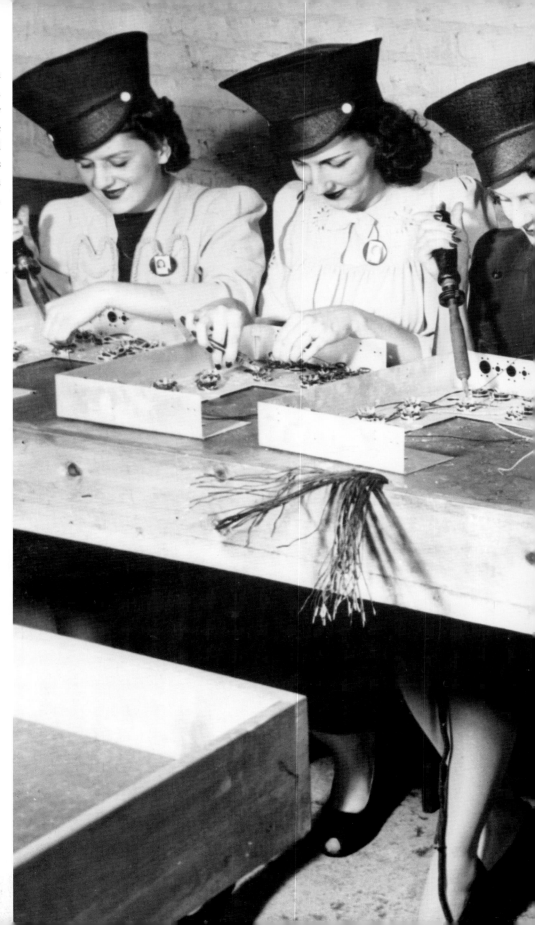

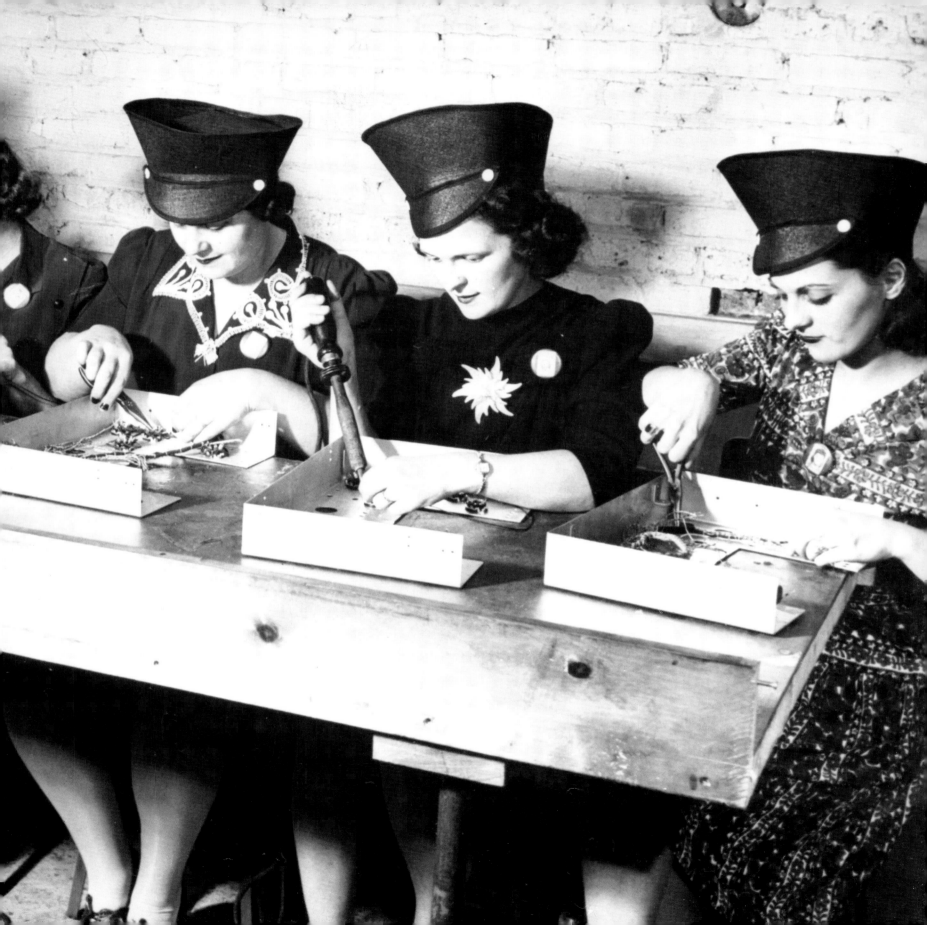

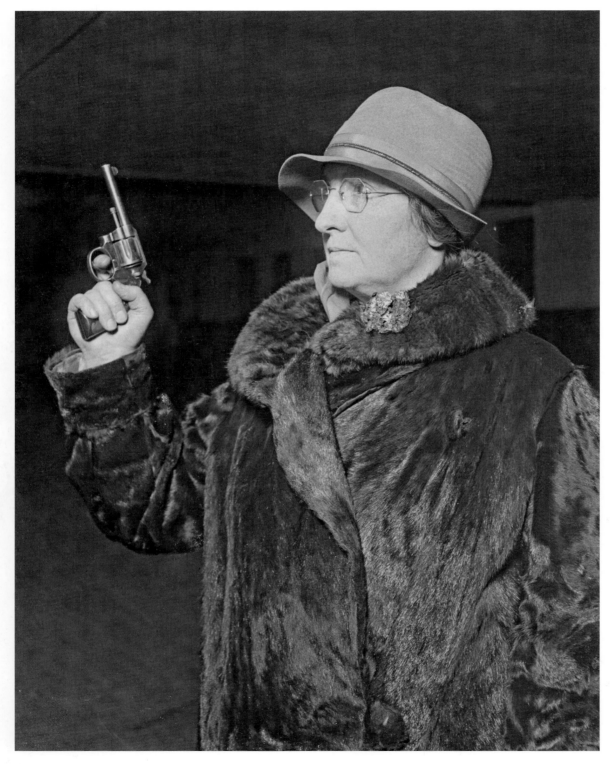

Small numbers of women even joined the police ranks in the 1920s. Shown here is Chicago policewoman Anna Sheridan, with pistol, in 1928.

This 1926 photograph showcases the rise in popularity of "dress maker" bathing dresses, which exposed more skin than previous bathing suit models. These new suits fit more closely and revealed the shape of the woman's figure, reflecting the popular fashions of the 1920s.

As a rail hub, Chicago welcomed performers from all over the country who came through the city by train. Shown here are vaudeville performers at Union Station. The women's clothes reveal fashions characteristic of the late 1920s: short skirts, bobbed hair, cloche hats, and fitted overcoats. Also noteworthy is that these single women were most likely traveling unchaperoned, and performing in public, challenging traditional views of appropriate behavior for women.

Two women outside the Rainbow Fashion Show, in 1926. Period fashion reflected a new degree of leisure and freedom for women: clothes were worn loose, skirts were shorter, and eye-catching accessories and adornments were popular.

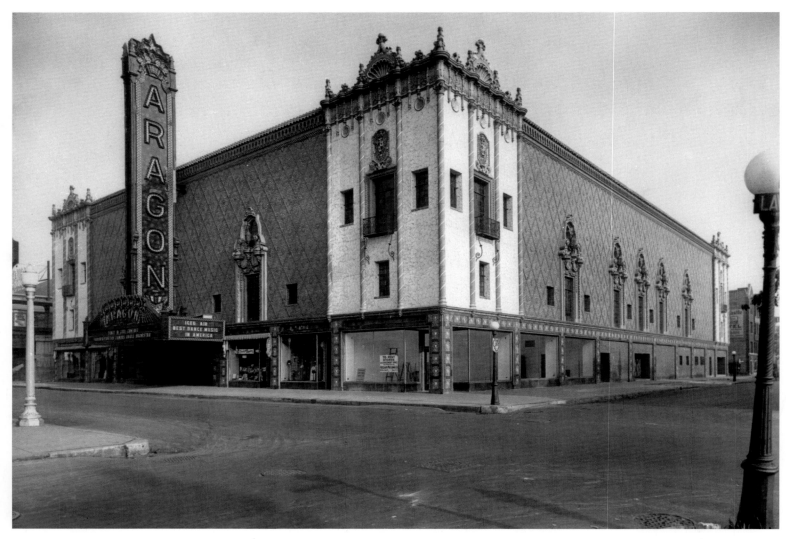

Located at 1106 W. Lawrence Avenue, the Aragon Ballroom opened in 1926 and quickly became a center of Chicago's dancehall culture. WGN began broadcasting from there in 1927. The ballroom was segregated and attracted mostly working-class white patrons. The marquee advertises "Iced Air" (air conditioning) and the "Best Dance Music in America."

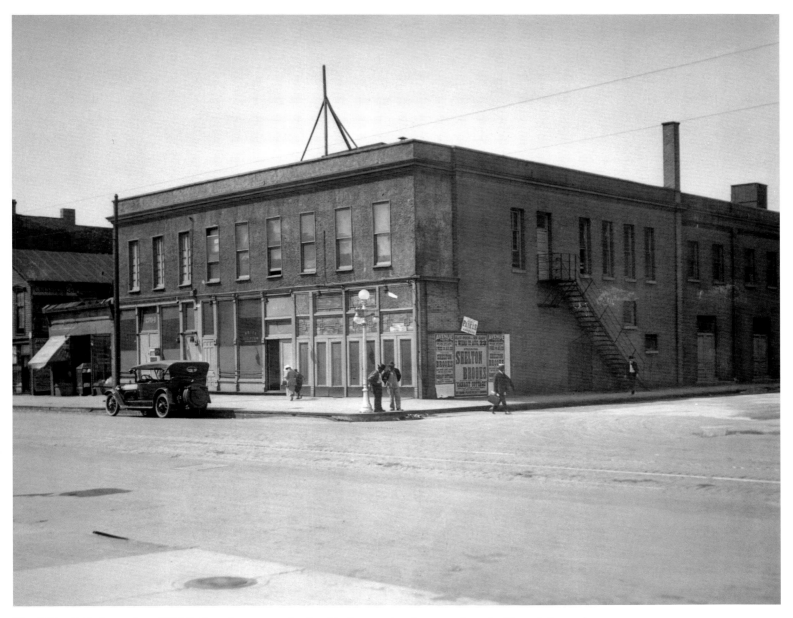

The Pekin Cafe, located on 2700 S. State Street, was the first black-owned and operated vaudeville and theater in Chicago. It was opened by Robert T. Motts in 1905 and served the black community. Many of Chicago's nightlife venues, even those in the black community, remained off-limits to African American patrons, despite the fact that they often featured black entertainers.

The Plantation Cafe, located on 35th Street and Calumet Avenue, was integrated and attracted white patrons as well as black. These clubs, sometimes called black and tans, were some of the only businesses in Chicago with an integrated clientele. Nightclubs like these were often caught up in turf wars as the gangs jockeyed for control of Chicago's nightlife venues and speakeasies. Most of these clubs were either owned by the gangs or they paid protection money to remain open.

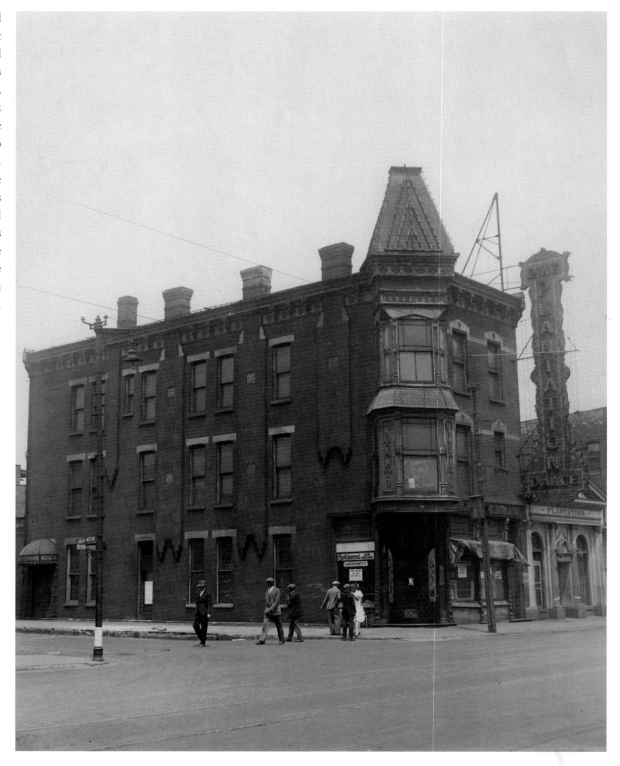

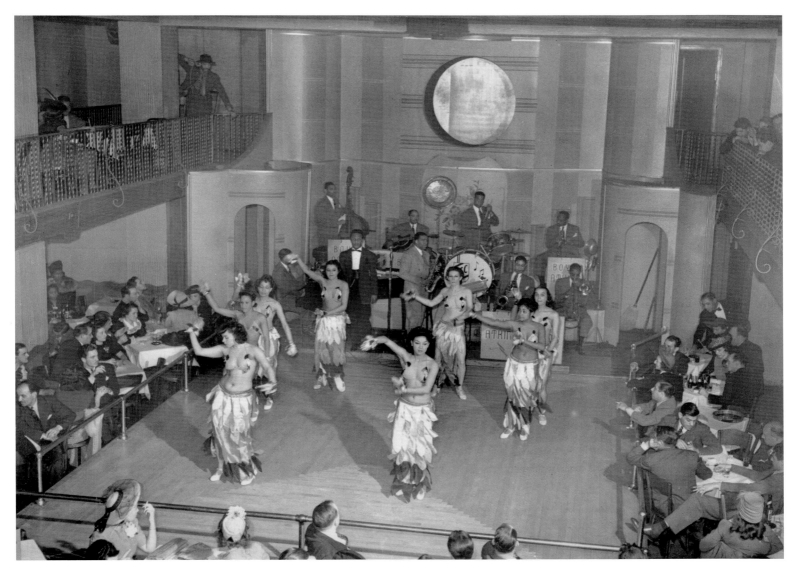

Black-and-tan clubs almost always featured African American performers and integrated audiences, although it was not uncommon for blacks and whites to be segregated within the venue.

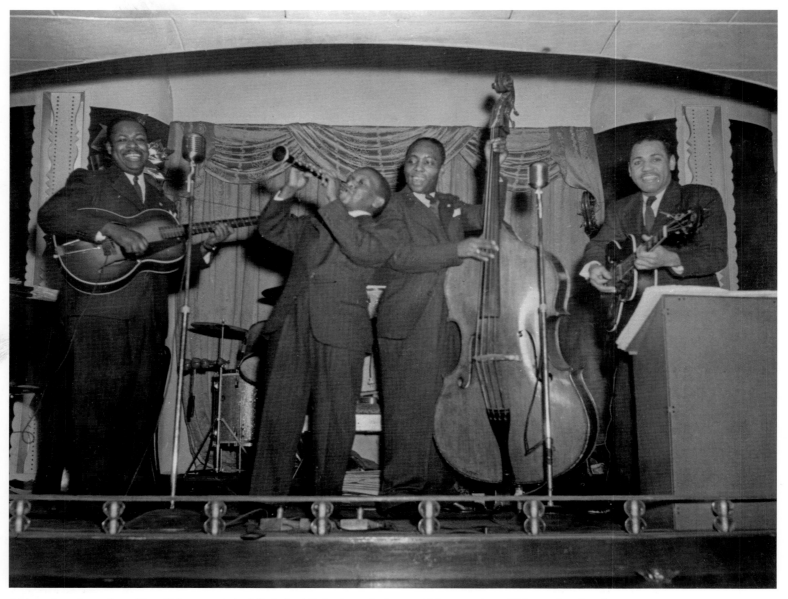

African Americans from New Orleans and the Mississippi Delta brought jazz and blues music to Chicago. Local and regional labels such as Okeh, Vocalion, and Paramount recorded African American jazz musicians and marketed and sold these records to black customers. Known as "race records," these recordings offered African American musicians a chance to reach a wider audience.

Louis Armstrong arrived in Chicago in 1922 and joined Joseph "King" Oliver's Creole Jazz Band at the Lincoln Gardens Cafe. He went on to record for Okeh records in Chicago with his Hot 5 & Hot 7, from 1925 to 1928. Armstrong played with many of the most innovative early jazz musicians including Kid Ory, Fletcher Henderson, and Lil Hardin, later to become his wife.

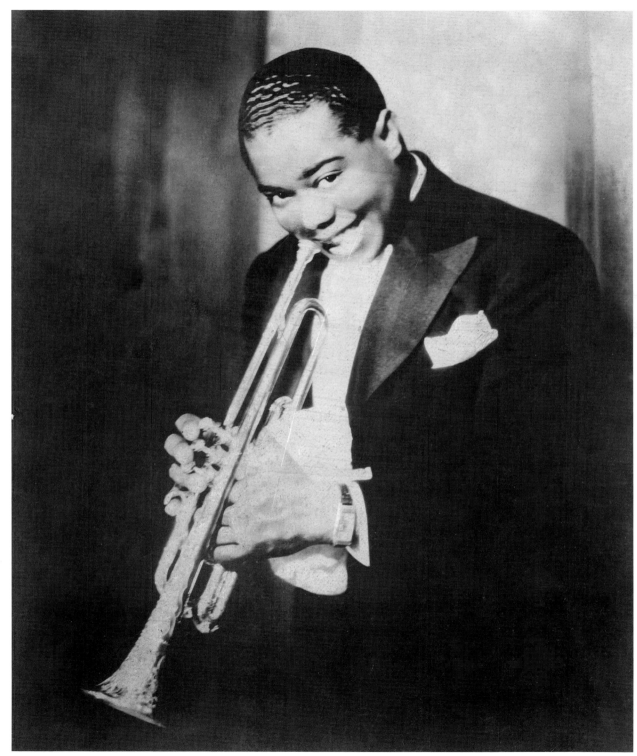

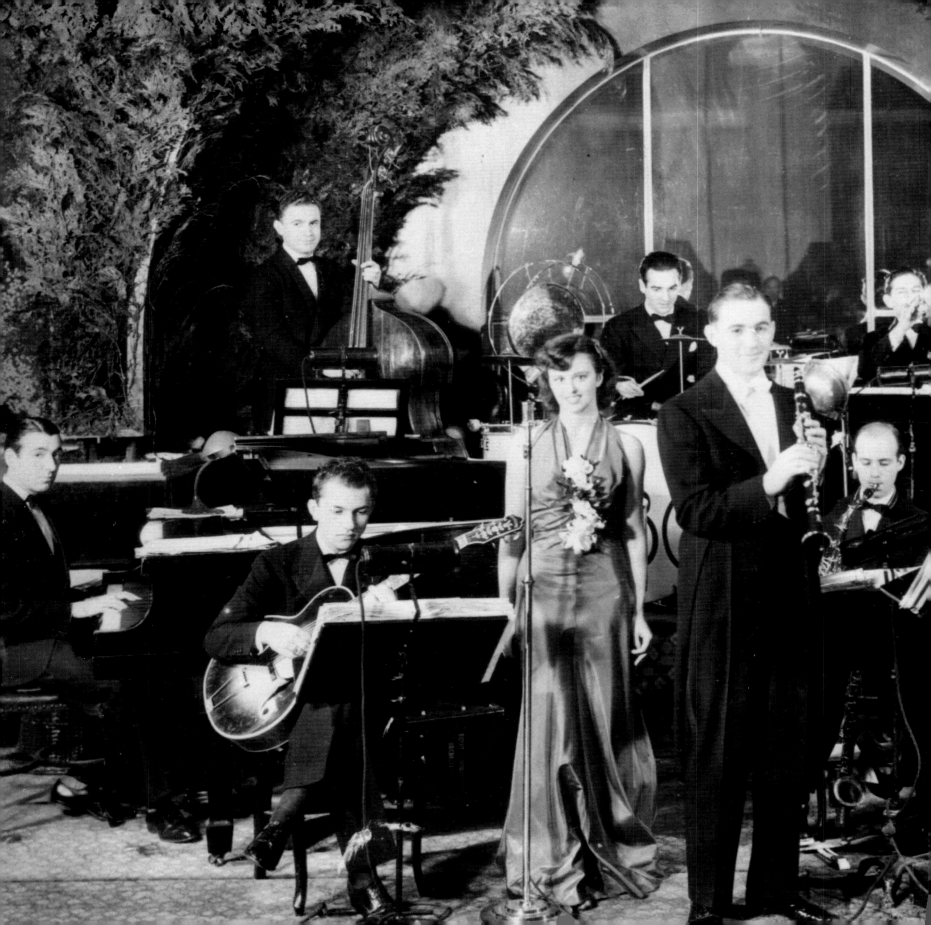

Famed clarinetist and band leader Benny Goodman learned jazz music in the clubs on Chicago's South Side in the 1920s and went on to lead the Big Band "Swing" craze of the 1930s. Goodman, like the young members of Chicago's Austin High Gang, was captivated and inspired by the African American jazz music that was featured in Chicago's South Side nightclubs.

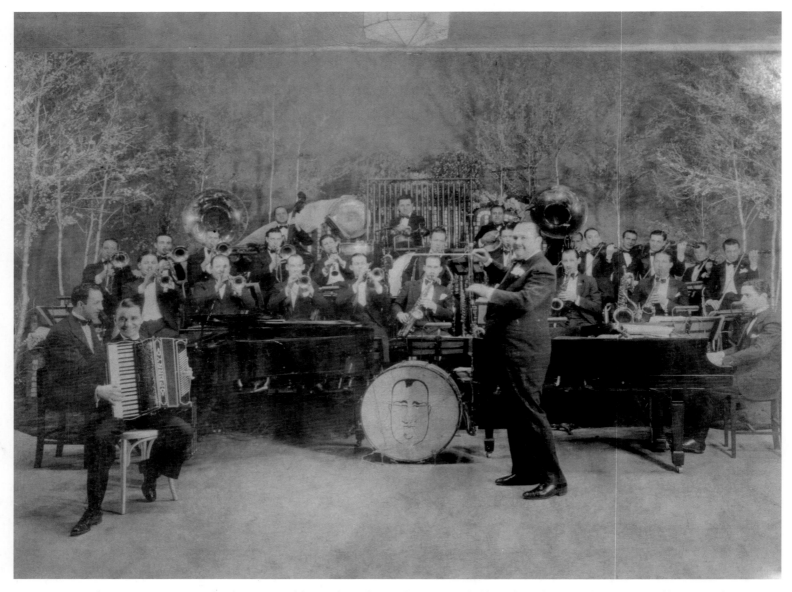

Paul Whiteman and his Ambassador Orchestra recorded heavily and appeared in the 1930 film *King of Jazz*. Many white musicians adopted the jazz style of black musicians in Chicago and devised a form of the music that appealed to white audiences. Whiteman's "Whispering" was one popular recording.

This 1928 Marathon Dance competition was part of the growing phenomenon of youth culture in the 1920s. Dance halls grew in popularity as "teenagers" emerged as a demographic, and a market for "suitable" entertainment for youth grew. Other fads came and went throughout the decade, including pole-sitting and the Mah Jong craze.

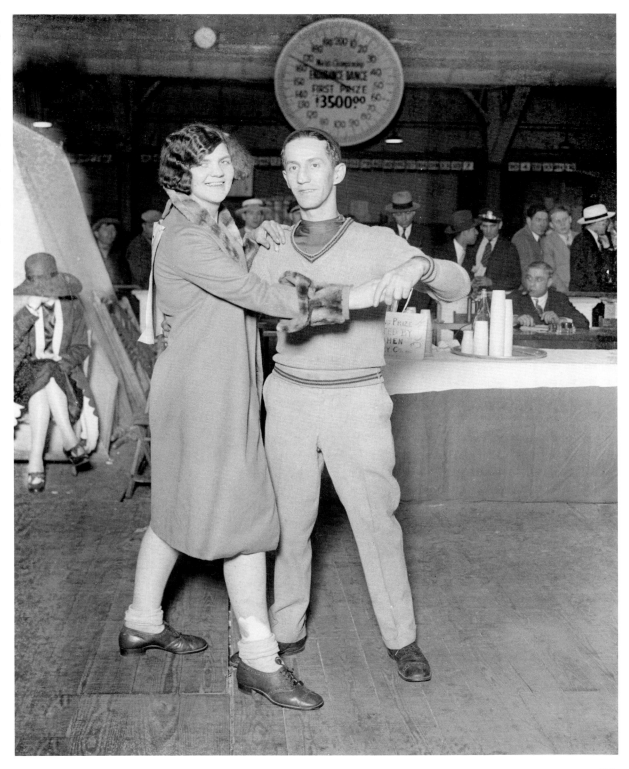

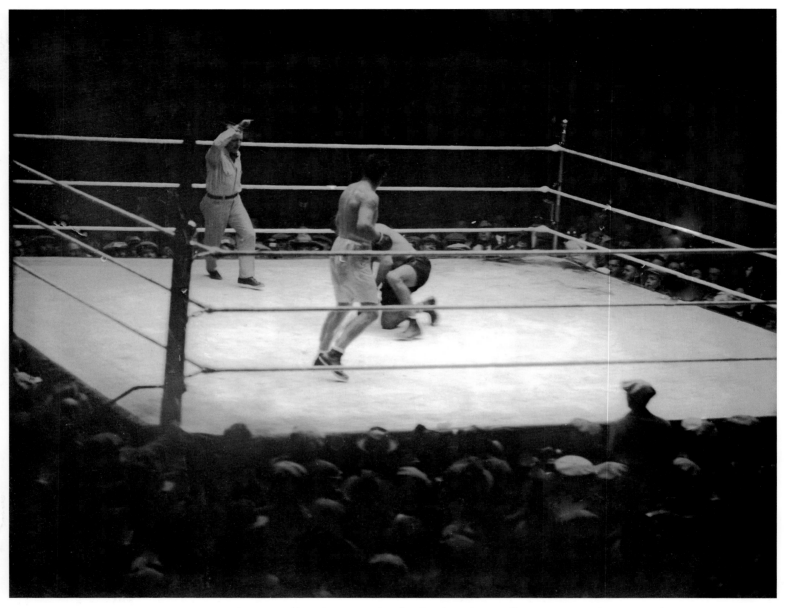

Gene Tunney took Jack Dempsey's title after the infamous "long count"—what appeared to many spectators to be an excessively long count by the referee to ensure that Tunney could recover after being knocked down by Dempsey. The fight and the controversy served only to reaffirm Chicago's corrupt reputation.

Prizefighting was illegal in Chicago between 1900 and 1926. Republican Mayor William Hale Thompson legalized the sport during his third term and is shown here with Jack Dempsey in 1927.

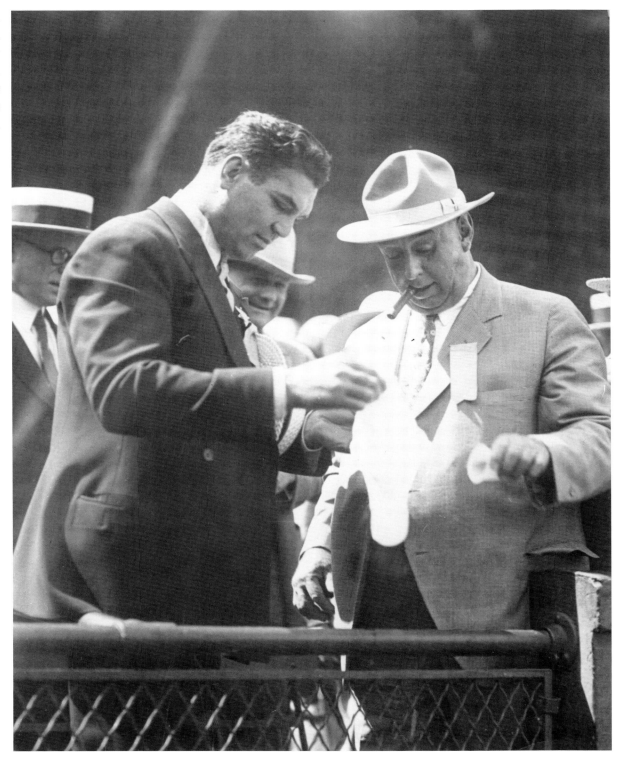

William Hale "Big Bill" Thompson was mayor of Chicago from 1915 until 1923 and then again from 1927 until 1931. Thompson was seen, at best, as soft on crime, and at worst, as corrupt. He was criticized for "ethnic baiting," including pandering to black voters, "flip flopping," and general corruption. Under Thompson's administration the gangs thrived.

Charles C. Healey, a former police chief, had been charged with "grafting" after it was discovered he had accepted money from professional gambler Billy Skidmore. Healey was successfully defended by Clarence Darrow and avoided jail time. This event prefigured Darrow's later fame and solidified the questionable reputation of the Chicago Police Department.

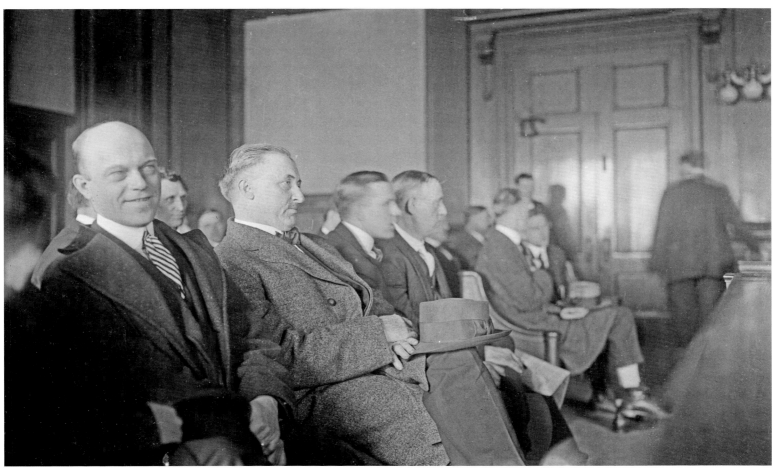

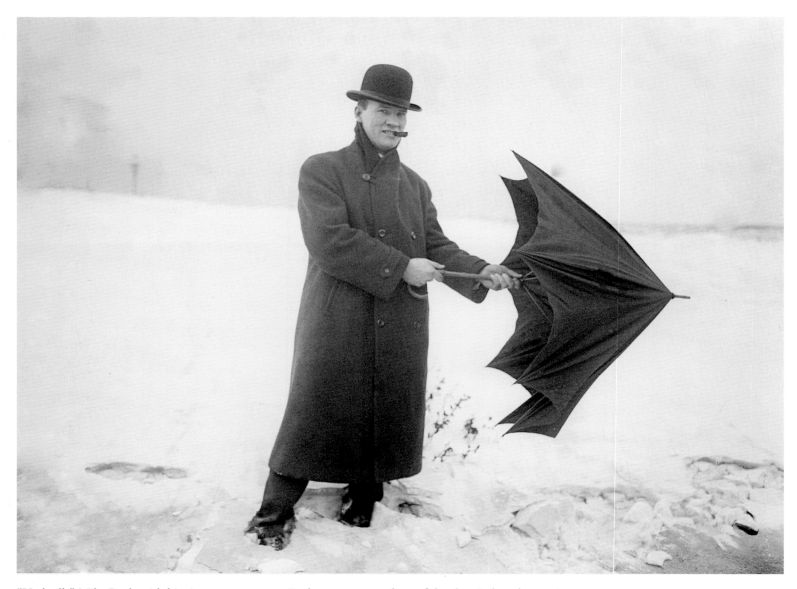

"Umbrella" Mike Boyle with his signature accessory. Boyle was a corrupt boss of the electrical workers union who had his bribes dropped into his umbrella. Corruption was so widespread in Chicago that many honest officials were considered crooked.

Corruption in Chicago extended beyond just the realm of politicians, law officers, labor leaders, and sports figures. Shown here, bankers from Wilson Avenue Bank and Mason Bank talk to a reporter and respond to charges of embezzlement.

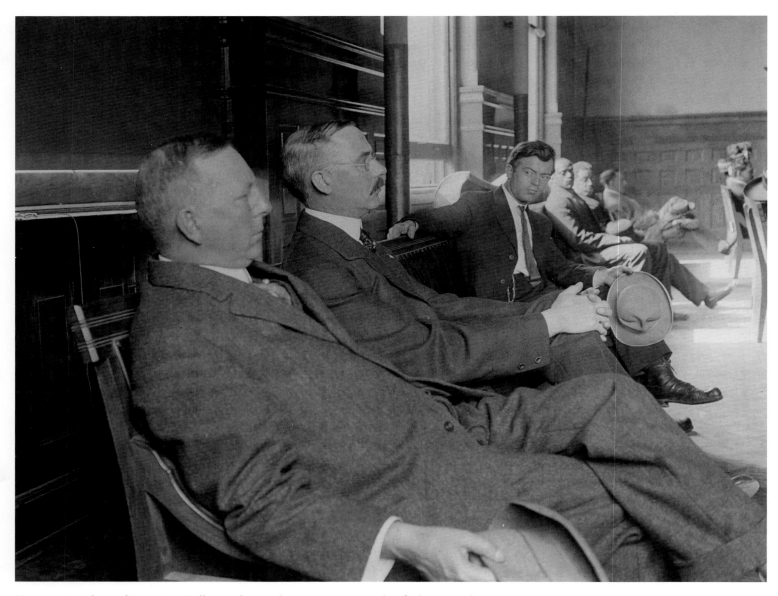

Harrison B. Riley and Justin M. Dall, president and secretary respectively of Chicago Title and Trust. The two were taken to court for leasing land for "disorderly purposes." Title and Trust was one of the city's oldest leasing companies, having been able to salvage their records from the devastation of the Great Fire of 1871.

Violent crime in Chicago in the 1920s was not limited to gang activity. The criminal courts saw an increase in female defendants, including Beulah Annan and Belva Gaertner, the murderesses featured in the recent musical *Chicago.* Another murderess, Mrs. Rene B. Morrow (pictured here), spent time in the Cook County Jail after her husband's death was ruled a murder rather than a suicide, as first assumed.

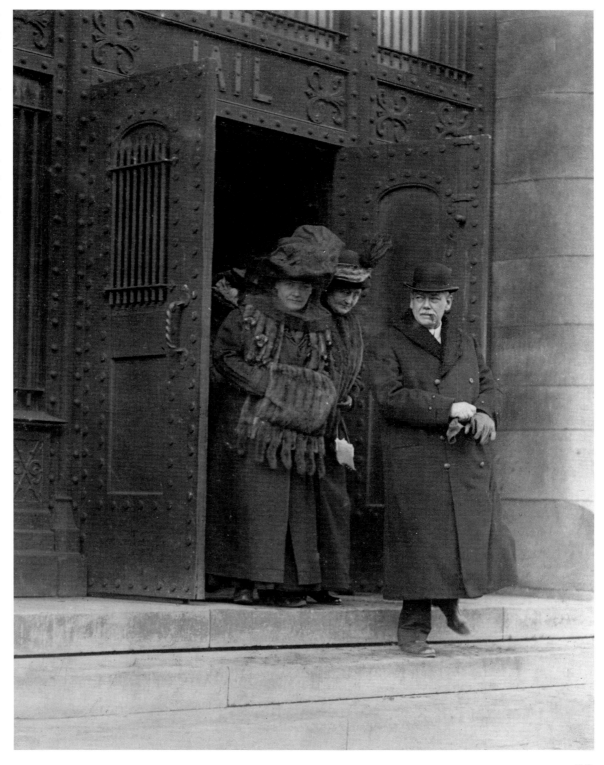

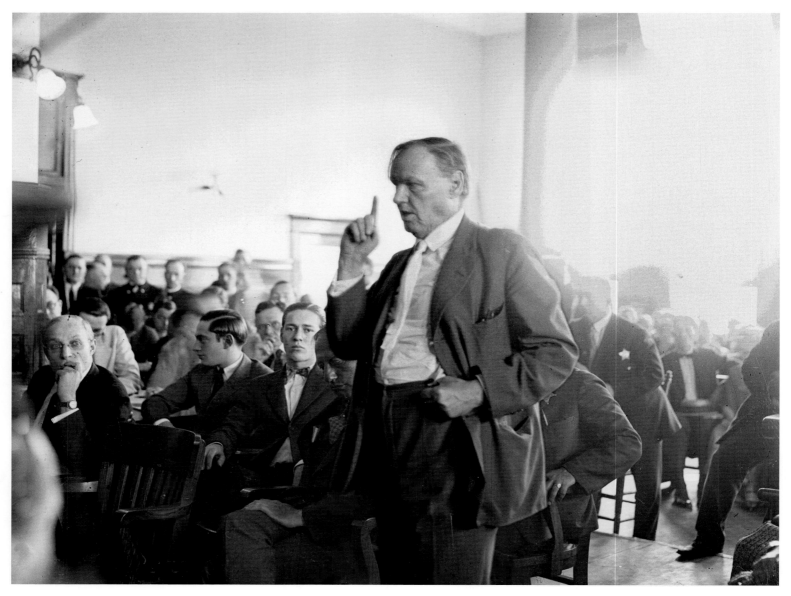

The biggest criminal case of the 1920s didn't involve gangsters, sports heroes, or civic leaders. Chicago's "trial of the century" concerned the murder of fourteen-year-old Bobby Franks by elite youths Nathan F. Leopold, Jr., and Richard Loeb. Clarence Darrow's eloquent defense of Leopold and Loeb, in which he argued for rehabilitation over retribution, saved the defendants from the death penalty and captivated the nation by emphasizing the psychological state of the criminals. Darrow, a prominent Chicago attorney who had also defended Eugene Debs and would go on to defend John T. Scopes, was coaxed out of retirement to work on the case.

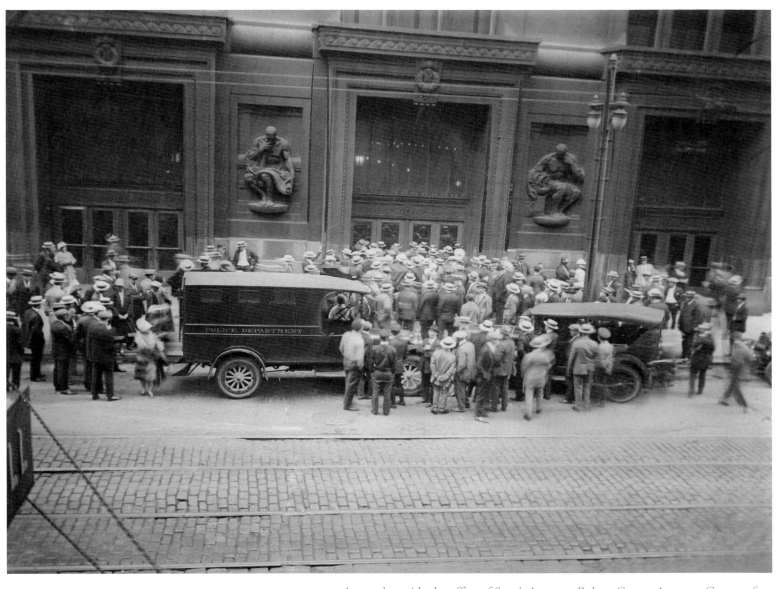

A crowd outside the office of State's Attorney Robert Crowe. Attorney Crowe, often accused of corruption himself, was the chief prosecutor in the Leopold and Loeb case.

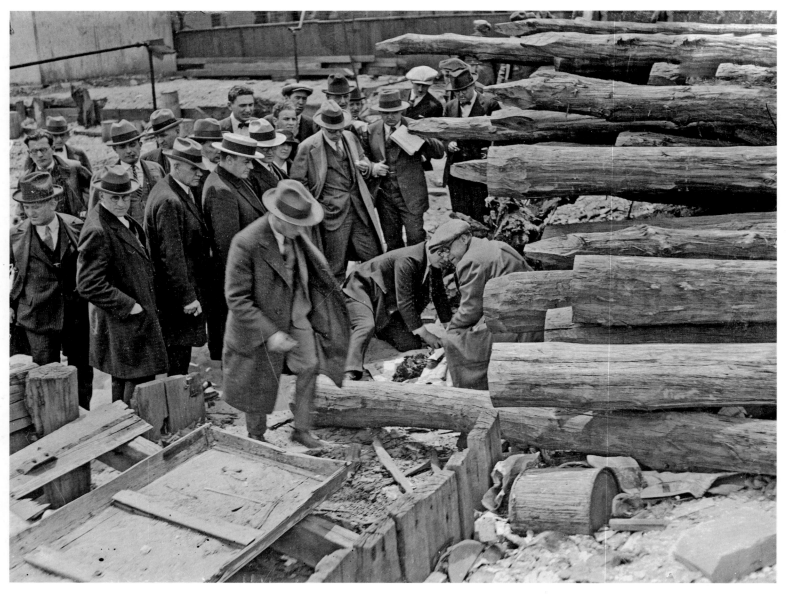

This photograph depicts a group of men near the crime scene where Franks' corpse was hidden. The case received national attention because of the heinous nature of the crime, a thrill killing, and the background of the criminals: both came from prominent Jewish families and were well educated. They also appeared to be involved in a homosexual relationship.

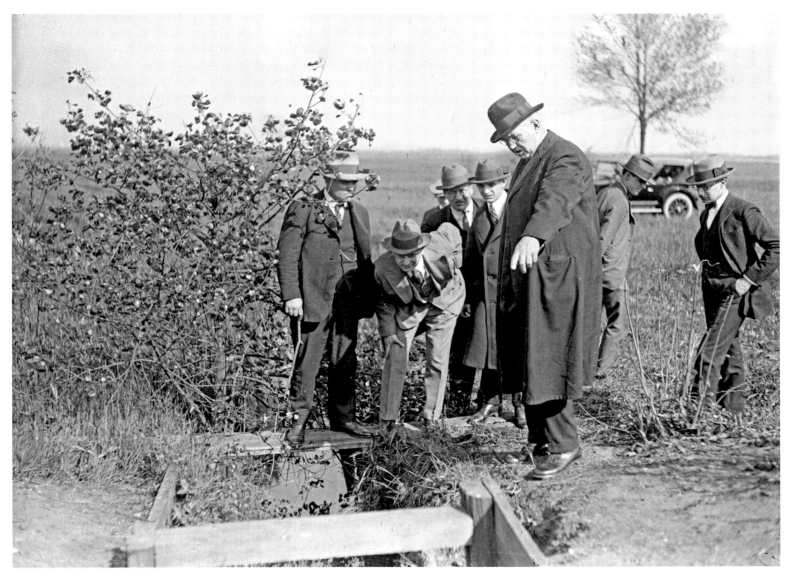

The "perfect crime" was foiled because Nathan Leopold left his eyeglasses at the scene.

James Mulroy and Alvin Goldstein, shown here in 1924, were local reporters who broke the Leopold and Loeb murder case. Chicago's ambitious investigative reporters were seen by some as the only trustworthy voice in the city. They were also frequently accused of embellishing or sensationalizing stories to sell more papers.

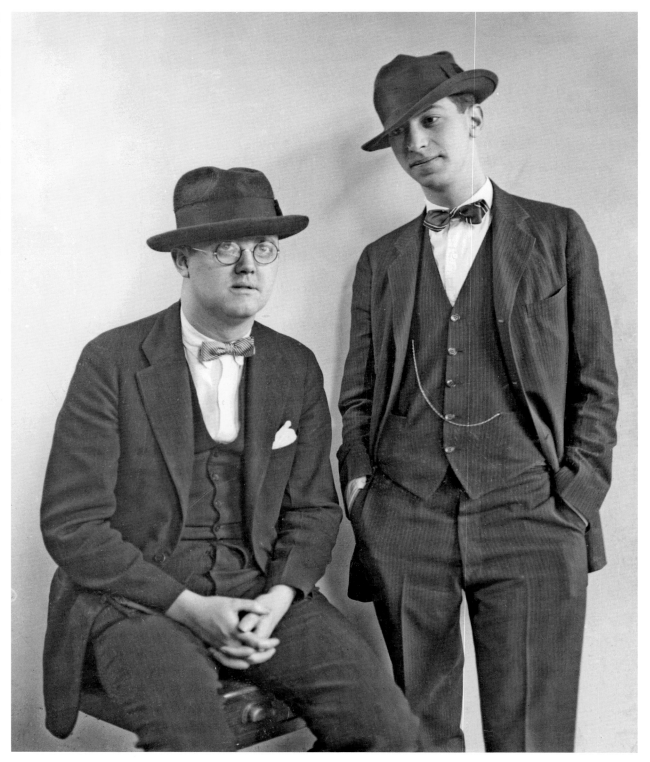

The Criminal Court of Cook County at Hubbard and Dearborn streets. It was here that Leopold and Loeb were tried for the murder of young Robert Franks.

The Cook County Jail, where Leopold and Loeb were held during the trial.

Although many gangland criminals spent time behind these walls, in 1924, Chicago's most infamous criminals were two graduate students from the University of Chicago, Nathan F. Leopold, Jr., and Richard Loeb.

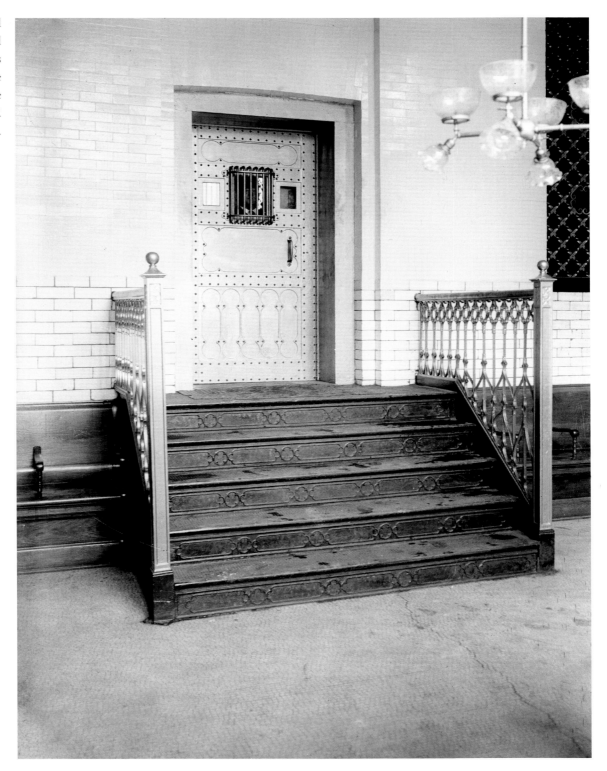

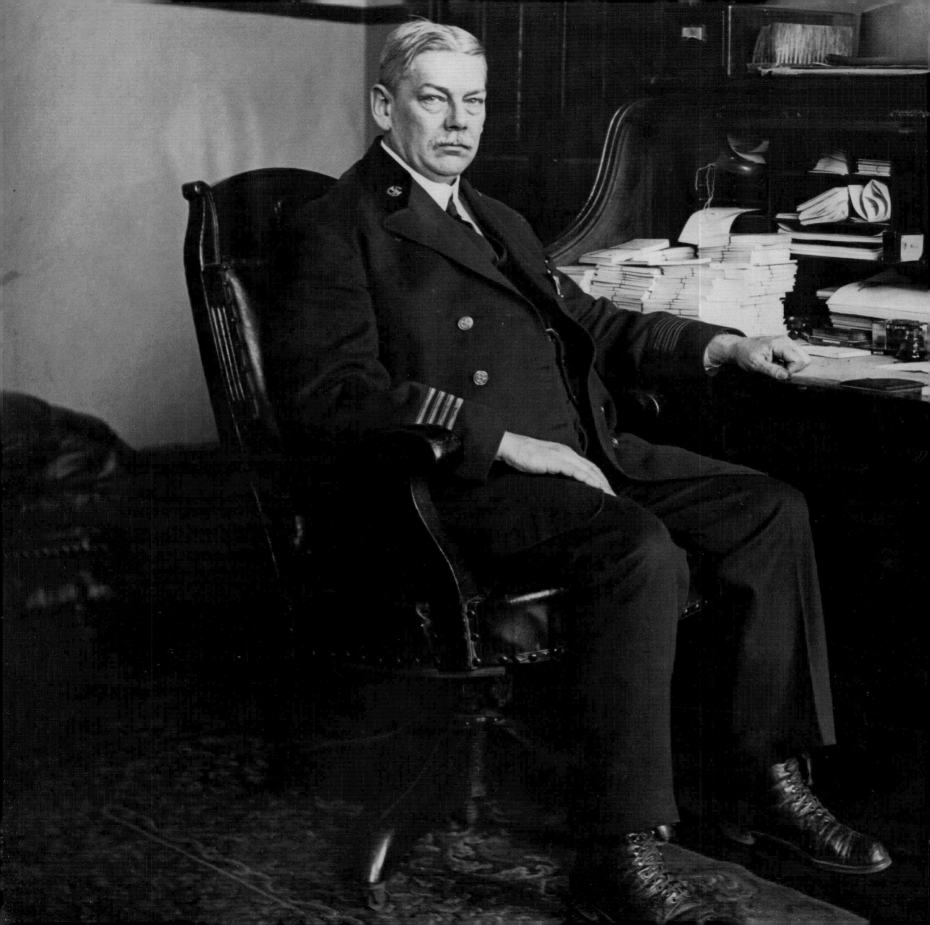

William T. Davis, of Cook County jail. Some jailers were intimidated or bribed to allow special privileges for gangsters or wealthy prisoners.

The yard at the Cook County Jail. Leopold and Loeb, like many of Chicago's famous gangsters, were allowed many special privileges, including catered meals and drinking and smoking privileges.

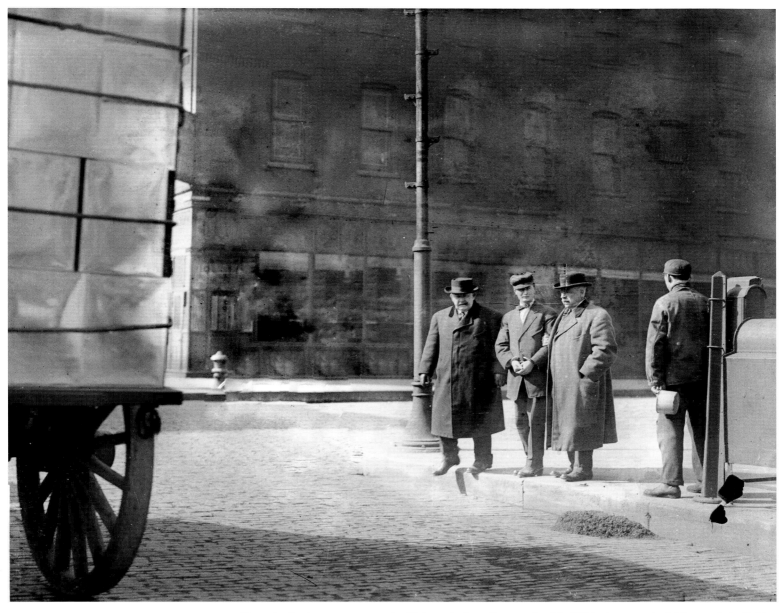

Organized crime was present in Chicago before Capone. In this 1911 photograph, U.S. marshals Colder and Donovan walk with a handcuffed Gianni Aldoni, who was involved in a Black Hand case. "Black Hand" refers to a technique of extortion used by gangs in the early twentieth century and was a precursor to Chicago's more famous and sophisticated gang activity in the 1920s.

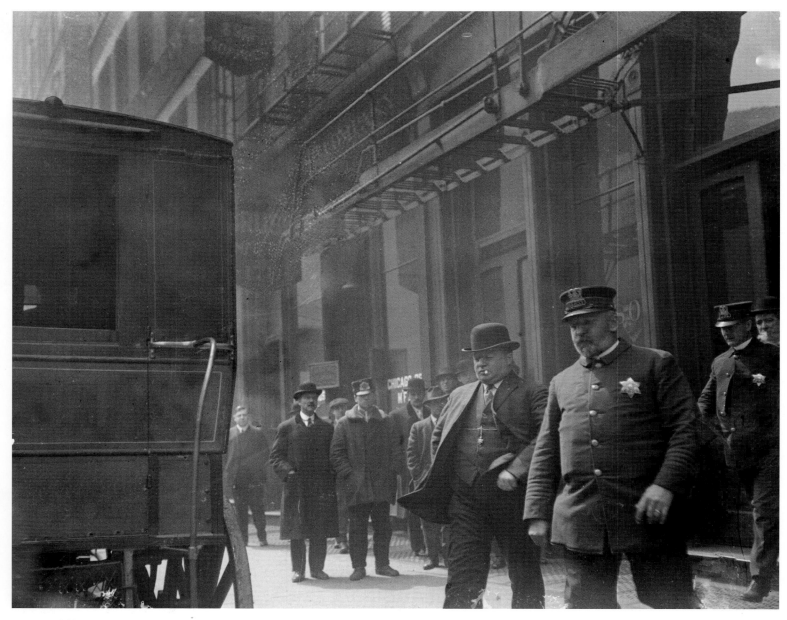

Revenge killings were not uncommon before Capone. Here, James Franche crosses the sidewalk with a police officer during the Isaac Henagow murder trial, 1914. Franche confessed to murdering Henagow at the Roy Jones Café on South Wabash Avenue.

James "Big Jim" Colosimo with Attorney Charles Erbstein shortly before Colosimo's murder. Colosimo built his illegal operations around prostitution, running a string of brothels in Chicago. An early prototype of the Chicago gangster, Colosimo maintained good relations with city politicians. Colosimo was likely murdered by Frankie Yale either in an attempt to acquire Colosimo's operations for himself, or under contract for Al Capone and John Torrio.

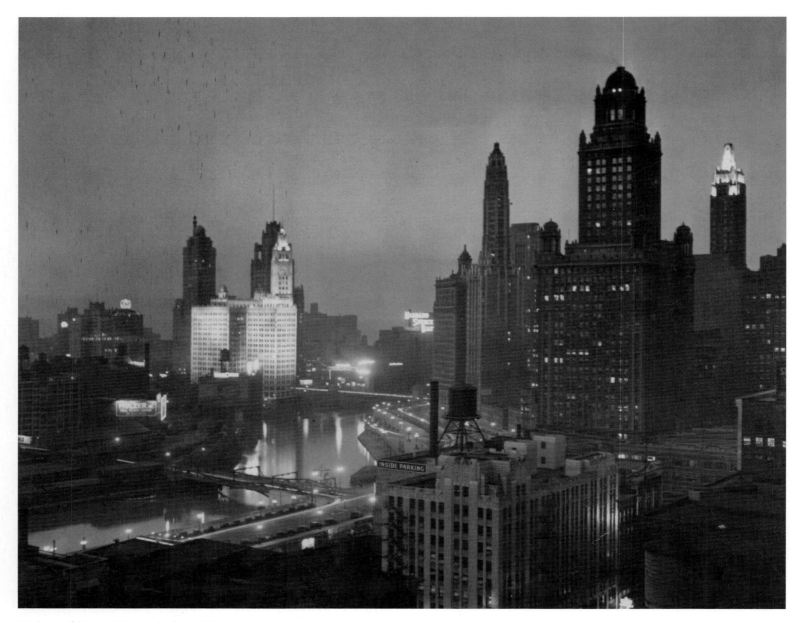

Darkness falls on Chicago in the 1920s.

BIRTH OF THE CHICAGO GANGSTER

(1919–1926)

On the afternoon of May 11, 1920, Jim Colosimo was murdered unceremoniously in the lobby of a Chicago building. "Big Jim" as he was known, was the king of Chicago vice—his criminal enterprise: prostitution. He and his wife, Victoria Moresco, built an empire around the sex trade. Big Jim opened Colosimo's Cafe at 2128 South Wabash Avenue, in the heart of the city's first ward. With the support of two corrupt first ward aldermen, John "Bathhouse" Coughlin and Michael "Hinky Dink" Kenna, Colosimo was able to operate freely and influence the political machinery to keep his illegal business safe from the police.

Colosimo's business grew in part because of John Torrio, a racketeer from Brooklyn who organized Colosimo's operations and spread Big Jim's influence. After ten successful years, Torrio looked to Brooklyn gangster Frankie Yale for someone to help him run Colosimo's operations. Yale sent Alphonse Capone, a nineteen-year-old bartender and bouncer with a vicious streak.

Capone was a high-school dropout involved with Brooklyn gangs. He worked for Yale at his bar, the Harvard Inn. After moving to Chicago, Capone proved himself to be both intelligent and ruthless. He quickly became indispensable to Torrio and Colosimo. After Colosimo's murder, Torrio and Capone built a close relationship. Torrio identified Capone as his chief lieutenant. Capone had already asked Torrio to be godfather to his first-born son, Albert.

The pair expanded Colosimo's operations to include gambling and beer and liquor production and distribution. They also dramatically expanded Colosimo's prostitution business. In 1923, to avoid the increased scrutiny of new Chicago mayor and reformer William Dever, they moved their operations to Cicero, Illinois, a close suburb of Chicago. In Cicero they controlled and expanded local vice, manipulated city elections, and still maintained control of their Chicago operations.

Conflicts and turf wars with rival gangs occurred regularly throughout these years. After Torrio and Capone had North Side gangster Dean O'Banion murdered in his State Street flower shop, O'Banion's successors came after Torrio. In 1925, they nearly killed him. Shaken, Torrio retired and left the Chicago operations to Capone.

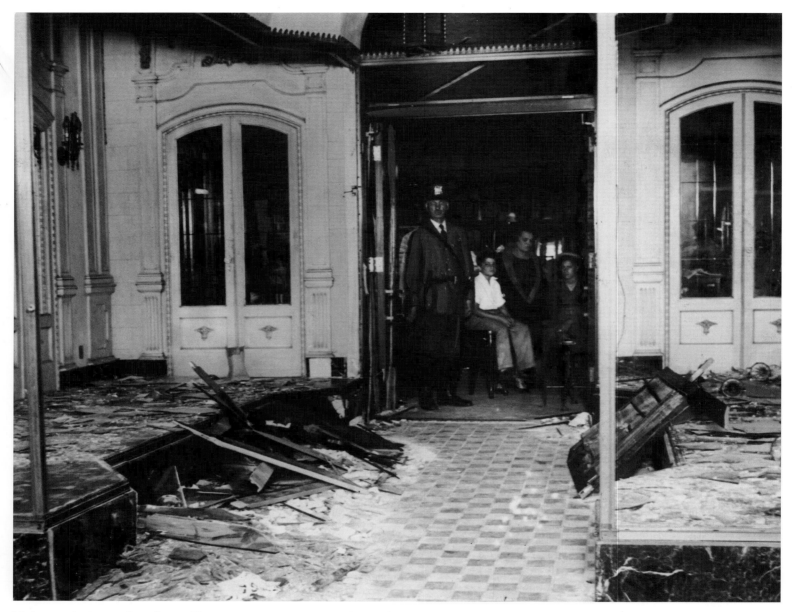

Violent explosions and gunfire in Chicago were not so common during the gangster era as some might imagine, but they were part of the city's soundtrack. Shown here, a dry goods store at 7303 S. Halsted Street owned by Benjamin Wolfe is destroyed by a bomb. Wolfe maintained that he was the victim of a labor conflict.

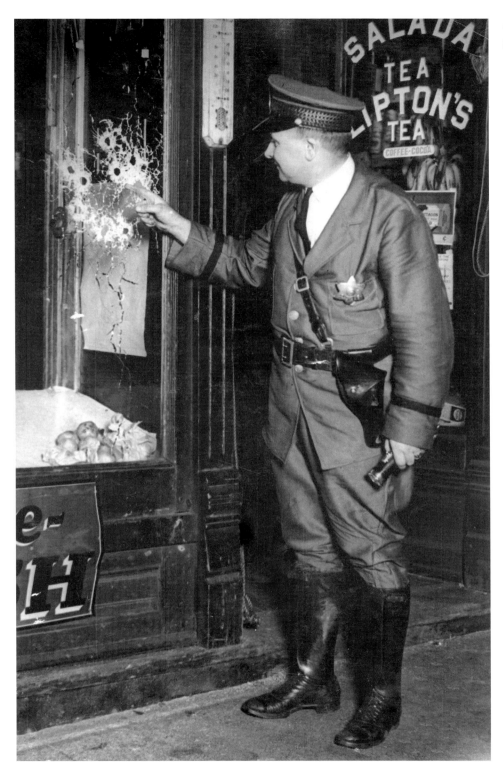

A Chicago police officer examines 13 bullet holes in a glass window at the scene of an attempted murder.

Al Capone (left), born on January 17, 1899, in Brooklyn, New York, rose quickly in the organized crime world of Chicago. After moving to the Windy City in 1919 to work under crime boss John Torrio, Capone became second in command after just three years. When Torrio fled Chicago after an attempt on his life in 1925, Capone took over and expanded the criminal operations, reportedly raking in over $100,000,000 a year in illegal dealings. The other man pictured here is likely Isaac Roderick, a bail bondsman.

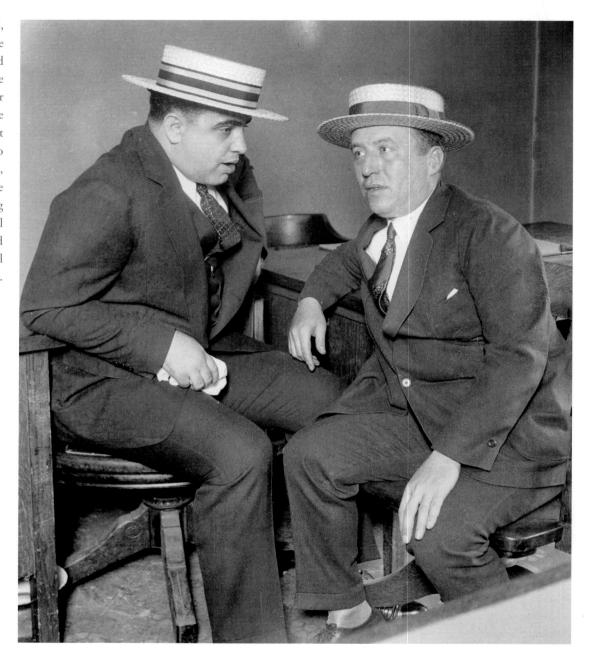

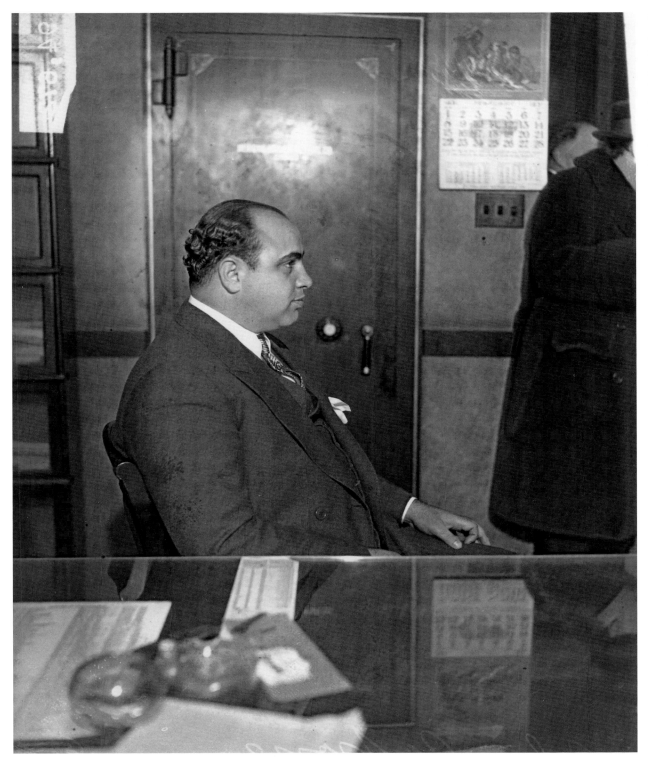

Capone earned the nickname "Scarface" while working as an eighteen-year-old bouncer in Frankie Yale's Brooklyn bar, the Harvard Inn. Capone's left cheek and neck were cut after he insulted a patron and her brother pulled a knife to defend her honor. Capone always preferred to be photographed on his right side.

John Torrio was brought to Chicago by "Big Jim" Colosimo in 1909. Capone came to work with Torrio in Chicago in 1919. Torrio fled the city in 1925 after an assassination attempt on his life, leaving his growing crime syndicate to Capone.

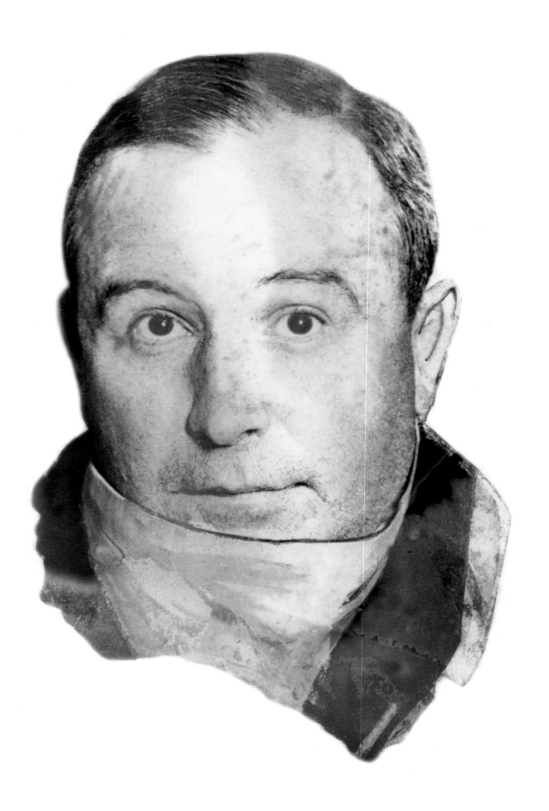

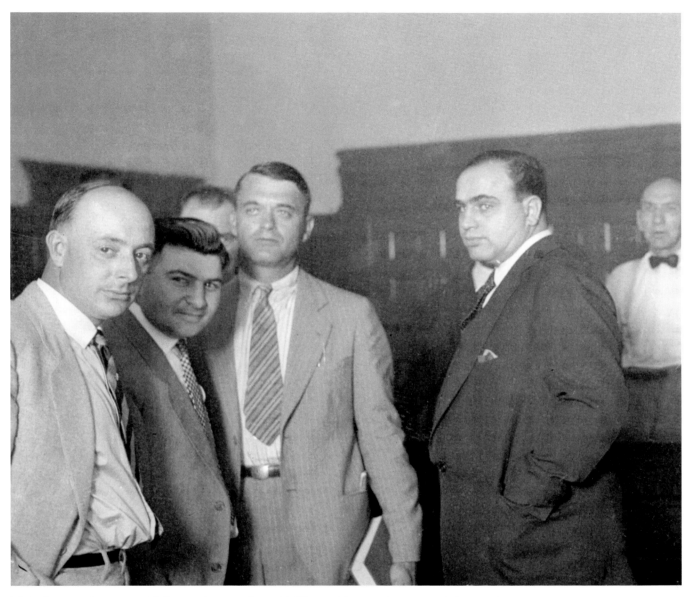

This photograph captures Al Capone in court in 1926. He would return in 1929 and then again in 1931, but he was never prosecuted for a Prohibition violation.

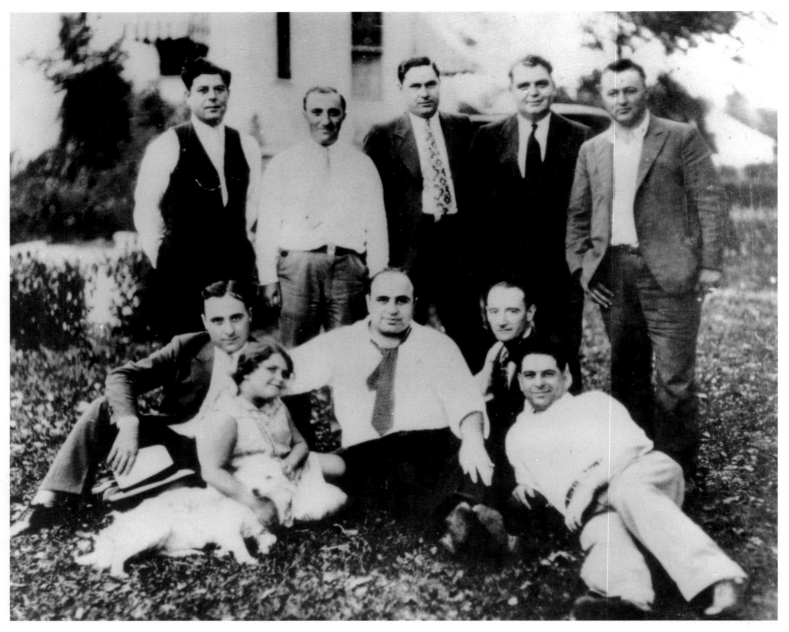

Al Capone (seated, center) with associates, including racketeers Jim Emery
and Frankie La Porte in Chicago Heights.

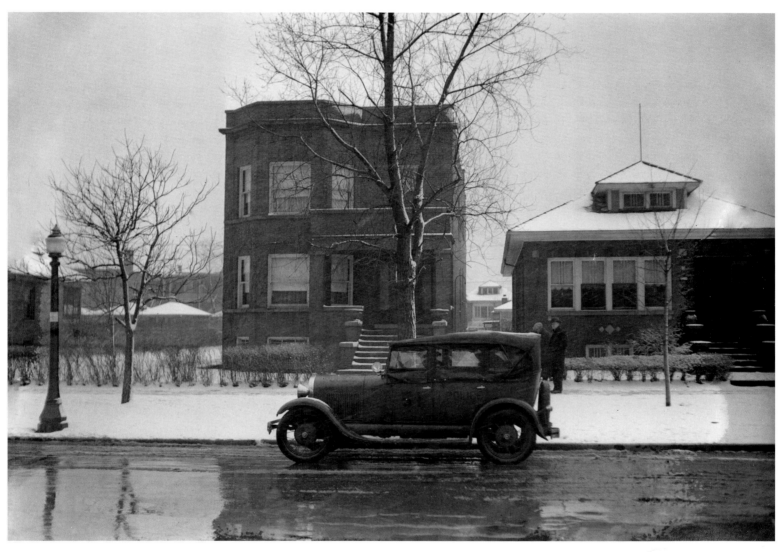

A police car sits outside Al Capone's modest home at 7244 Prairie Avenue.

Al's brother, Ralph Capone (left) and Anthony Aresso, two members of Capone's gang. Capone brought many of his family members to Chicago, including his brother Frank, who was killed in a shoot-out with Chicago police on Election Day in Cicero, 1924.

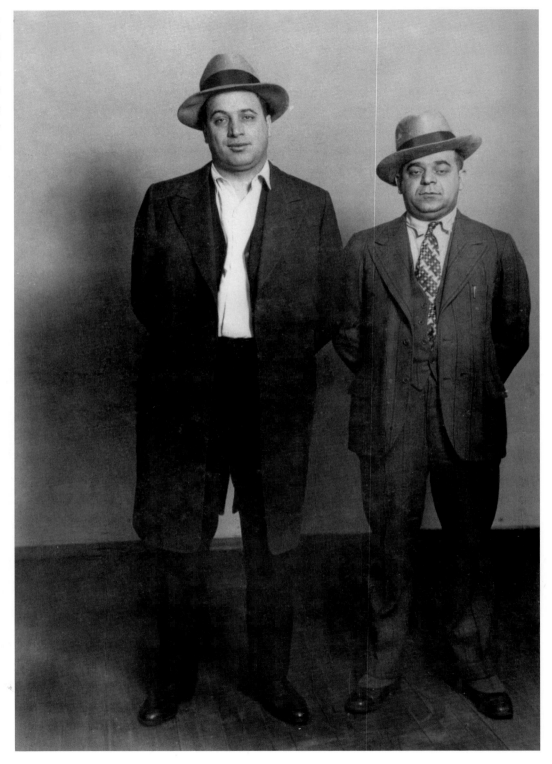

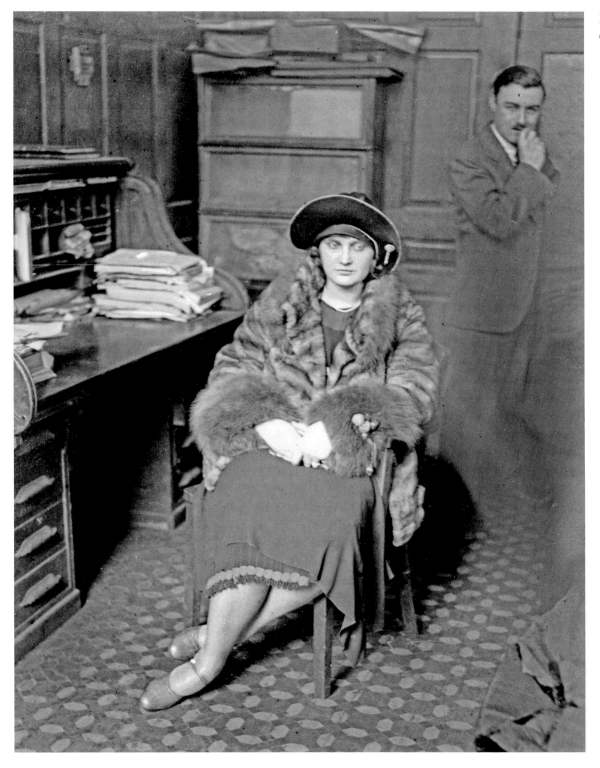

Mrs. Ralph Capone, wife of Al Capone's brother.

Longtime Capone enforcer and bodyguard, "Machine Gun" Jack McGurn, was a key player in Capone's operations. In 1929, he was accused of participating in the St. Valentine's Day massacre.

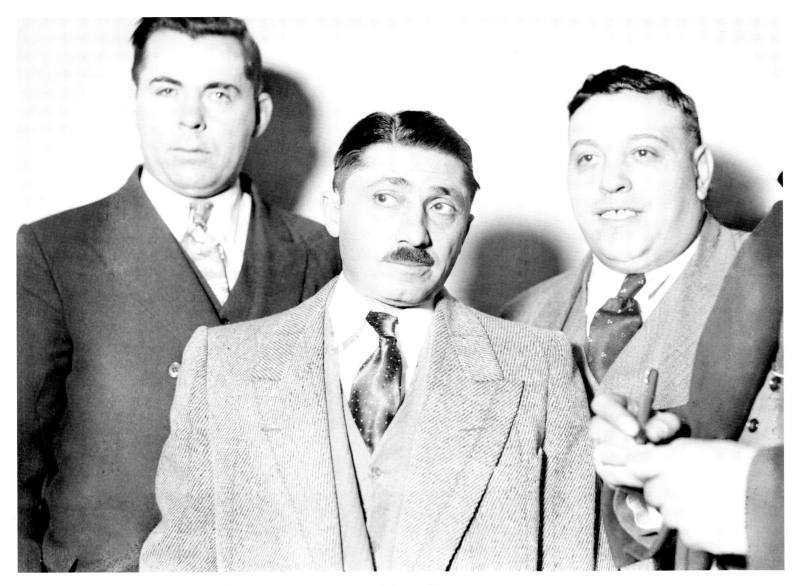

Frank Nitti (center) was Capone's second in command and ran most of the bootlegging operations carried out by the gang. Nicknamed "the Enforcer," he eventually became boss of Capone's organization when "Scarface" went to jail.

Frankie Yale, a Brooklyn vice lord, was Capone's first boss in organized crime. He likely murdered "Big Jim" Colosimo in 1920. In 1927, Capone sent two hit men, Albert Anselmi and John Scalise, to Brooklyn to kill Yale. One of the tommy guns used in Yale's murder was later linked to the St. Valentine's Day Massacre.

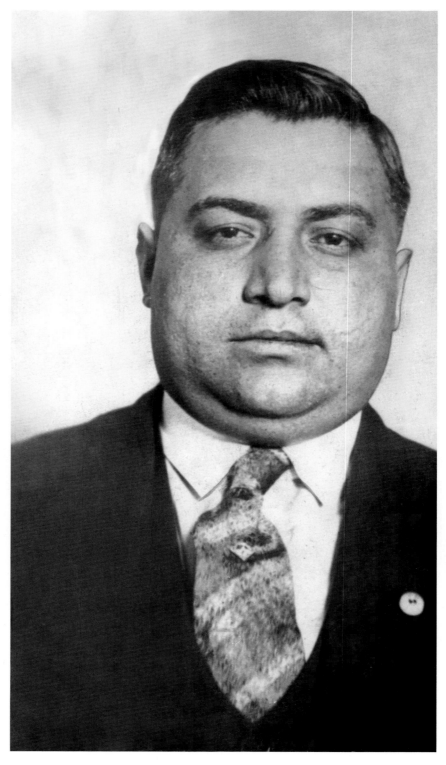

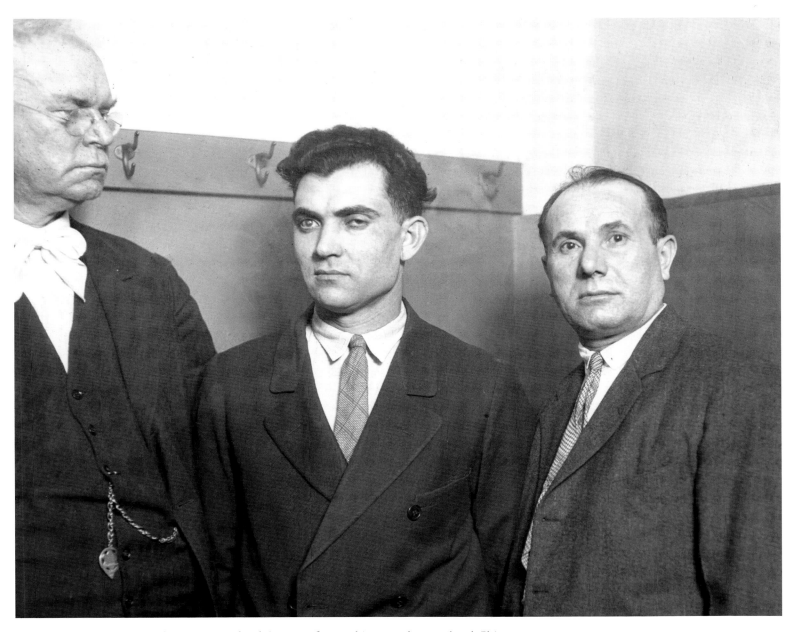

John Scalise and Albert Anselmi (center and right) were infamous hit men who murdered Chicago gangster and Capone rival Dean O'Banion in his flower shop on State Street on November 10, 1924. They murdered Frankie Yale in 1927 and victims of the St. Valentine's Day Massacre in 1929. Scalise was about to be indicted for the massacre when he and Anselmi turned up dead. It is suspected that Capone believed the two were going to turn on him.

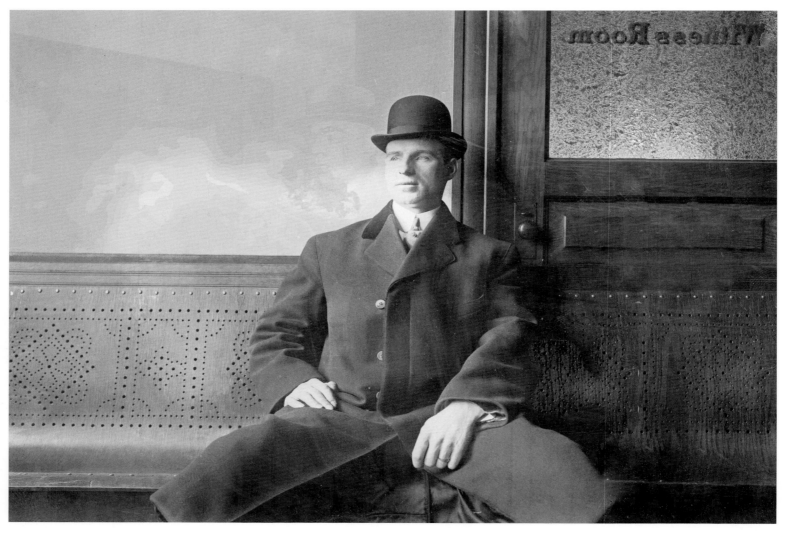

Harry Cullett, or "Chicken Harry," a Capone bodyguard, sits on a bench in the Criminal Courts Building on Chicago's Near North Side.

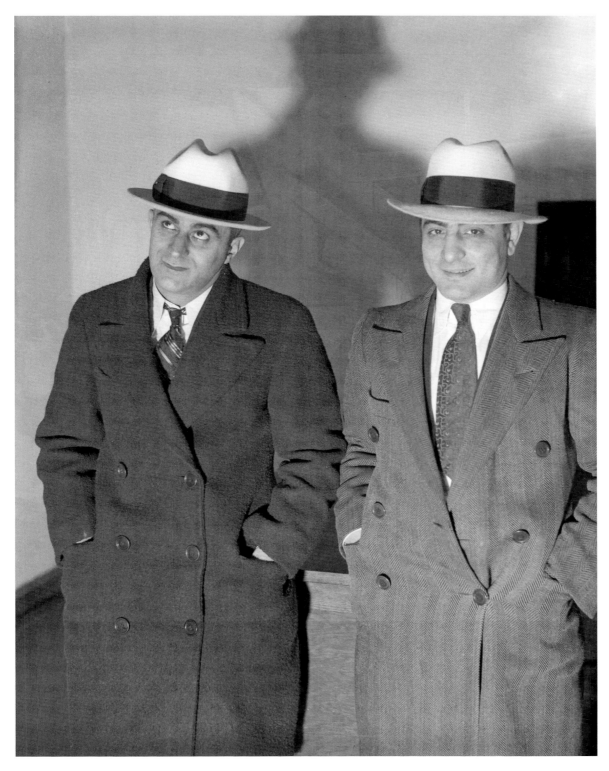

Louis Clementi, a gunman for Capone, and Phillip Mangano of New York's Gambino crime family.

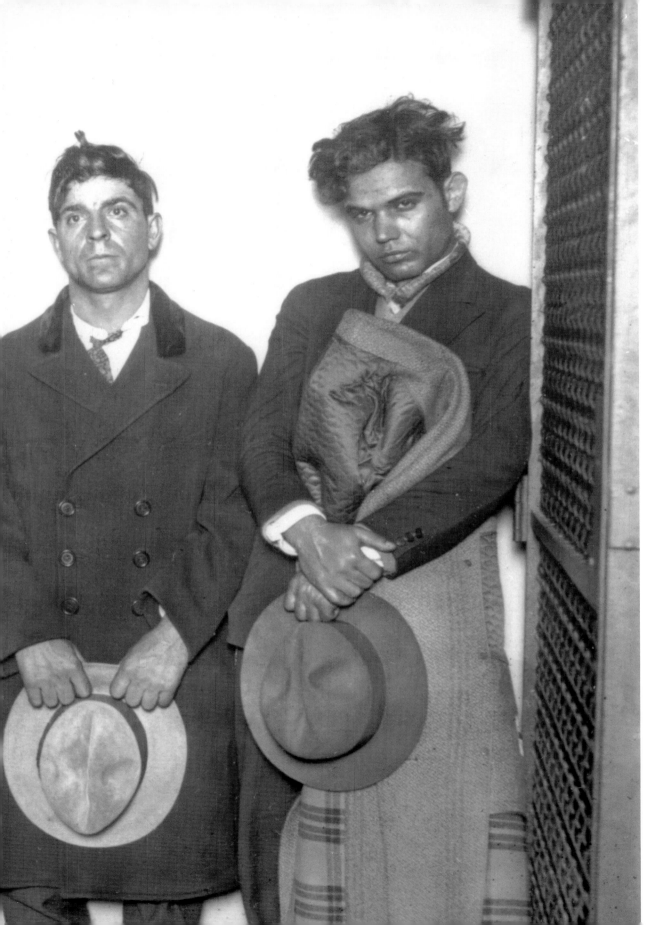

A crew of gangsters lined up in a Chicago jail. From left to right are Mike Bizarro, Joe Aiello, Joe Bubinello, Nick Manzello, and Joe Russio.

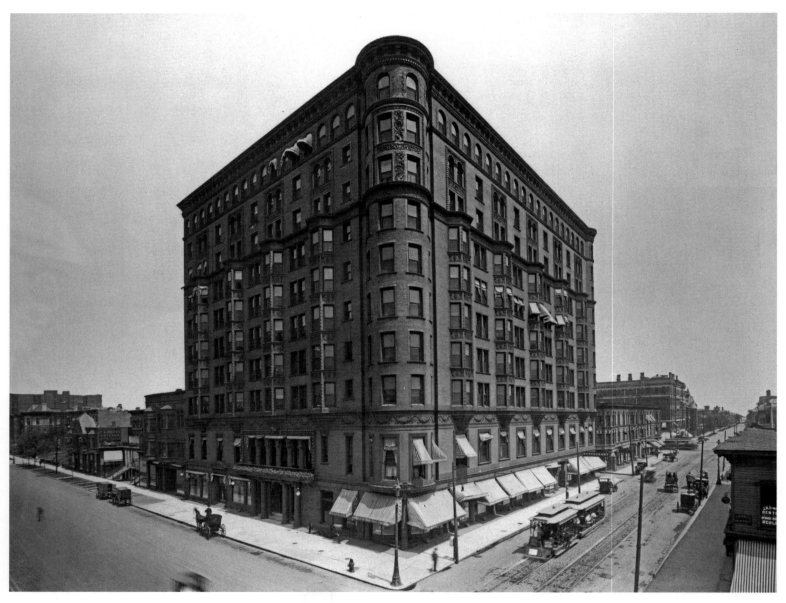

A shrewd businessman, Capone streamlined and organized crime operations in Chicago. In addition to establishing suburban headquarters, he ran operations in Chicago out of the Metropole Hotel, 2300 S. Michigan Avenue, the Four Deuces Club at 2222 S. Wabash Avenue (named for its address), and the Lexington Hotel (pictured here) at the corner of Michigan Avenue and 22nd Street.

Capone, Torrio, and the other Chicago gangs were able to do business quite easily under Mayor William Hale "Big Bill" Thompson. But in 1923, Thompson withdrew from the mayoral race and William Dever was elected. Dever ran as a reformer and threatened gang operations in the city. Capone and Torrio decided to move their operations to the sleepy suburb of Cicero, where a weak local government and proximity to Chicago combined to help their organization grow tremendously. In 1927, with the help of Al Capone, Thompson became mayor again.

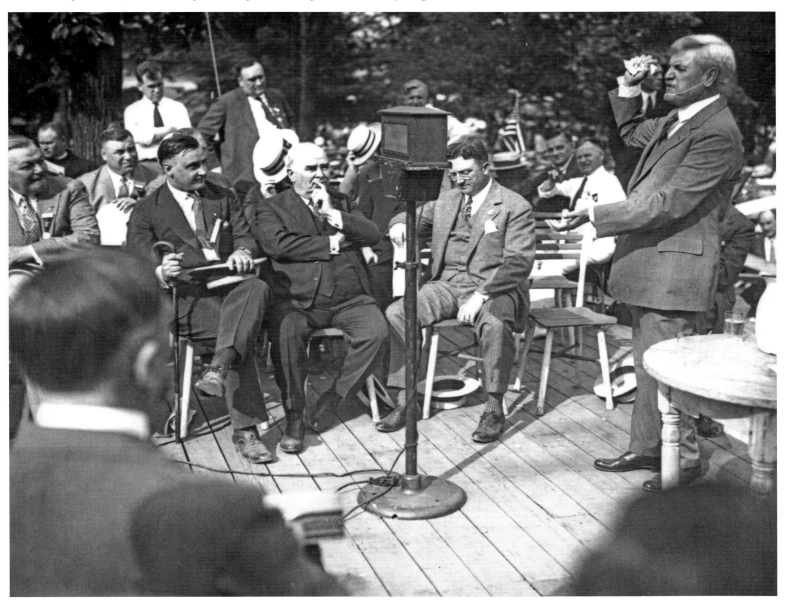

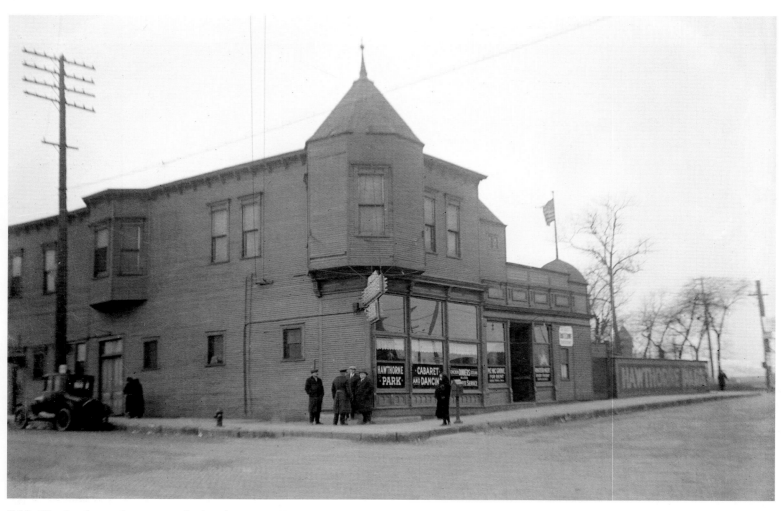

Eddie Tancl, a former boxer turned saloonkeeper and bootlegger, operated the Hawthorne Cabaret in Cicero until he was shot and killed in 1924, shortly after the Capone-Torrio organization moved in.

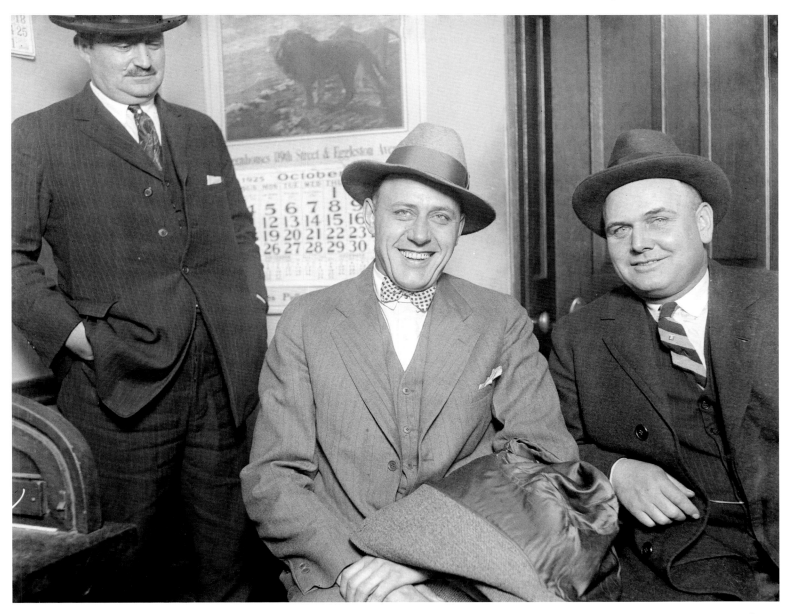

Edward "Spike" O'Donnell in 1925. O'Donnell was a South Side gangster embroiled in the Beer Wars of early Prohibition, where rival gangs jockeyed for control over the underground beer trade.

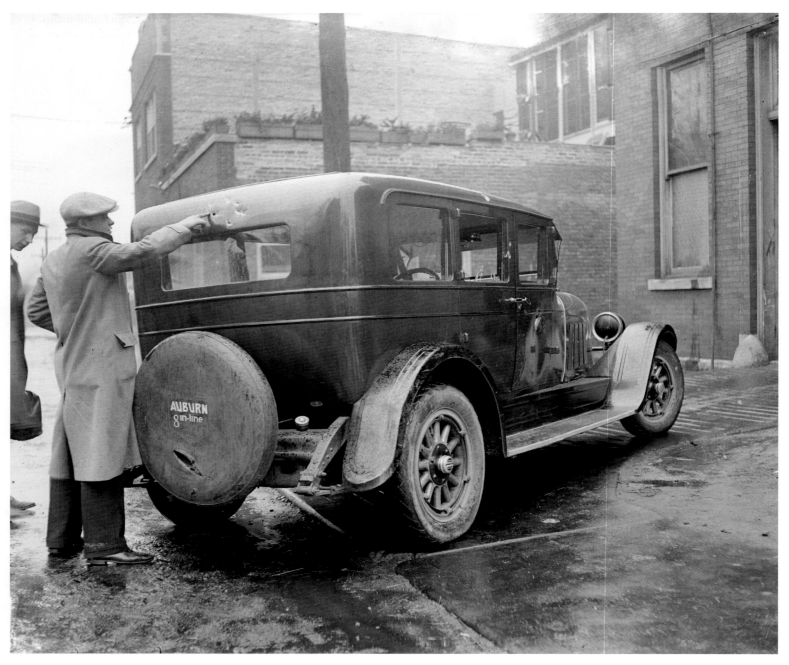

A man points to bullet holes in Edward "Spike" O'Donnell's car. Frank McErlane, O'Donnell's main rival for South Side control, made this unsuccessful attempt on O'Donnell's life in what is reported to be the first gangster crime committed with a Thompson submachine gun, or tommy gun.

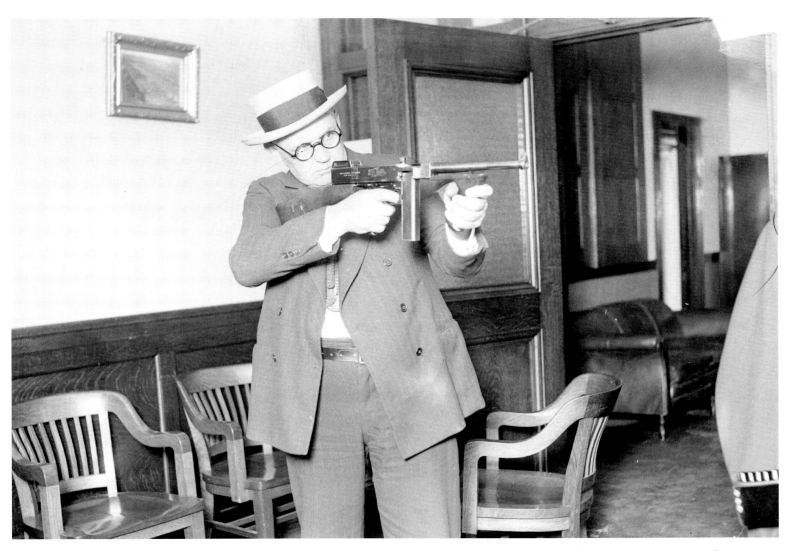

Police Chief William Shoemaker points a Thompson submachine gun, or tommy gun, for reporters. Developed for the battlefields of World War I, the tommy gun could fire multiple rounds of ammunition at a very rapid rate, making it popular with gangsters.

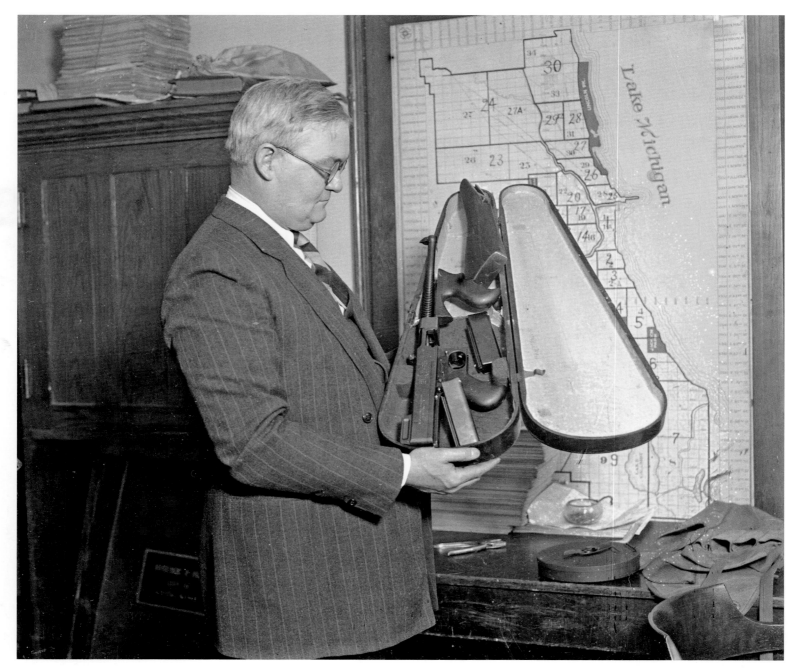

Chicago police captain John Stege displays a machine gun concealed inside a violin case.

The Chicago Police Department struggled to curtail the gangs. Widespread corruption on the force and in the judicial system undermined the willingness of many Chicago policemen to put themselves at odds with the powerful and violent Chicago gangs.

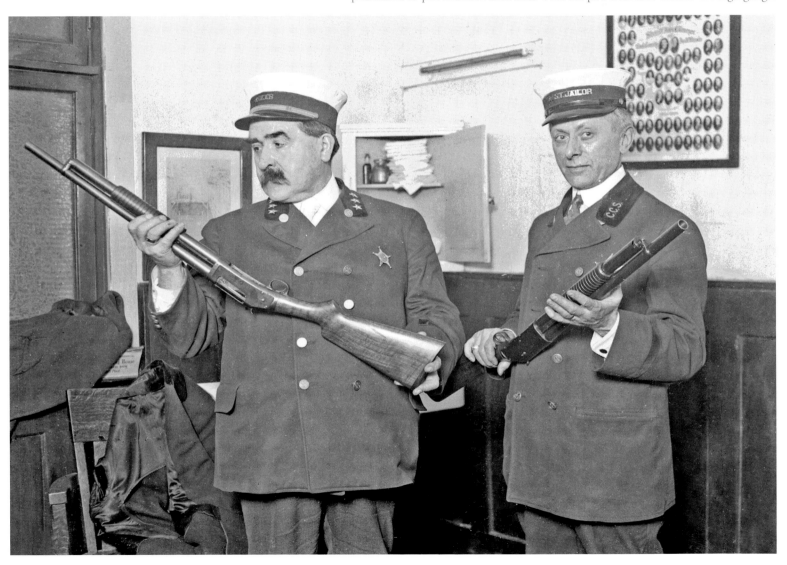

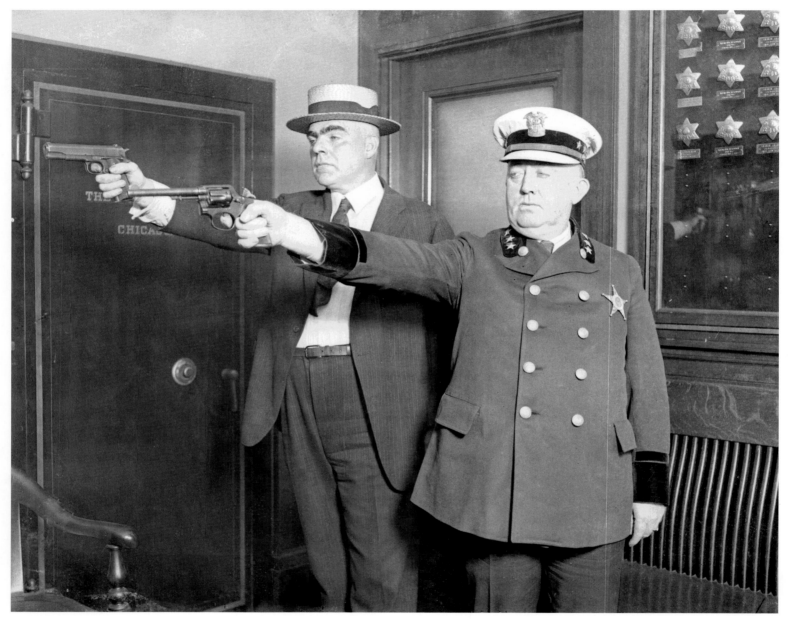

Chief of Detectives Captain James Mooney and Chief of Police Colonel John J. Garrity aim handguns for reporters inside a police station. The Chicago police were seen by many as ineffectual at stopping the gangs, and in some cases, as simply corrupt.

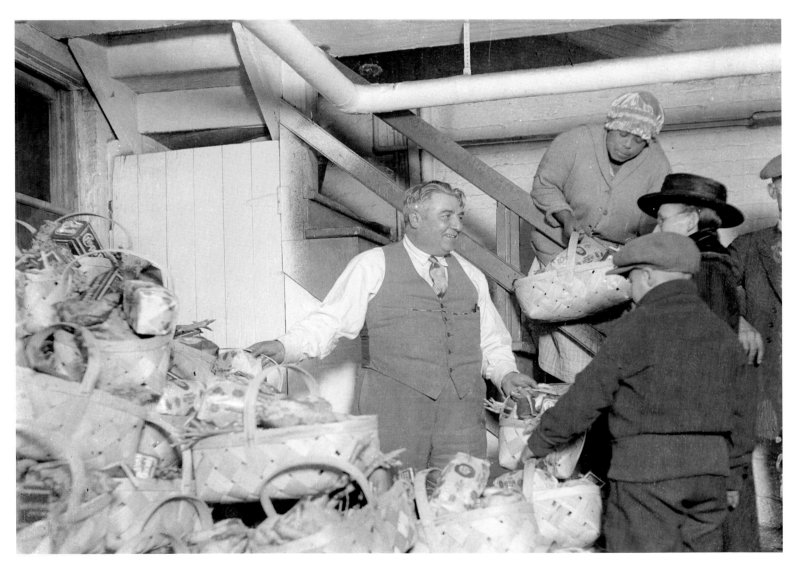

Joe Esposito hands out baskets of food to people in 1926. "Diamond Joe" was a politician and gangster serving as Boss of the West Side's 19th Ward. In an operation common to many gangsters and politicians, Esposito was generous both to the people and to the mob men who lived in the communities he controlled. Esposito offered political protection to John Torrio, Capone's mentor.

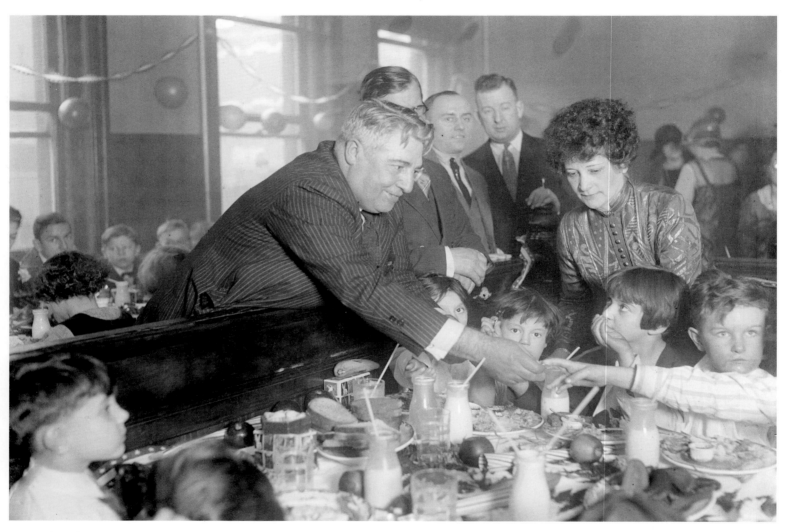

Originally a friend to John Torrio, Joe Esposito eventually became a rival of Capone. He was shot to death in front of his wife and daughter at the Republican primary on March 21, 1928.

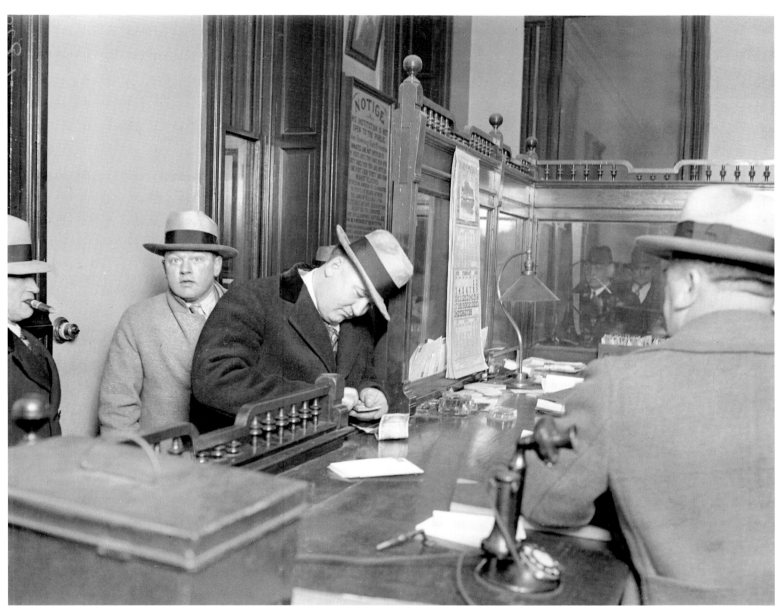

Joe Saltis, partner of Frank McErlane, leaves Chicago's Bridewell police station in 1929. Saltis and politician "Dingbat" O'Berta arranged a conference in the fall of 1926 to call a ceasefire between gangs, including Capone's organization and the North Side Mob run by George Moran. The ceasefire lasted only two months.

Mrs. Joe Saltis, wife of the powerful Southside gangster. Most of the Chicago gang leaders had spouses and many had children.

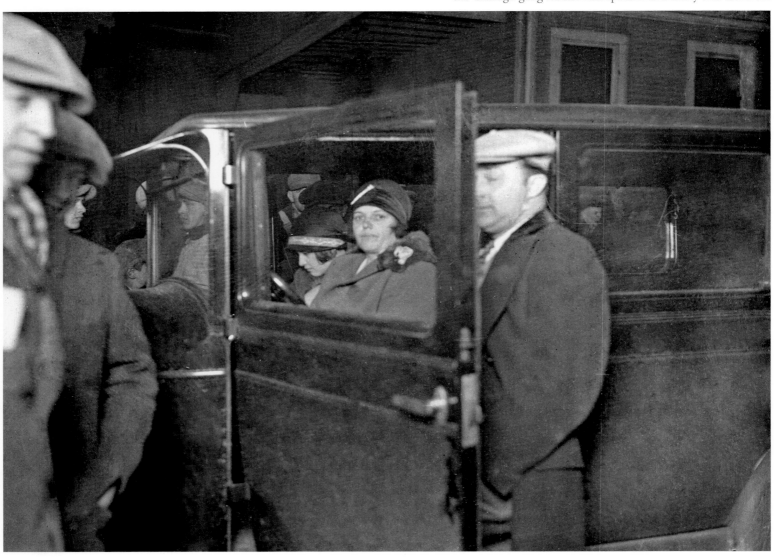

A crowd gathers for the funeral of John "Dingbat" O'Berta, a politician with considerable ties to Chicago gangs. O'Berta worked closely with Joseph "Polack Joe" Saltis and Frank McErlane during prohibition, even using his political power to get a murder case against himself and Saltis dropped. O'Berta was found dead of a gunshot wound to the head.

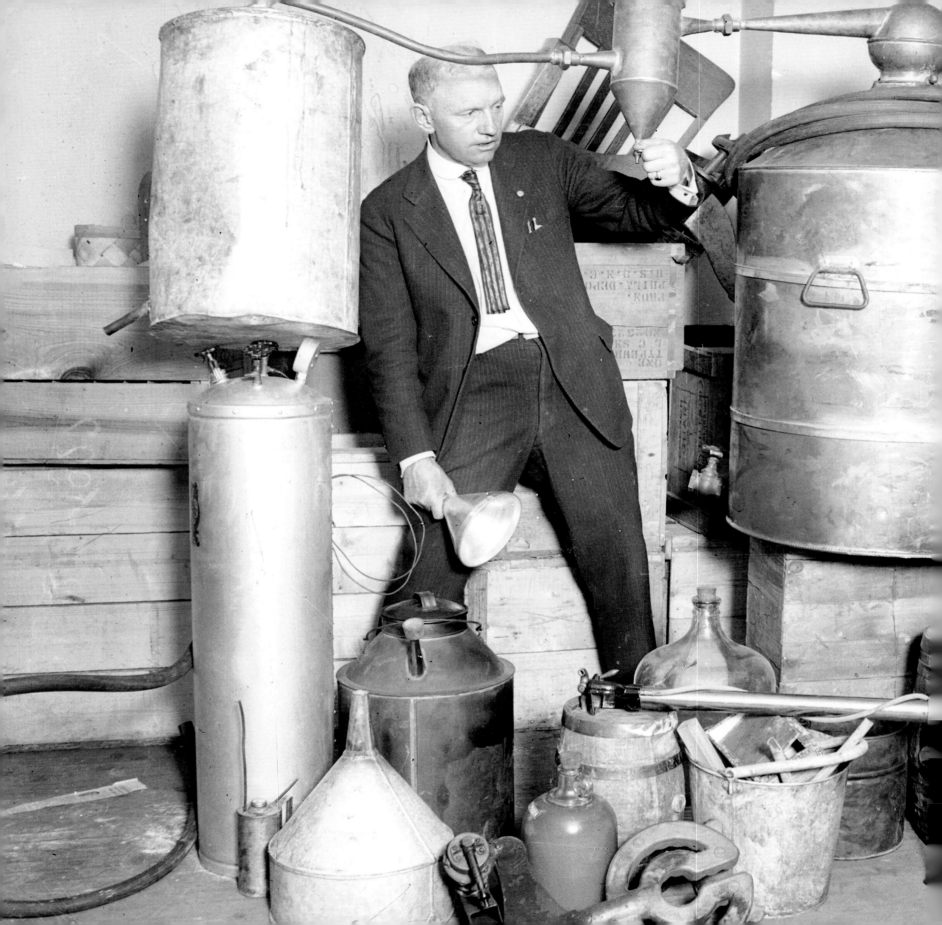

Under Mayor Dever's administration, modest headway was made to limit gang activity and curtail bootlegging. In this view, a still is confiscated in a South Side raid.

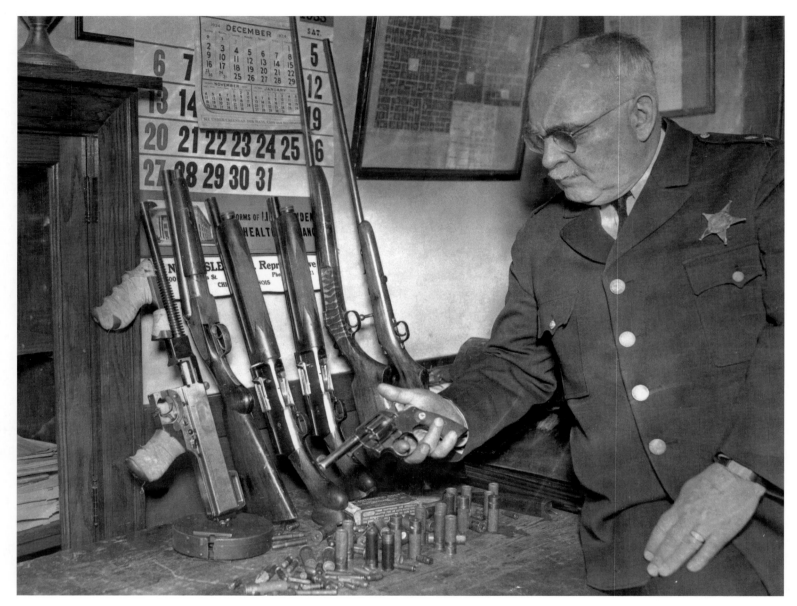

Captain Willard Malone with rifles, automatic shotguns, machine guns, and ammunition confiscated in raids by police.

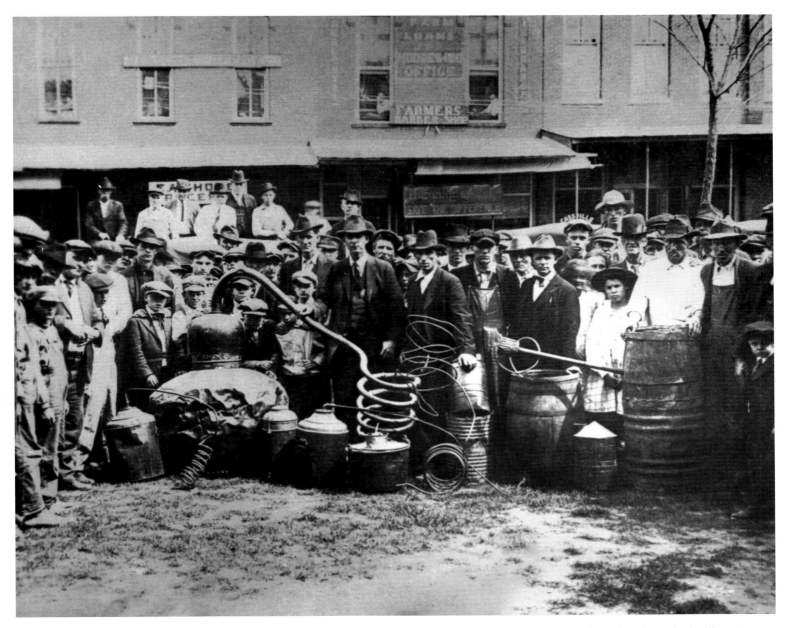

Confiscated and smashed still equipment.

Two men pour out barrels of confiscated moonshine. Home-distilled moonshine was fermented in wooden barrels to make it taste more like whiskey.

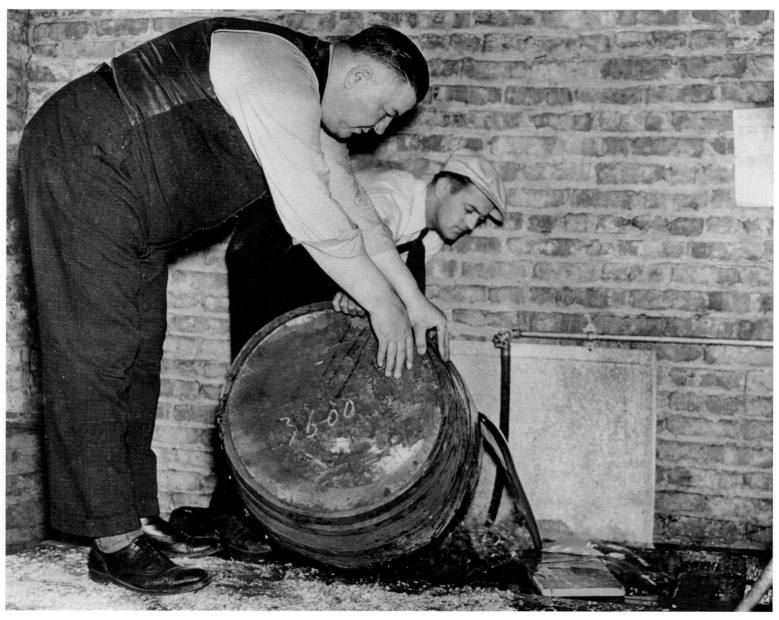

The gangs made money from all sorts of illegal activity, including prostitution and gambling. Authorities are smashing slot machines in this photograph. As early as 1900, the Chicago Vice Commission's report listed gambling as a main concern.

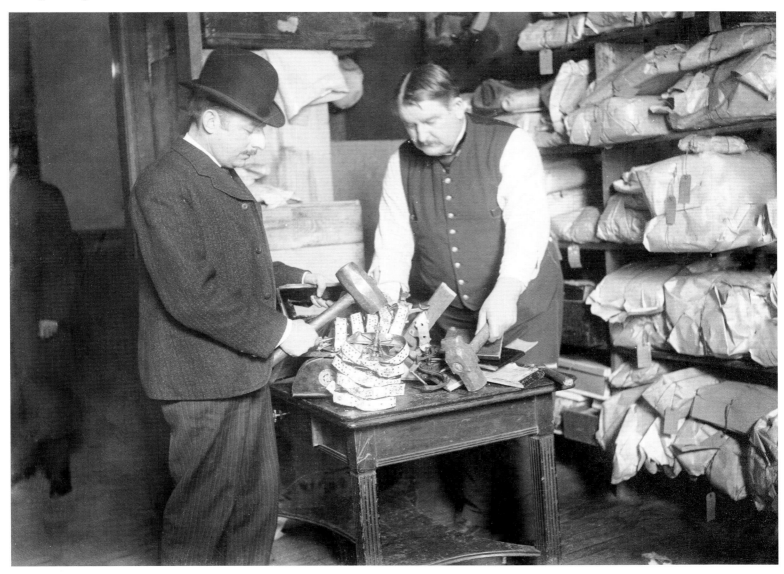

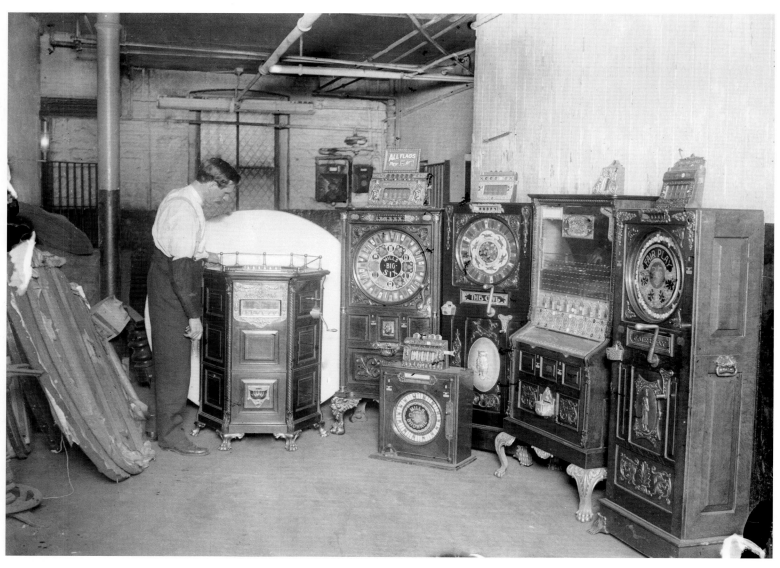

A store of confiscated illegal slot machines.

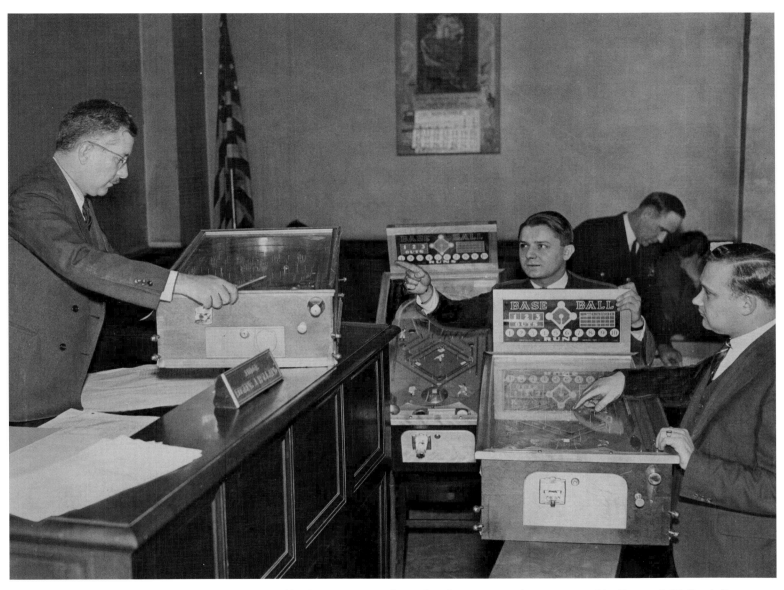

Illegal pin games confiscated in four tavern raids are examined by Eugene J. Holland, Prosecutor James Jeroulis, and Assistant State's Attorney William Brumlik.

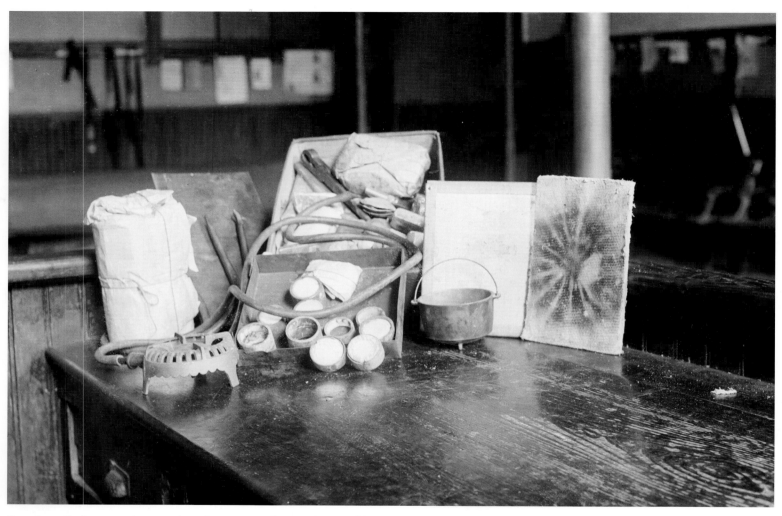

Paraphernalia from another popular crime: counterfeiting. Coin molds are pictured here.

A counterfeit coin–making operation was run out of this building at 6657 S. State Street.

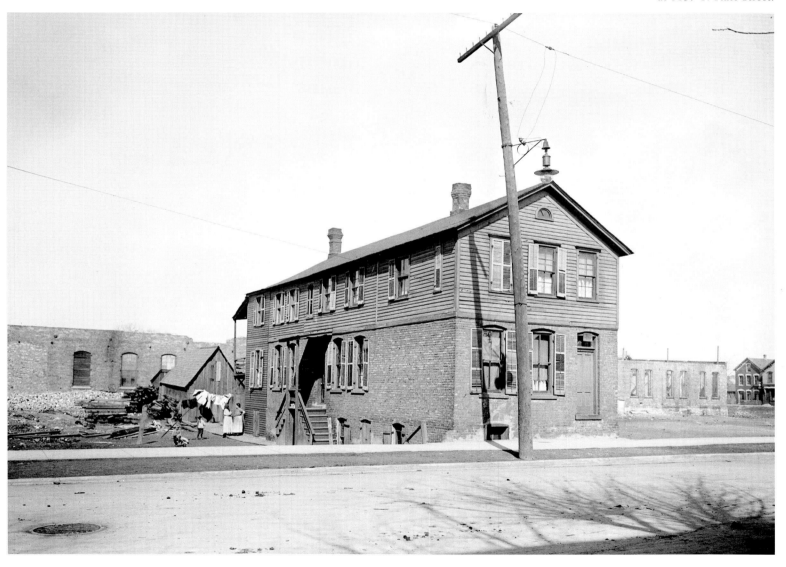

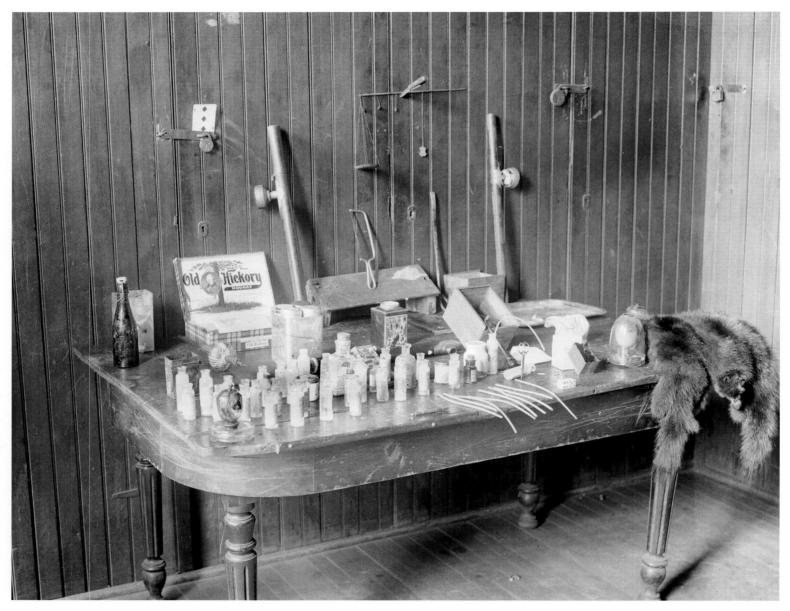

Alcohol was not the only illegal substance being trafficked by gangsters. Shown here
is confiscated cocaine, opium, and morphine.

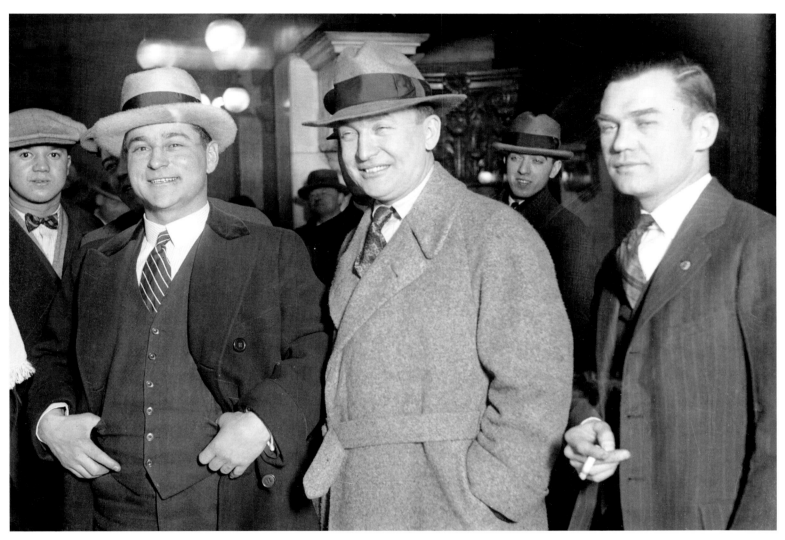

Louis Alterie and Scott Stewart (wearing fedoras, Alterie at left). Alterie was a member of the North Side Gang under mob boss Dean O'Banion and a pallbearer at his funeral. Stewart, a former Chicago DA turned defense attorney, was famous for his creative courtroom antics. He was the inspiration for the fast-talking lawyer Billy Flynn in the musical *Chicago*.

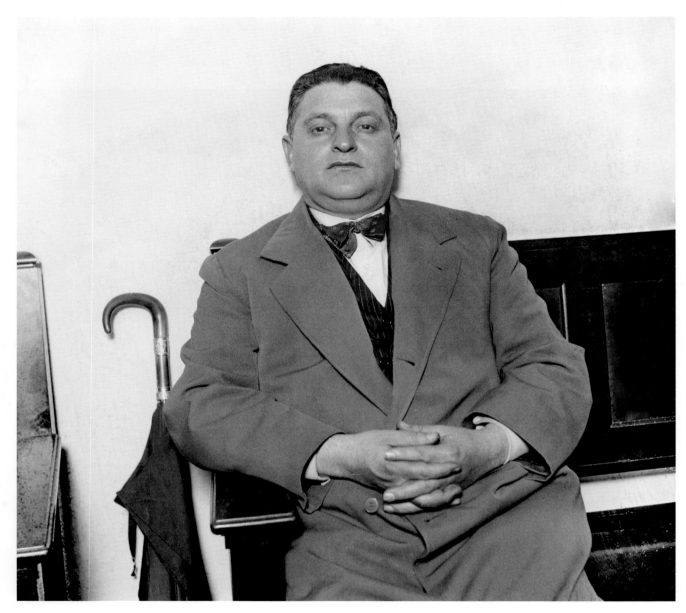

Vincent Genna, known as Jim, was one of the "terrible Gennas," six violent Sicilian
bootlegging brothers who operated out of Chicago's Little Italy neighborhood. They had a
license to sell "industrial alcohol" and skirted the Prohibition laws easily.

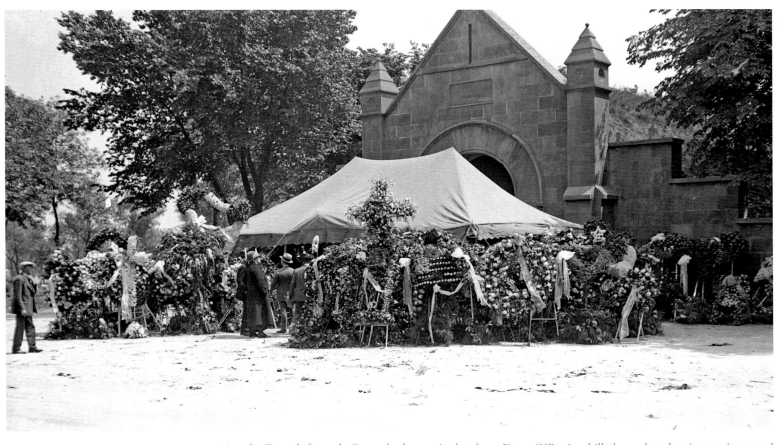

Angelo Genna's funeral. Genna had conspired to have Dean O'Banion killed over bootlegging territory and price disputes. Genna was killed by O'Banion's successors in retaliation. Revenge killing and greed was the cause of most of the inter-gang violence.

Organized crime spread outside Chicago as well. The Shelton Gang and their rivals, the Birger
Gang, ran competing bootlegging operations in Williamson County in southern Illinois. The
Shelton Gang's vehicle is pictured here.

Vehicle and guns belonging to the Birger Gang, southern Illinois bootlegging rivals of the Shelton Gang. Testimony from Charles Birger helped put the Shelton brothers in jail and secured the Birger Gang's reign over bootlegging in that region.

The Birger Gang, southern Illinois bootleggers, pose with guns. Charles Birger is at center, on top of the car.

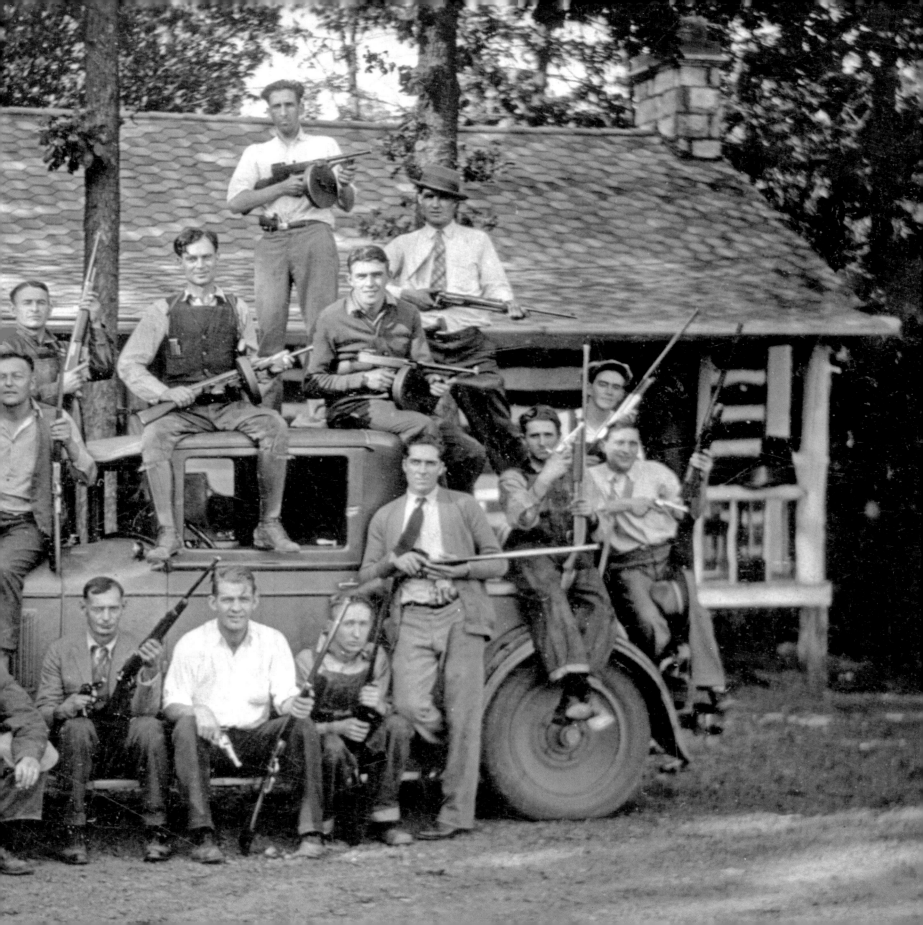

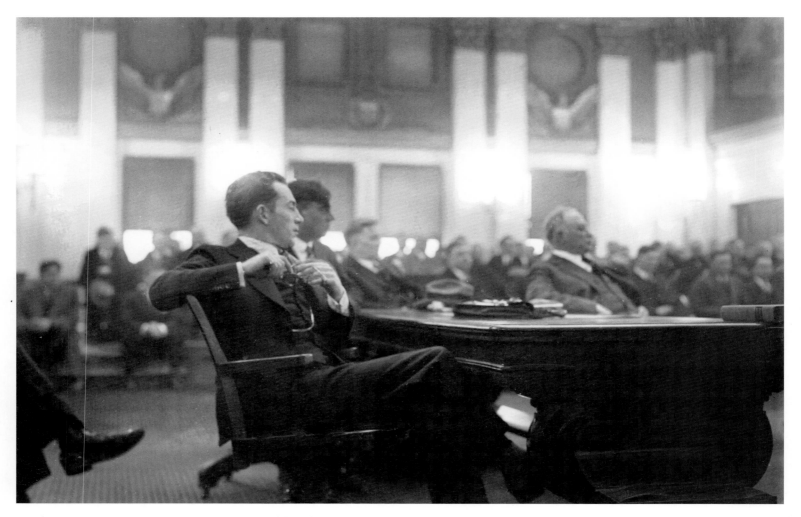

Bootlegger Terry Druggan in court. Druggan's wealth and political clout helped him acquire and maintain multiple breweries in the Chicago area, although he did have to give Capone 40 percent of his profits. Druggan was brought to trial with his partner Frankie Lake. Despite being found guilty, the two bribed the officers in jail and were allowed to come and go as they pleased during their one-year prison term.

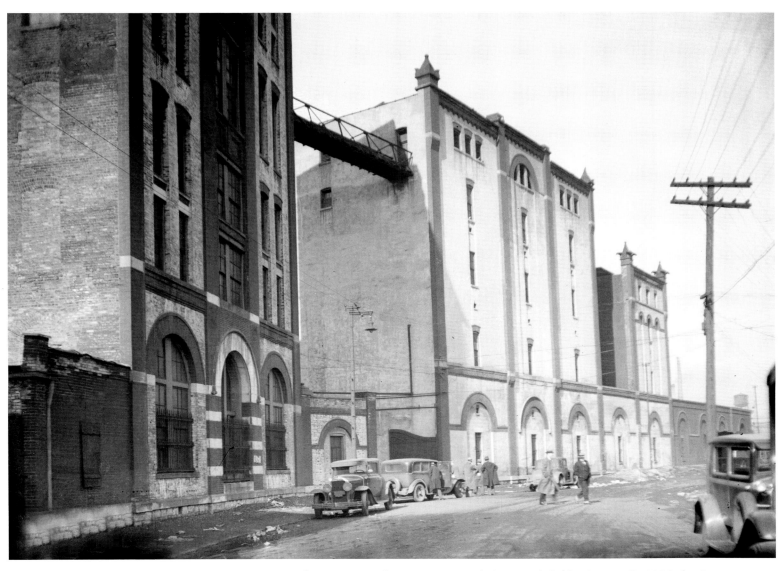

One of Terry Druggan's Breweries on 12th Street and Oakley Avenue. In 1924, despite attempts to bribe the courts, Druggan was forced to dump more than 70,000 gallons of illegal alcohol.

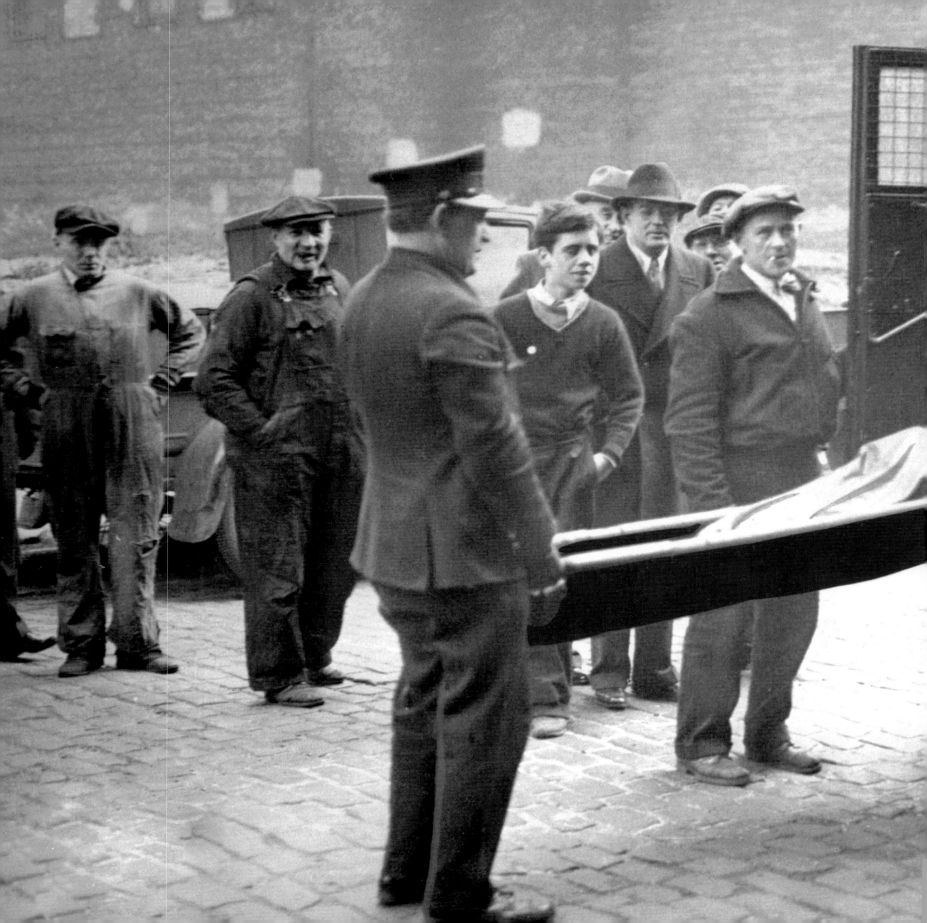

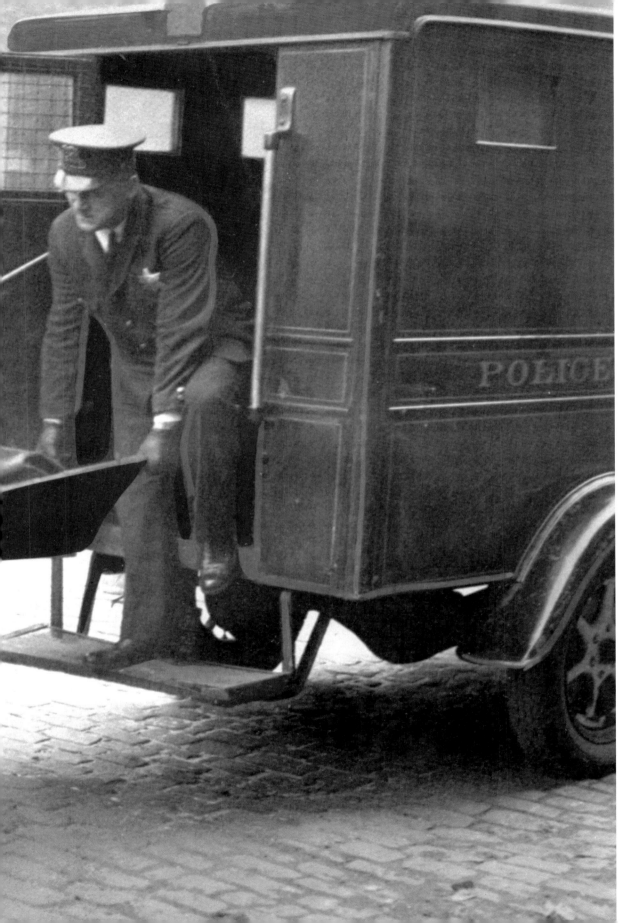

"West Side" Frankie Pope being put into an ambulance. Pope ran a gambling spot for Capone in Cicero called the Hawthorne Smoke Shop. Despite many years of what seemed to be loyal service, a dispute over earnings knocked Frankie out of favor with Capone's gang.

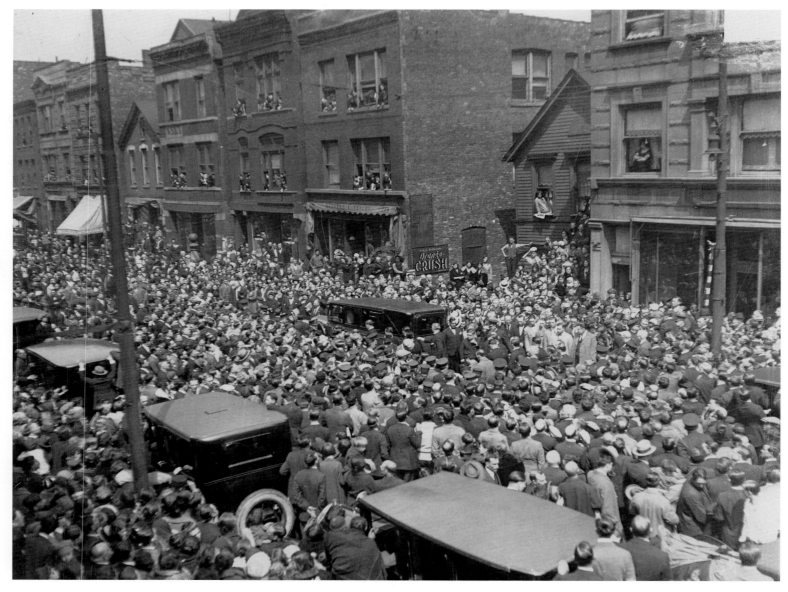

Crowd on the street for the funeral of William H. McSwiggin. McSwiggin was a successful assistant prosecutor who had grown up with and remained friends with some of Chicago's infamous gangsters. He was shot on April 27, 1926, by Capone assassins in an attempt to kill the rival gangsters McSwiggin was standing near.

William H. McSwiggin's funeral was held at St. Thomas Aquinas Roman Catholic Church at 5112 N. Washington Blvd. Public outrage over the murder of the star prosecutor turned up the heat on Capone. Of course, Capone denied he had McSwiggin killed, suggesting instead that they were close friends.

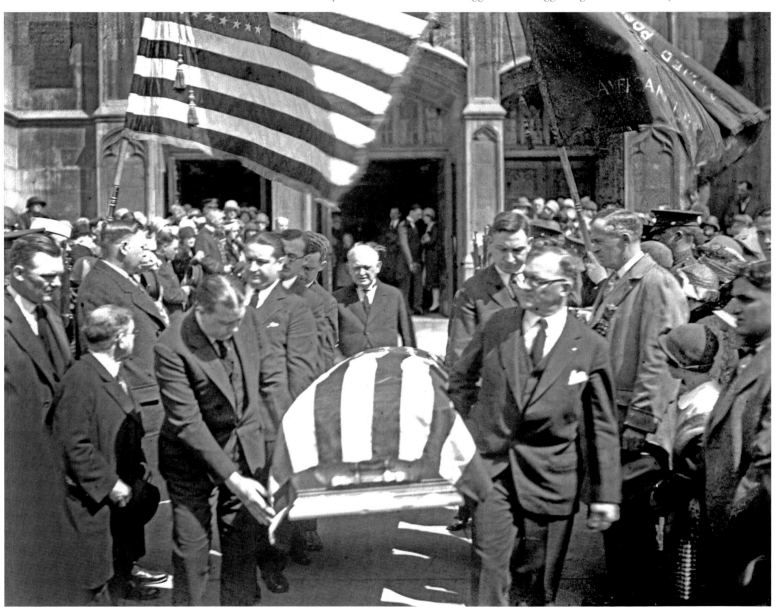

William McSwiggin's funeral, 1926.

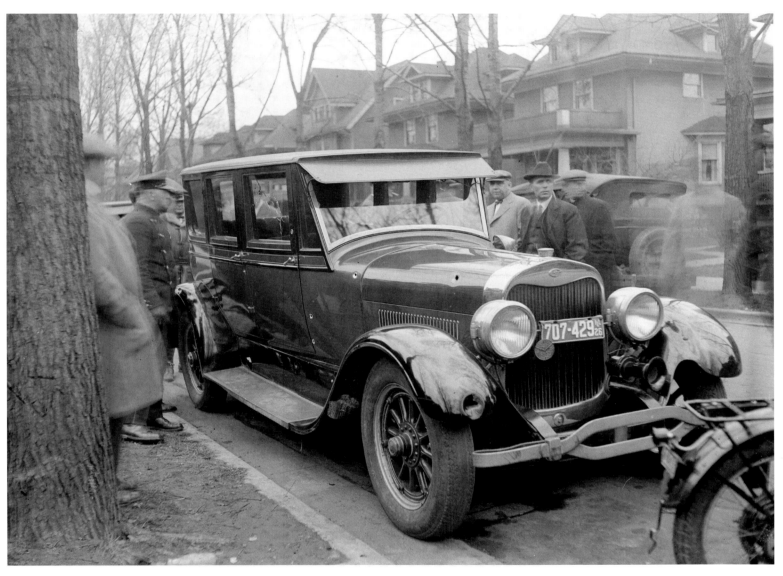

The Lincoln in which McSwiggin was riding the night he was killed. The car was owned by the O'Donnell brothers, rivals of Capone.

Captain John Stege, future head of the Dillinger Squad, a 40-man unit specifically tasked to find and capture the bank robber, inspects the Lincoln in which McSwiggin was riding the night he was murdered.

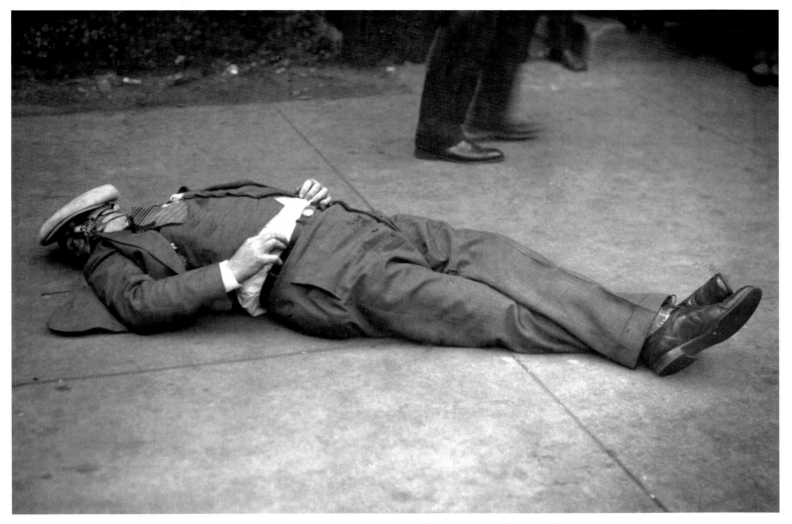

The body of Earl "Hymie" Weiss after he was gunned down on State Street October 11, 1926. The month before, Weiss had led an extremely violent attack on Capone's Cicero headquarters in an attempt on his life. He failed. Capone reached out to settle the dispute through an emissary, Tony Lombardo, but when no compromise could be reached, Capone had Weiss killed.

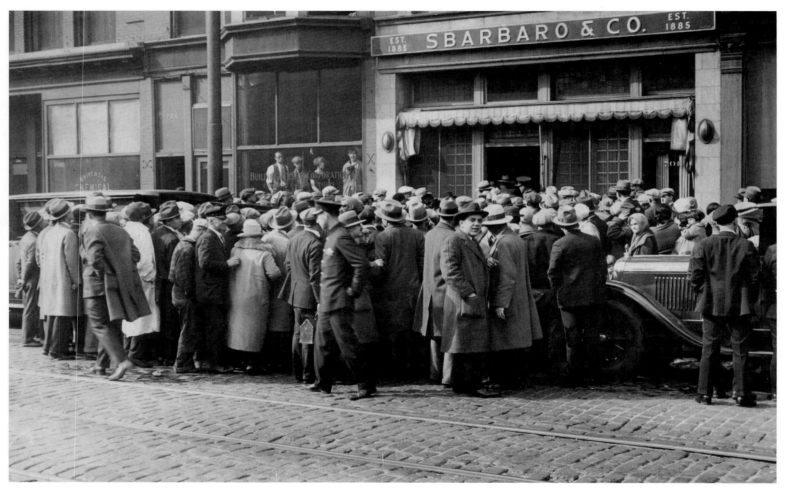

A crowd gathers at the scene of Hymie Weiss's murder on State Street in Chicago. Weiss was murdered in front of the same flower shop in which Dean O'Banion had been killed two years earlier. After the attack on O'Banion, Weiss and "Bugs" Moran took over the slain gangster's operations.

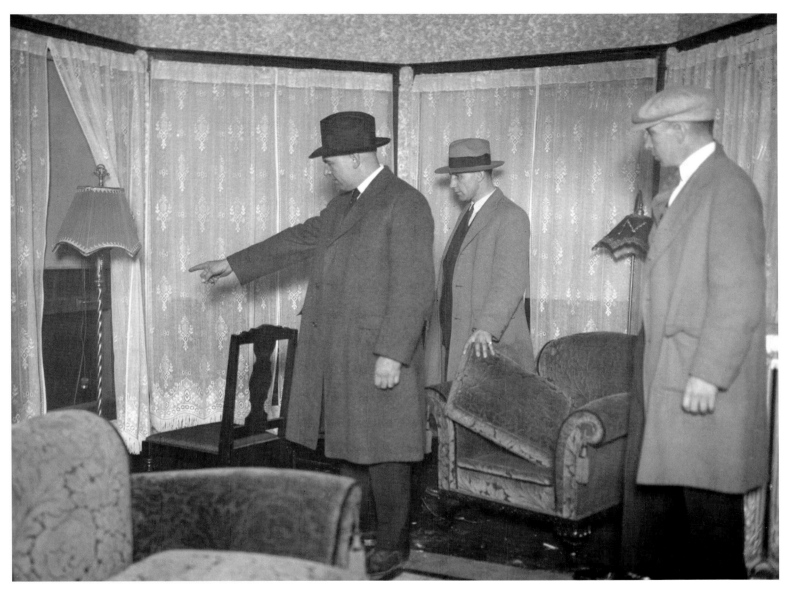

Police examine the window where Hymie Weiss's killer watched his movements for three weeks. The "gun nest," as it was called, was a popular method of assassination among gangsters, especially Capone.

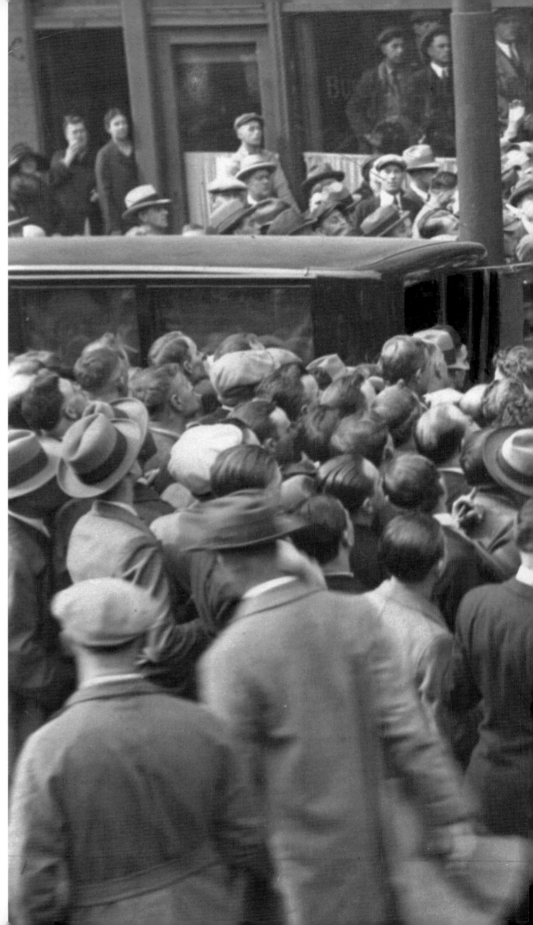

Weiss was buried October 16, 1926, at Mount Carmel Cemetery in Hillside, Illinois.

138

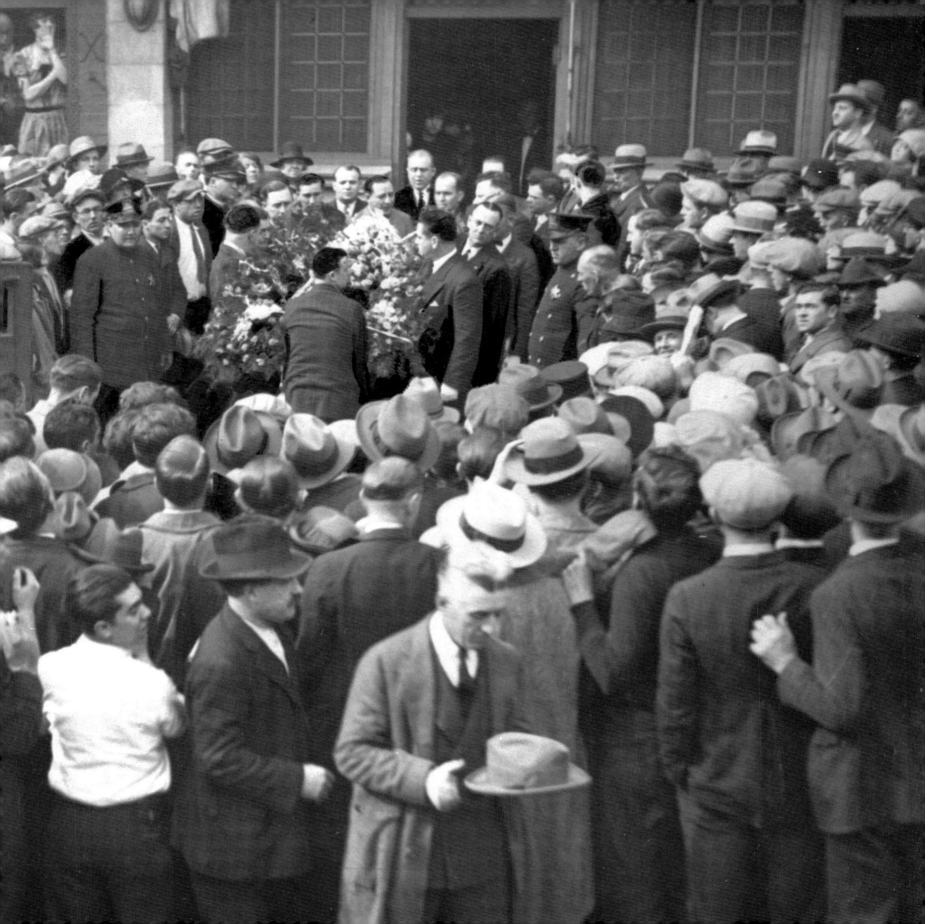

Hymie Weiss's widow.

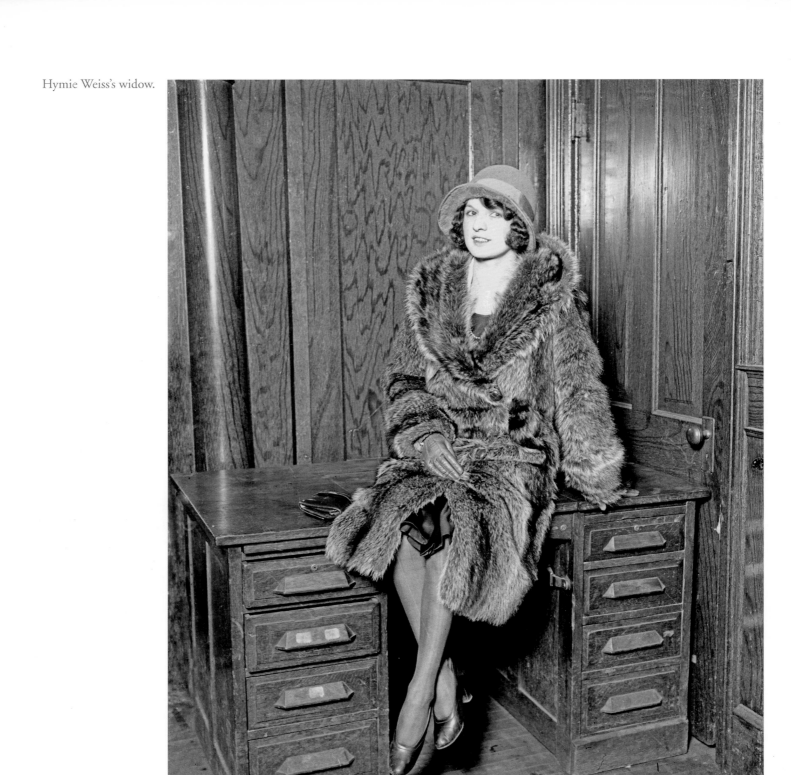

GANGLAND CHICAGO

(1927–1929)

In 1925, North Side Gang leaders Earl "Hymie" Weiss and George "Bugs" Moran tried to assassinate John Torrio. They shot him several times but failed to kill him. After the attack, Torrio retired and left his organization to Al Capone.

Capone effectively expanded the reach of his newly acquired gang and branched out into new illicit enterprises. Despite severe losses, such as the death of his brother Frank, and setbacks like the McSwiggin murder, Capone persevered. After the re-election of William Hale "Big Bill" Thompson in 1927, Capone's power and influence appeared to be growing.

Capone's main rival during this era was the head of the North Side Gang, Bugs Moran. After moving to Chicago in 1899, Moran had fallen in with a pack of young Irish toughs on the near North Side led by Dean O'Banion. O'Banion's gang included Hymie Weiss and eventually Louis Alterie. Prohibition was the new law of the land and the North Side Gang had carved out a piece of territory in which they controlled the supply of illegal booze. In fact, the entire city had been divided into regions controlled by gangs including those run by John Torrio and Al Capone, Joe Saltis, and "Spike" O'Donnell.

O'Banion had organized the North Side Gang and ran the operation out of Schofield's Flower Shop on N. State Street until he was gunned down on November 10, 1924. After Hymie Weiss was killed in 1926, Moran took charge. Moran and Capone were engaged in a continuous low-grade feud until Capone ordered the St. Valentine's Day Massacre in 1929. The hit was designed to kill Moran and his lieutenants. Some of the killers were dressed as police officers. They walked in unopposed, lined the men against a wall, and shot all seven of them dead. Moran escaped the violence. Capone was in Florida.

Although the hit failed to kill Moran, it did help to galvanize public opinion against the gangs. It also brought the young crime fighter, Eliot Ness, into the effort to bring down Capone. More than three years would pass, however, before Capone was behind bars and his career ended.

This photograph was taken on election night, April 25, 1927. Republican "Big Bill" Thompson's defeat of reform mayor William Dever was a positive sign to local gang leaders familiar with his chummy relationships with Chicago racketeers.

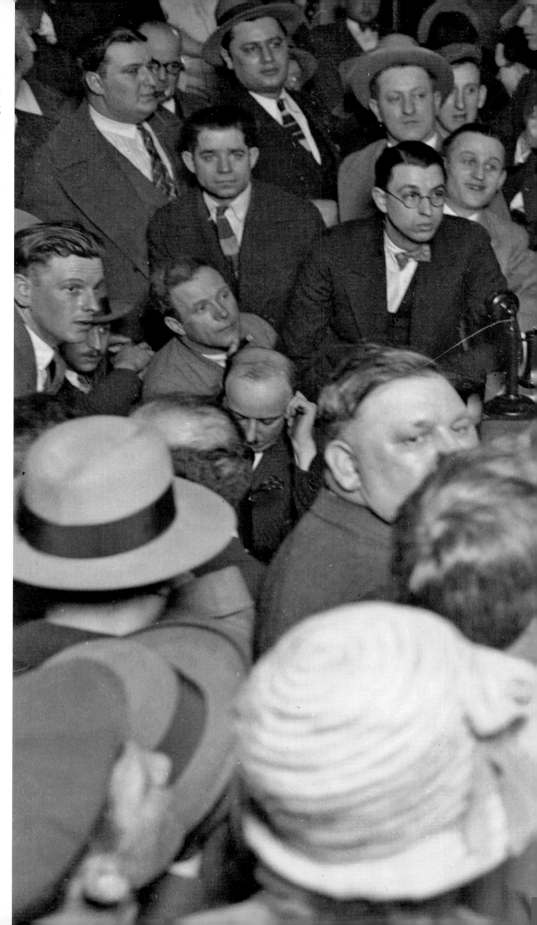

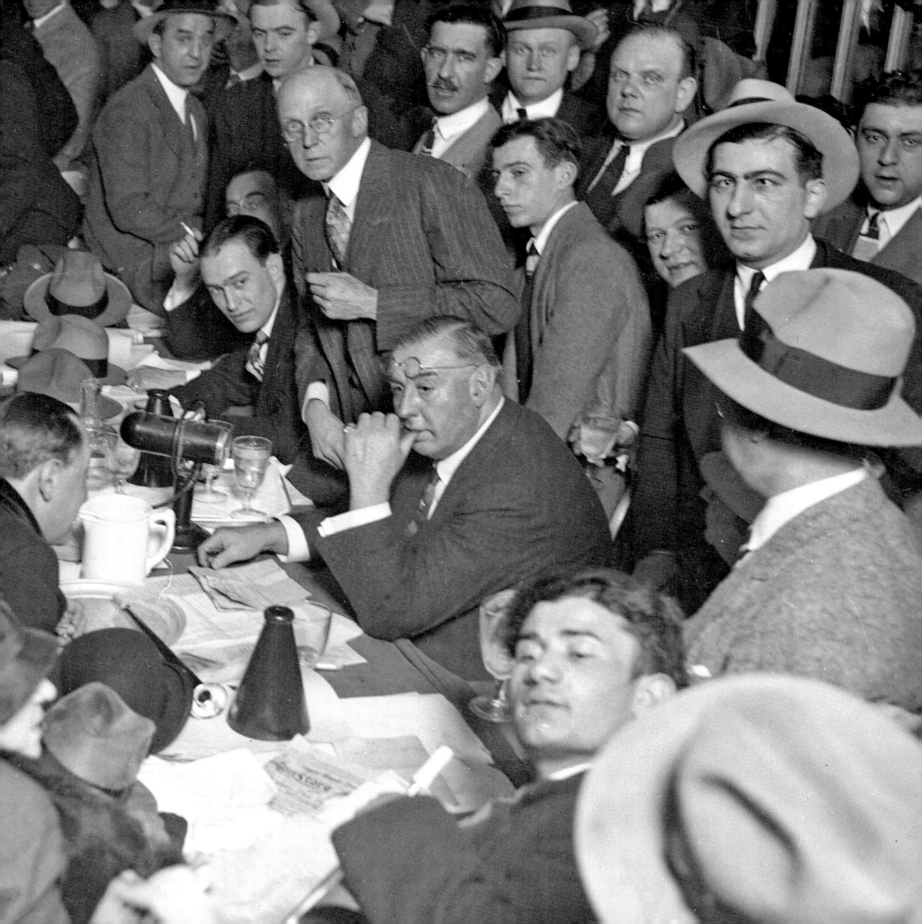

The Cook County Building and City Hall. It appeared to many that city and county officials were either unwilling or unable to stop the spread of gang violence.

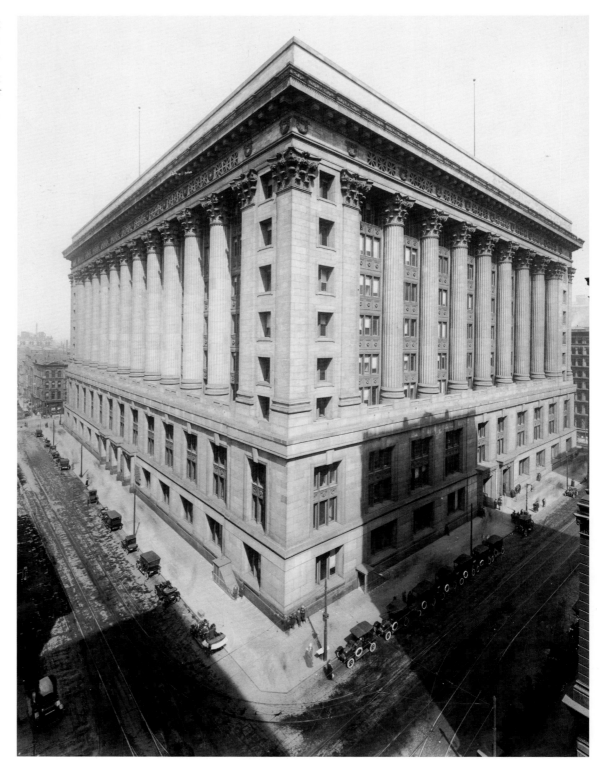

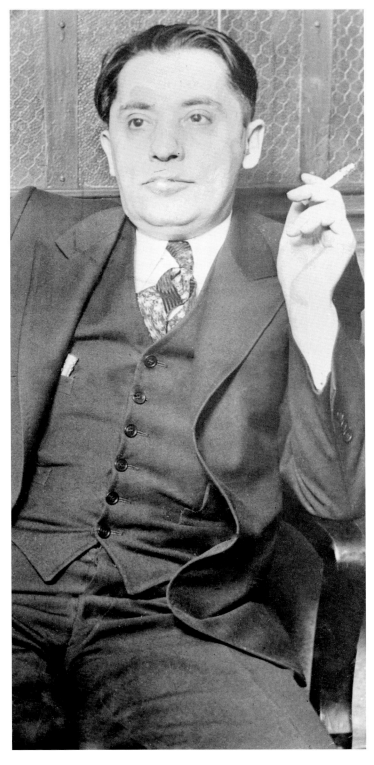

Jack Zuta, mob accountant for both Al Capone and later Capone's North Side rival George "Bugs" Moran, was responsible for keeping the financial records for the mobsters. These records often listed names of people affiliated with the gangs, including officials on the payroll. After Zuta's murder in 1931, his meticulous records were discovered in various safe deposit boxes, revealing the mob's extensive influence in Chicago's political circles.

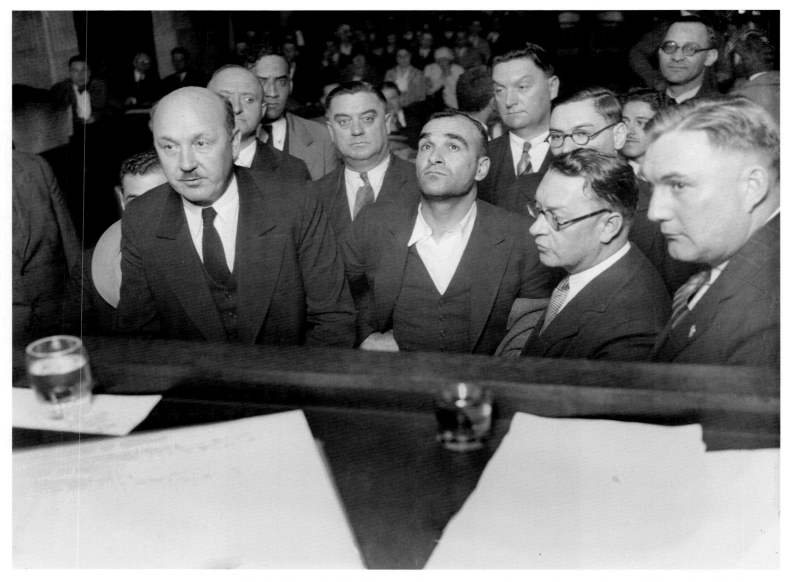

Frank Beige, alias Frank Perry, a Capone gunman, in court. Despite the end of Mayor Dever's reforming efforts and the return of "Big Bill" Thompson to the mayor's office, many gangsters still found themselves the target of police.

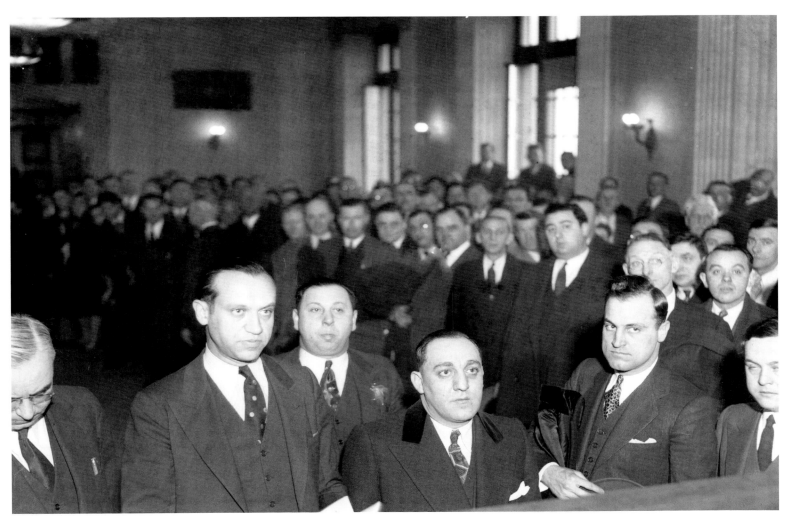

Capone bookie Hymie Levine in court (fourth from left, with dark lapels).

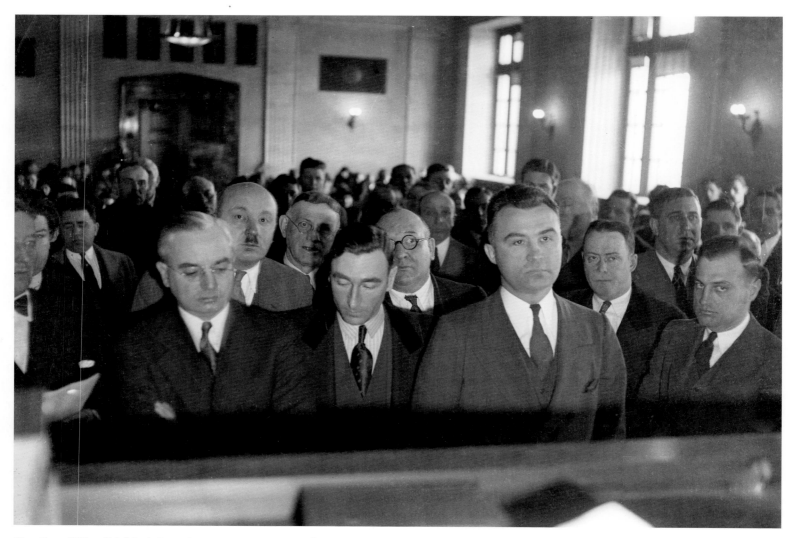

Hoodlum "West Side" Jack Barry in court on a vagrancy charge. He reportedly paid his fine and was released. The very next day he was involved in a shooting outside a tavern he had once owned.

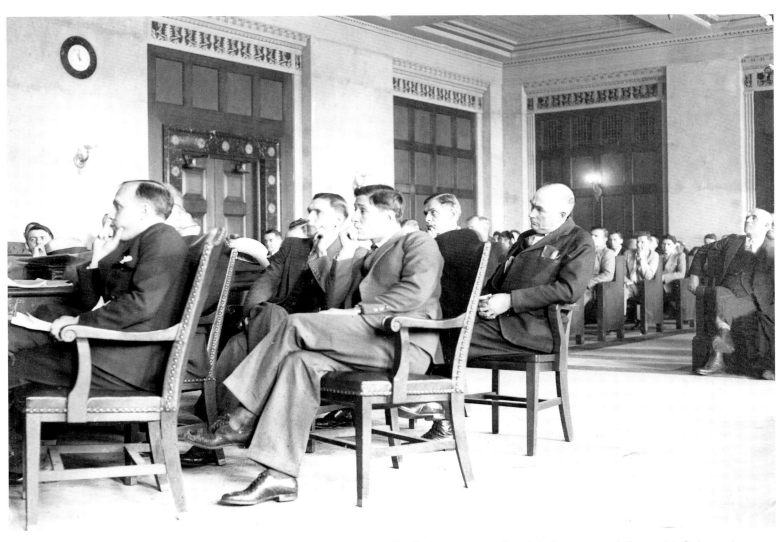

Small-time gangsters Dominic Brancato and George McGuinness in court.

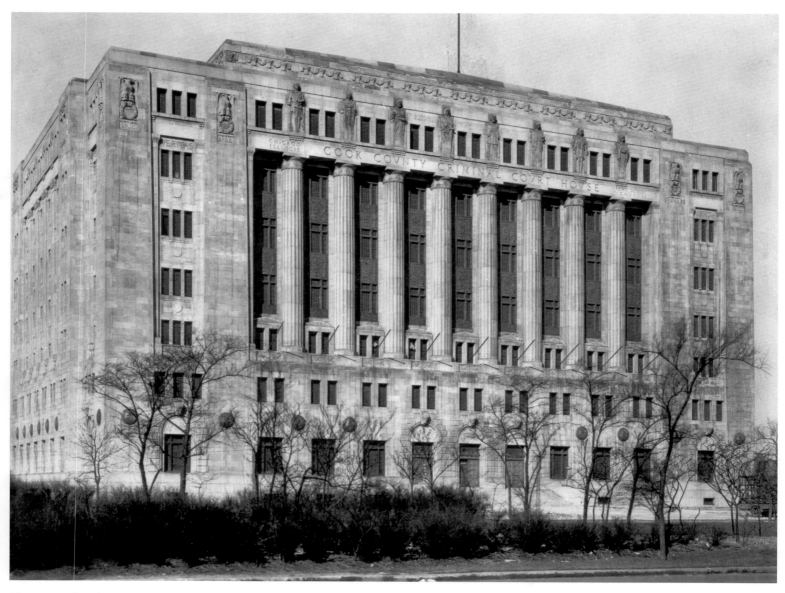

If prosecuted in the city courts or in the Cook County Criminal Court House (pictured here), Chicago gangsters were often able to avoid real jail time by intimidating or buying off witnesses, jurors, or judges. What they feared was being pursued by federal agents, like Eliot Ness, and ending up in federal court where their local influence would do them little good.

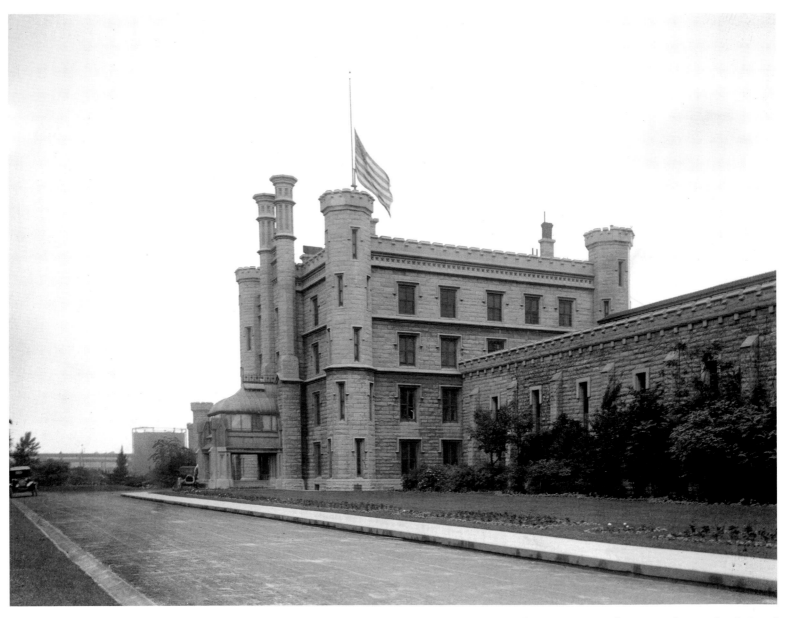

Exterior of Joliet prison, designed by William Boyington, the same architect who designed Chicago's famous Water Tower. At the time it was built in 1858, it was the largest prison in the United States. Many Chicago mobsters spent time inside the fortified walls of this prison.

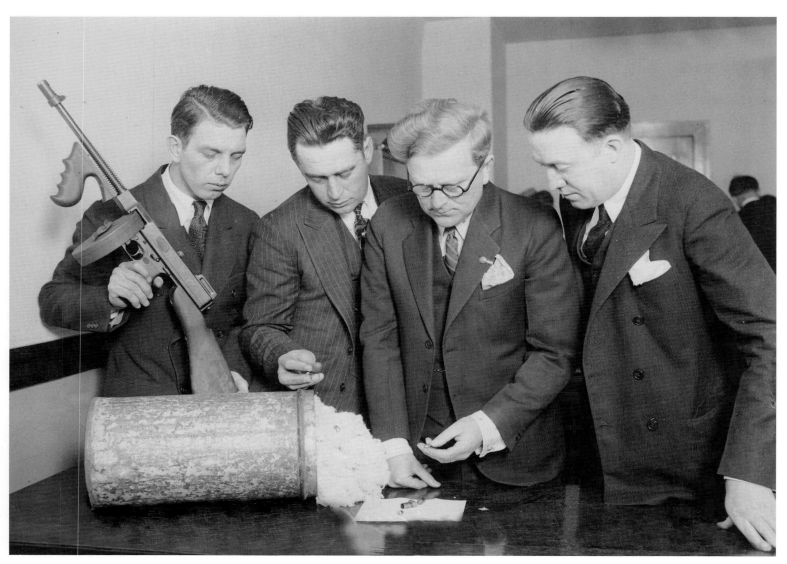

Bugs Moran's North Side Gang had proved itself to be a stubborn obstacle to Al Capone's total dominance of Chicago bootlegging. Moran was a formidable and ruthless opponent. In this image, a group of investigators examines evidence from a Moran Gang shooting. The man at left holds a tommy gun.

A crowd gathers outside the scene of the St. Valentine's Day Massacre. Al Capone and his syndicate were the suspected perpetrators of the crime.

On February 14, 1929, four men, some wearing police uniforms, entered a garage at 2122 N. Clark, owned by gangster George "Bugs" Moran, and murdered seven men. The event became known as the St. Valentine's Day Massacre, and it marked the beginning of the end for Al Capone.

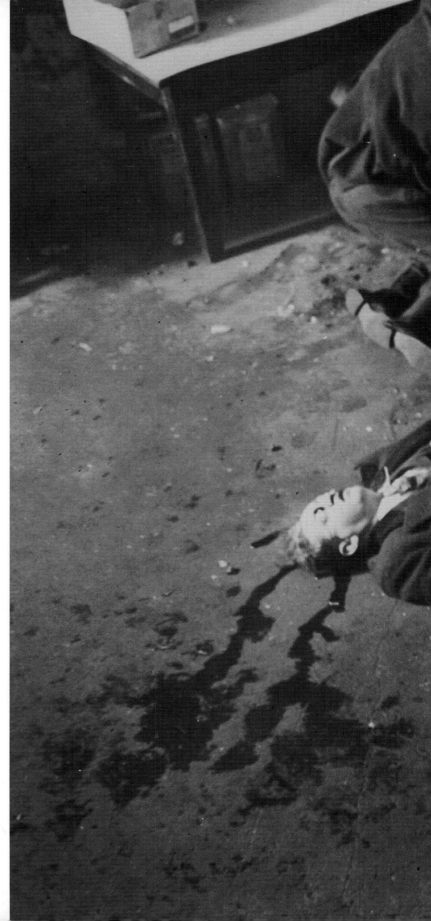

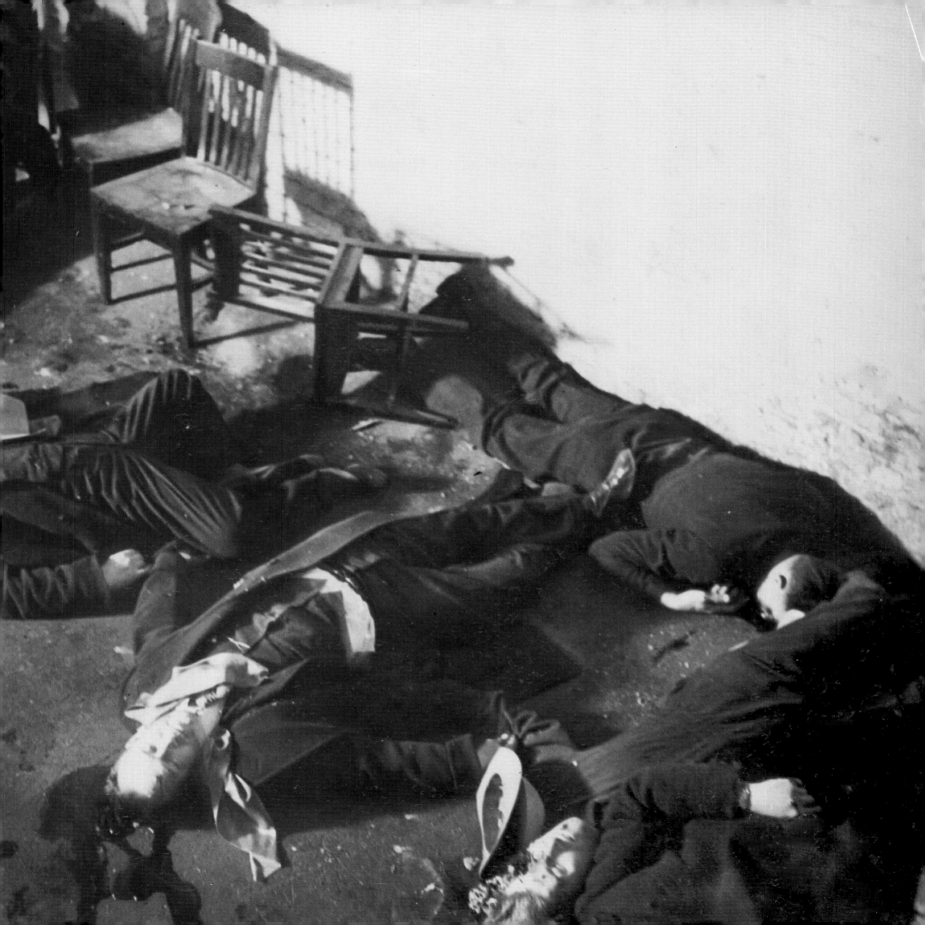

Police and spectators gather in front of the infamous garage. The St. Valentine's Day Massacre became a symbol of the unbridled violence and ruthlessness of Chicago's criminal underworld, especially Al Capone.

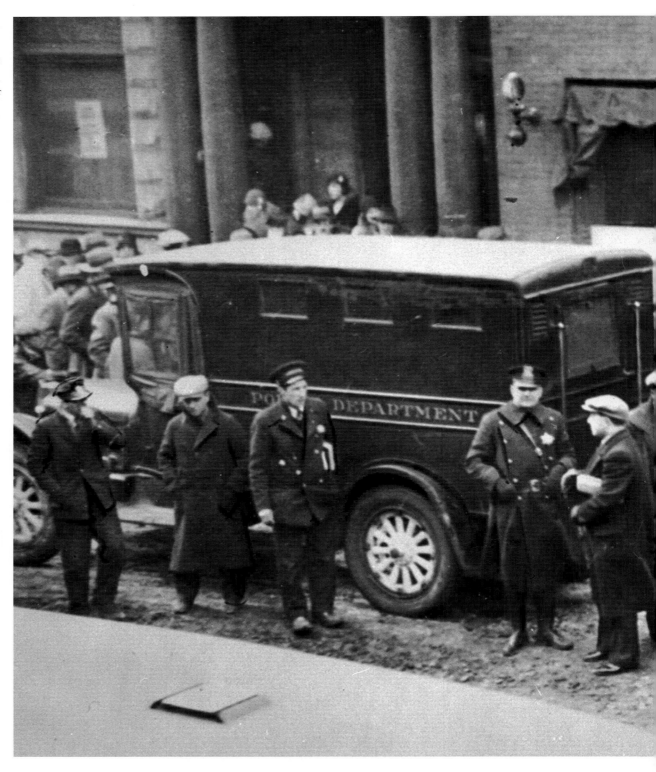

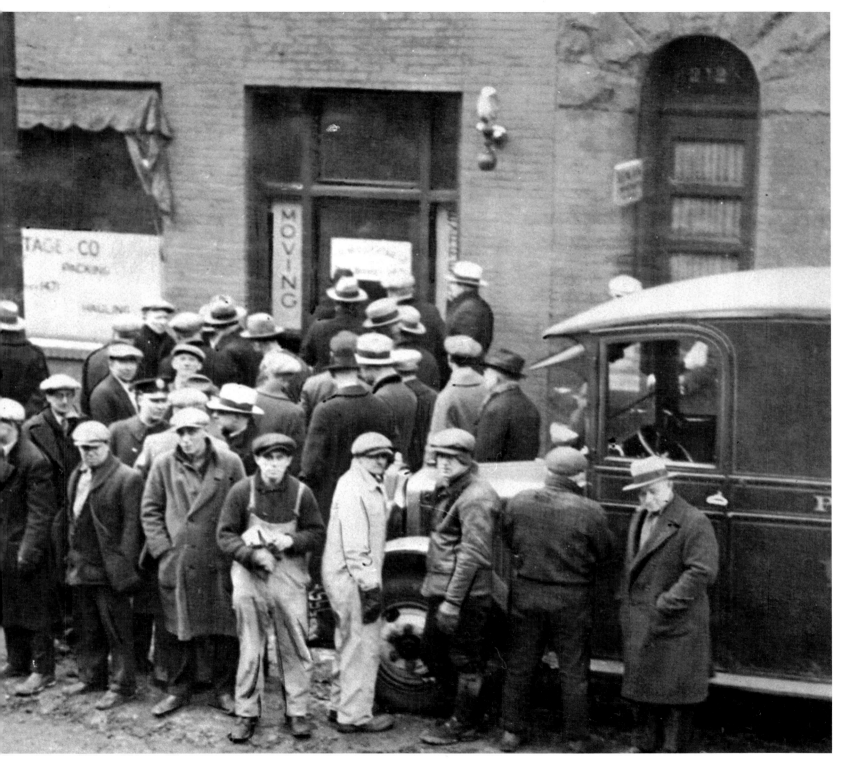

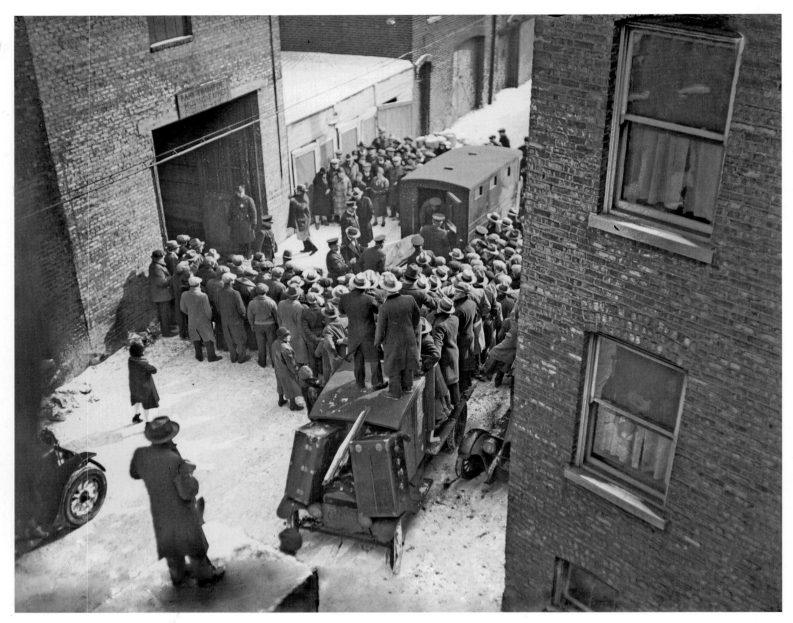

Police remove bodies from the scene of the St. Valentine's Day Massacre.

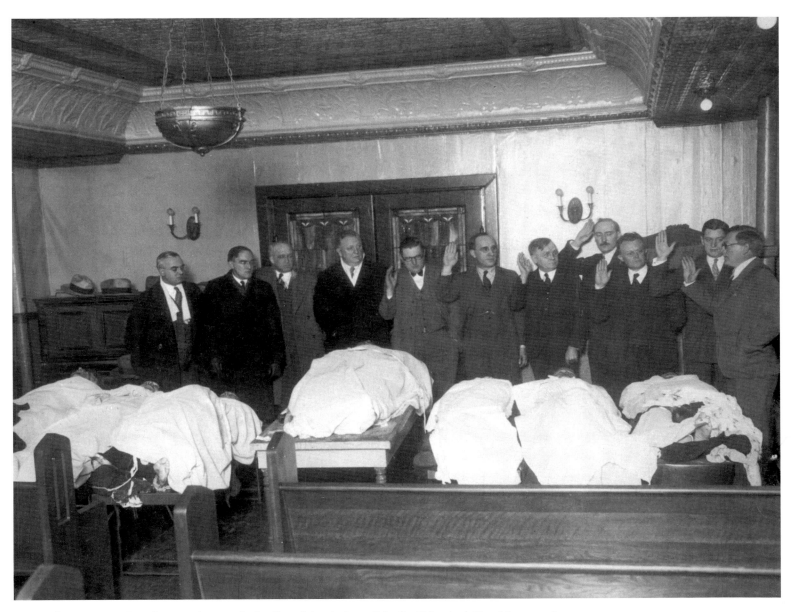

A special crime committee is sworn in over the bodies of the victims of the St. Valentine's Day Massacre. Law enforcement, as well as the public, was outraged by the incident (made even more embarrassing by the use of police uniforms as disguises by the killers), and increased attention was given to Capone's crime syndicate. The result was Eliot Ness's "Untouchable" investigative task force.

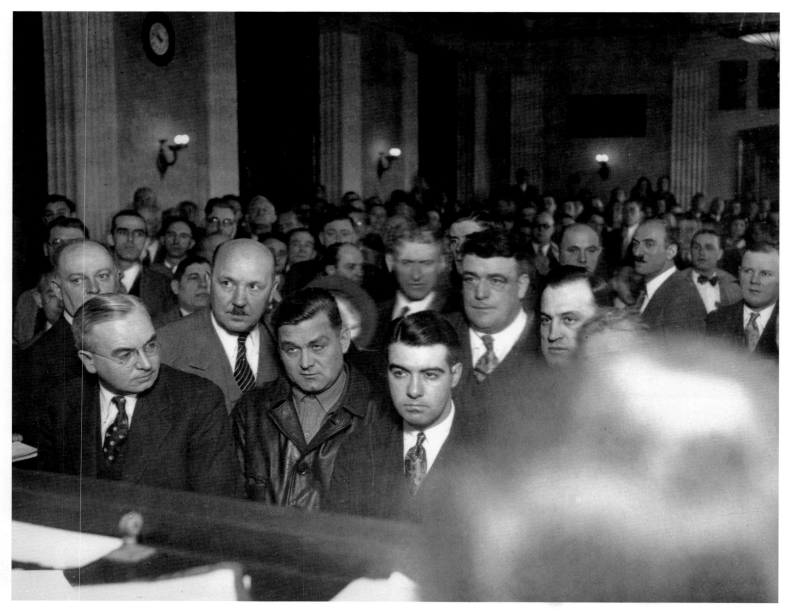

George "Bugs" Moran (in the leather jacket), leader of Chicago's North Side Gang and the original target of the infamous St. Valentine's Day Massacre, in court. Moran escaped Capone's assassins. He died of lung cancer in Leavenworth Federal Penitentiary in 1957 and was buried in the prison cemetery.

Jack McGurn, reputed gangster, and his girlfriend, Louise Rolfe, in court. McGurn was charged with participating in the St. Valentine's Day Massacre, but was acquitted. No one was ever convicted of the murders.

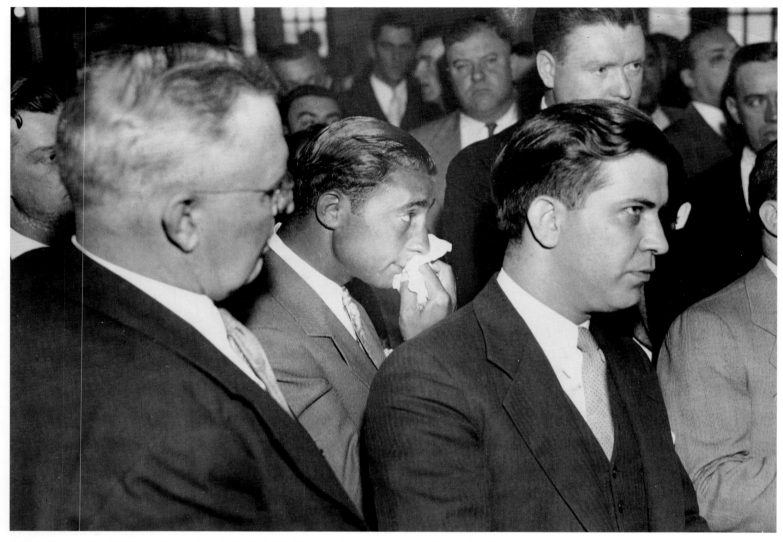

Chief of Detectives William Shoemaker (left), Jack McGurn, and Attorney Ben Feldman (right) in court.

It was widely believed that Capone had ordered the February 14 hit on the Moran Gang.

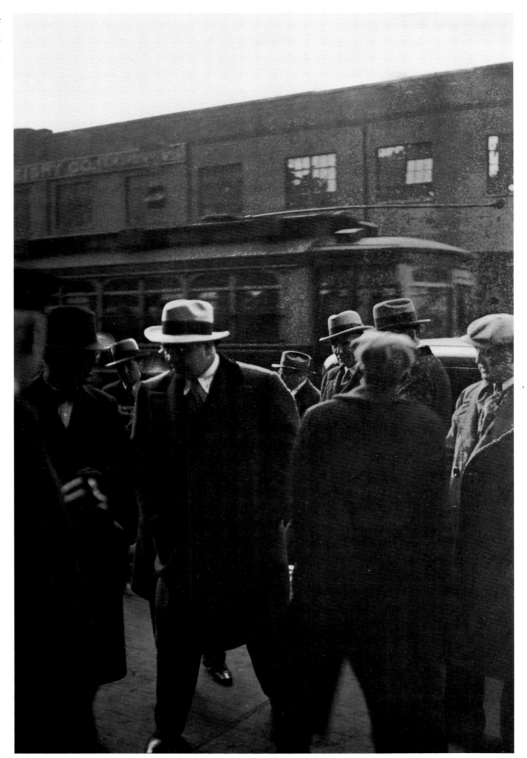

The 1920s would come to an end before the law caught up to Al Capone.

THE END OF THE CAPONE ERA

(1930–1939)

As the Roaring Twenties gave way to the 1930s and the noose tightened around Capone, other events began to take center stage. The stock market crash of October 1929 revealed that the national economy was a financial house of cards, which could crumble quickly and resist easy fixes. The Great Depression that followed soon overshadowed Capone as a national concern.

The depression hit Chicago hard. Manufacturing was at the core of the city's economy, and between 1927 and 1933, half of those jobs were lost. The city's finances were in tatters and with no safety net many industrial workers turned once again to labor unions. Strikes became increasingly common, as did consumer protests at local retail stores. Soup kitchens appeared, even one run by Capone.

As the Twenties ended so did the fortunes of the Chicago Republican Party. Chicago's Democratic machine emerged as an unstoppable political force, putting its party boss, Anton Cermak, in the mayor's office in 1931. No Republican has held the office since.

The Democratic surge was not simply a local phenomenon. In 1932, Franklin Delano Roosevelt accepted his party's nomination for president at the National Democratic Convention in the Chicago Stadium, just two weeks after the Republicans nominated Herbert Hoover in the same venue. One of Roosevelt's first acts as President was to sign into law the 21st Amendment to the U.S. Constitution, which repealed the 18th Amendment, the Volstead Act, ending the Prohibition era. Roosevelt's New Deal policies were meant to be an antidote for the Great Depression, but 10 years would pass and World War II would begin before the national economy recovered.

The increased law enforcement effort to get Capone in the late 1920s included the investigations and raids by a young Chicagoan and federal agent named Eliot Ness. Despite years of work by Ness's "Untouchables," Capone was not charged with murder, larceny, or violations of the Volstead Act. Instead he was undone by his failure to report the money he made from those illegal activities. In 1931, Capone was indicted on tax evasion charges, put on trial, and convicted. His 11-year sentence, though not a life term, effectively ended his career as a leader of the Chicago mob.

These Woman's Christian Temperance Union posters in support of prohibition state "Prohibition has reduced drinking two-thirds" and "Drinkers not drys make the gangsters." Questions about the effectiveness and consequences of prohibition contributed to a growing debate over the 18th Amendment.

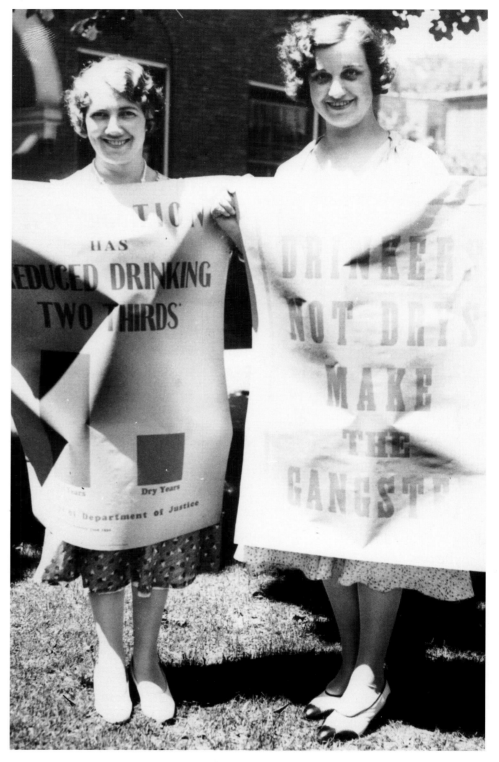

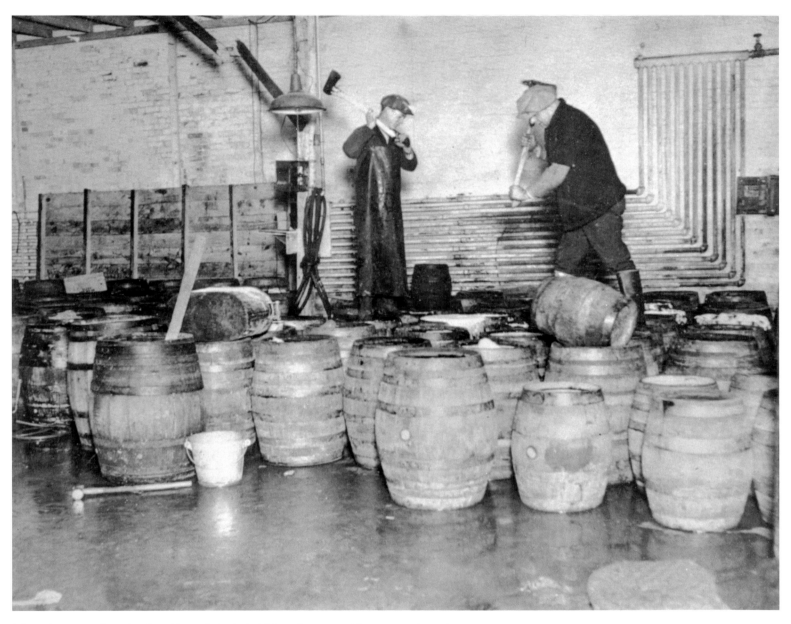

Men take axes to barrels of confiscated alcohol. Although many raids were conducted over the course of prohibition, this one on July 29, 1932, was said to be the largest outside Chicago. The facility raided in North Dakota could brew and hold nearly 1,000,000 gallons of illegal alcohol.

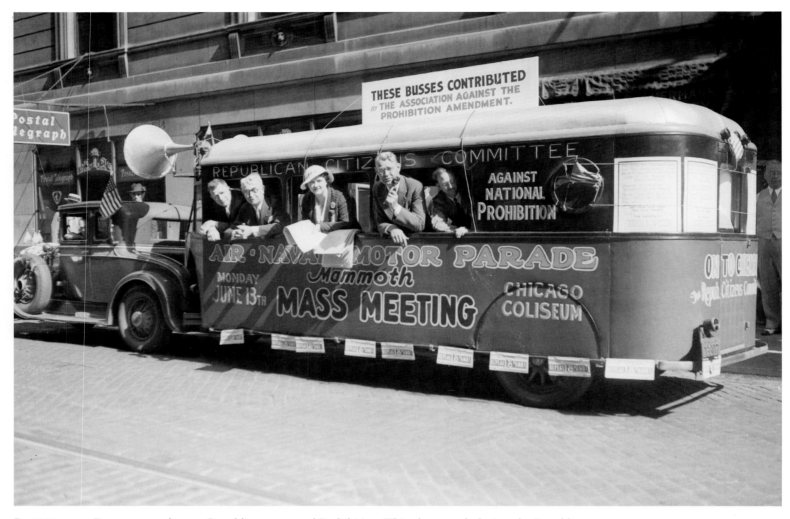

By 1932, most Democrats and many Republicans opposed Prohibition. This photograph depicts the Republican Citizens Committee campaigning for the repeal of the 18th Amendment that year. Arguments for the repeal included that prohibition hurt the economy and that it stimulated criminal activity. The 18th Amendment was repealed by President Franklin Delano Roosevelt in 1933.

Unemployed Chicagoans numbering 2,000 to 3,000 gather at Monroe and Sangamon streets on February 29, 1932, to protest worsening economic and living conditions. The Great Depression hit Chicago's economy especially hard.

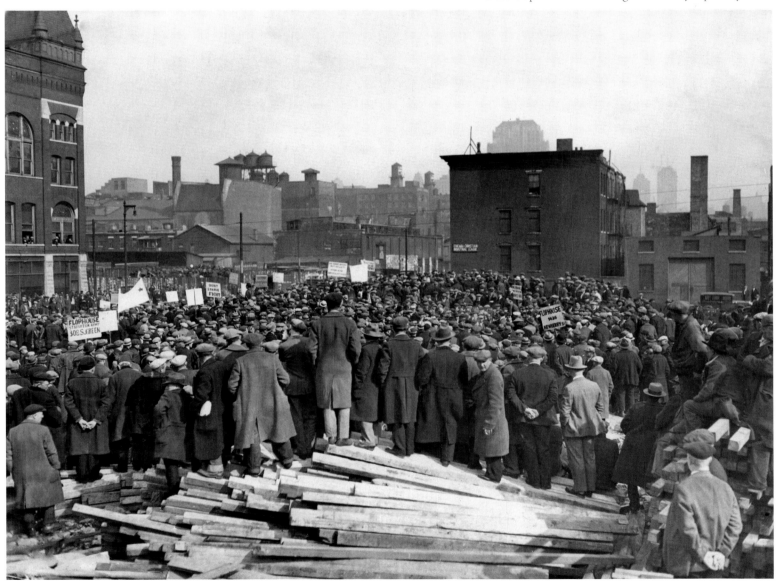

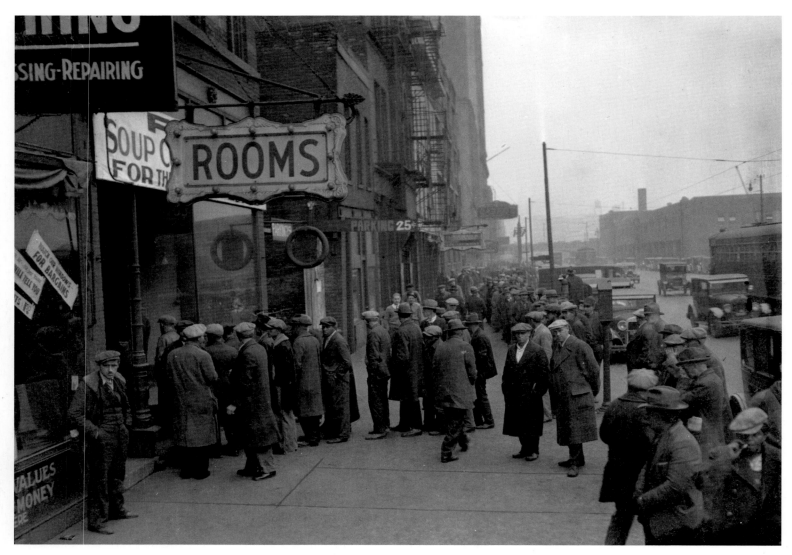

While the city cracked down on Capone's illegal activities, Capone was busy rebuilding his reputation. Capone opened his own soup kitchen in Chicago. He saw in the privations of the Great Depression an opportunity to improve his public image.

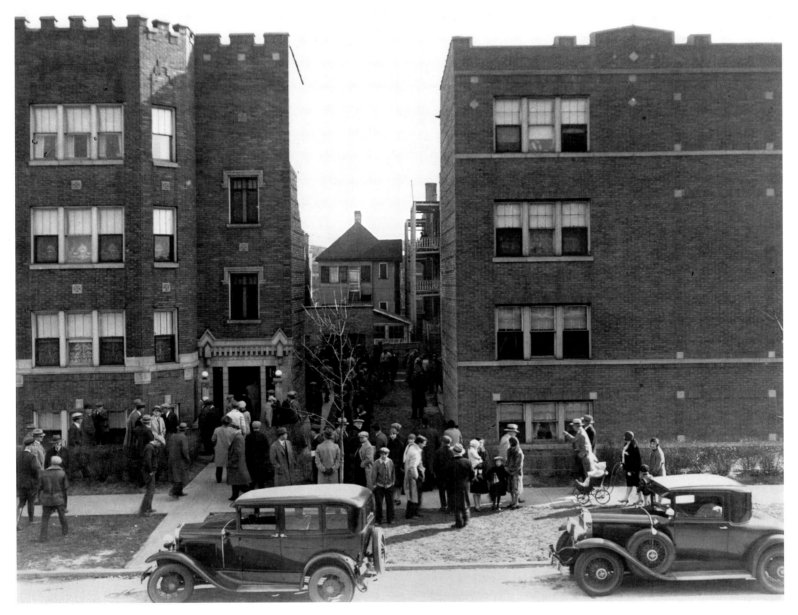

Capone continued to consolidate power and eliminate his rivals. A crowd gathers outside the murder scene of one of Capone's rivals, the Kolmer Avenue home of Joseph Aiello, head of Unione Siciliana, Chicago's Sicilian gang.

The 1933 Century of Progress Exposition was held in Chicago and projected an image of hope for the future amid anxiety over worsening economic conditions. The greater theme was the cooperation of science, business, and government. It was meant to build confidence in the national economy and politics, in sharp contrast with the grim realities of the Great Depression.

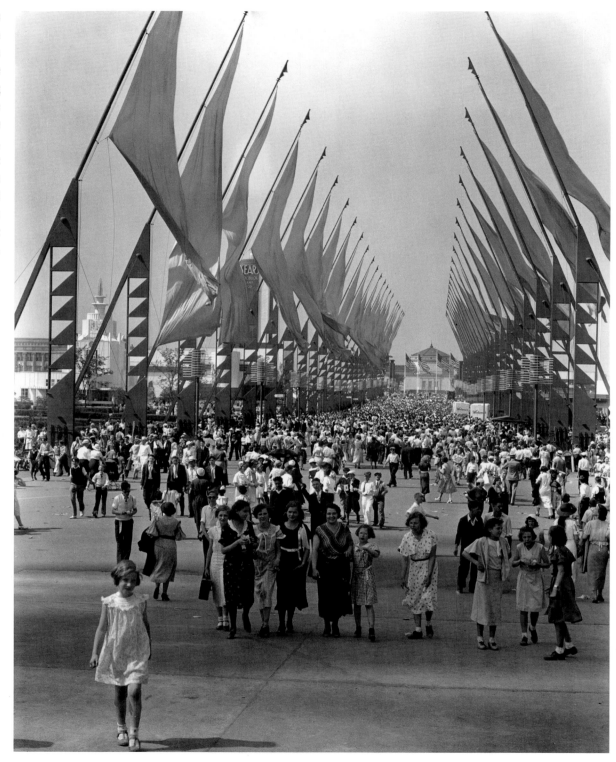

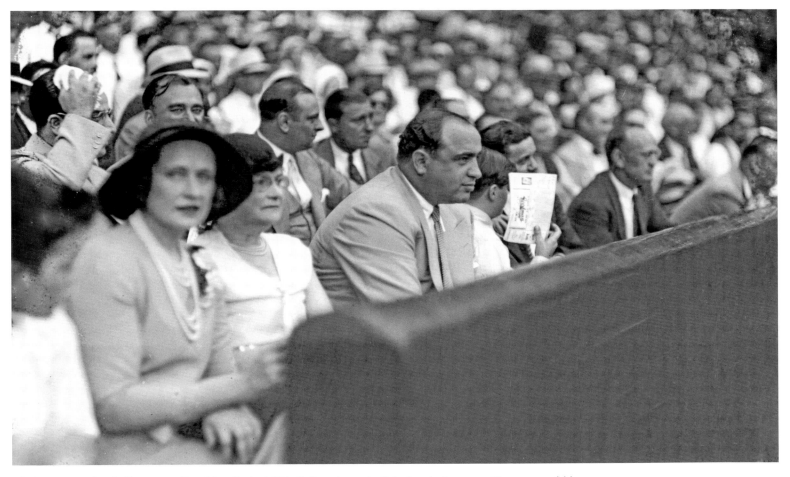

Al Capone at a baseball game at Comiskey Park, 1931. Before the end of the baseball season, Capone would be indicted on charges of tax evasion and failure to file tax returns.

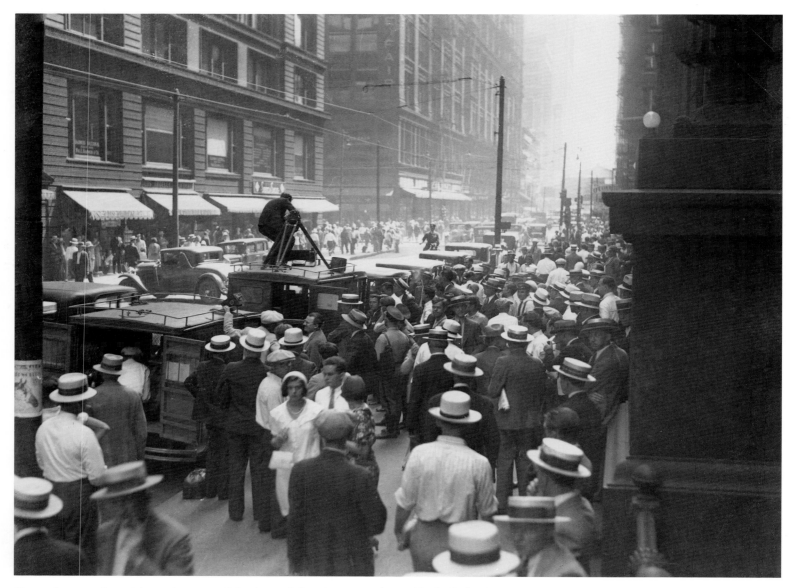

Capone's tax evasion trial was the event of the day and drew large crowds outside the Federal Building in Chicago hoping to catch a glimpse of the well-known gangster.

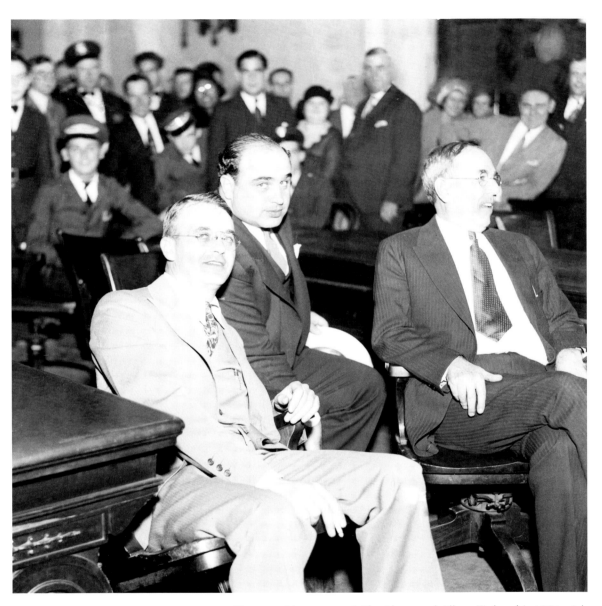

Capone with attorneys Mike Ahern and Albert Fink at his 1931 trial.

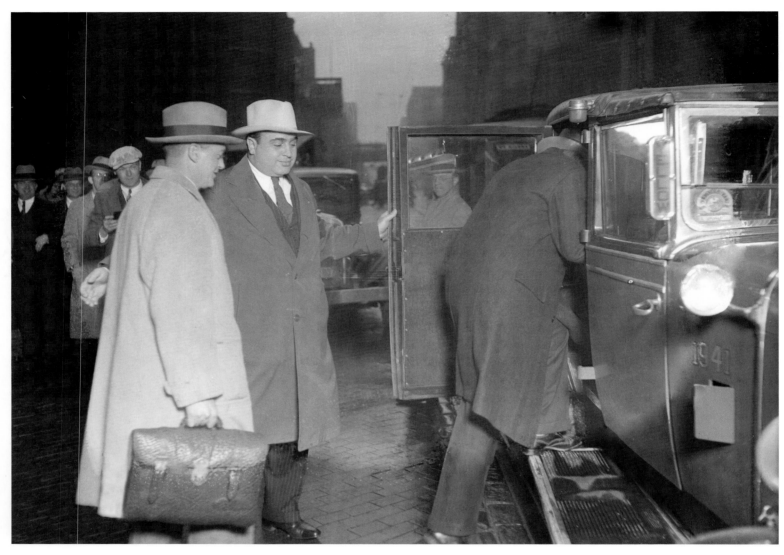

Capone, shown here with his attorney Mike Ahern, was charged with failure to pay taxes on his illegal earnings. Capone initially pled guilty thinking he could negotiate a plea agreement. But Judge James H. Wilkerson made it clear that there would be no deals for Capone.

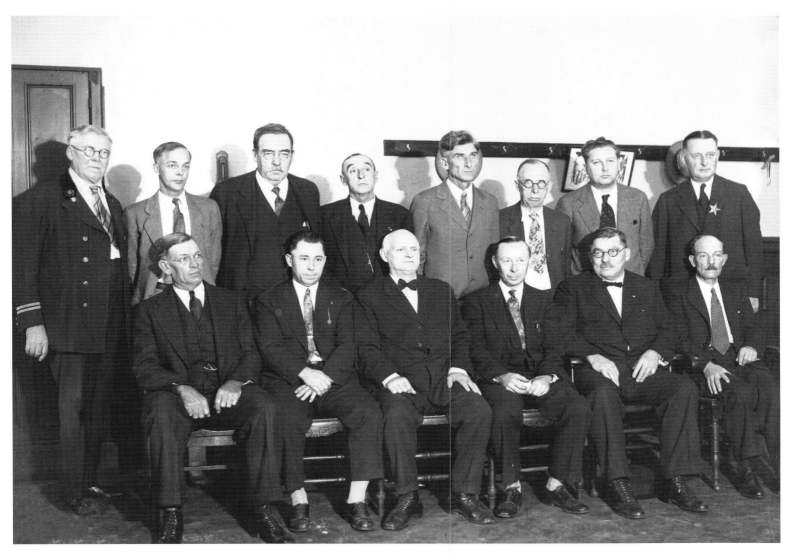

Despite Judge Wilkerson's unwillingness to negotiate with Capone, the gangster remained confident that he would be acquitted at trial. His plan: bribe or coerce members of the jury.

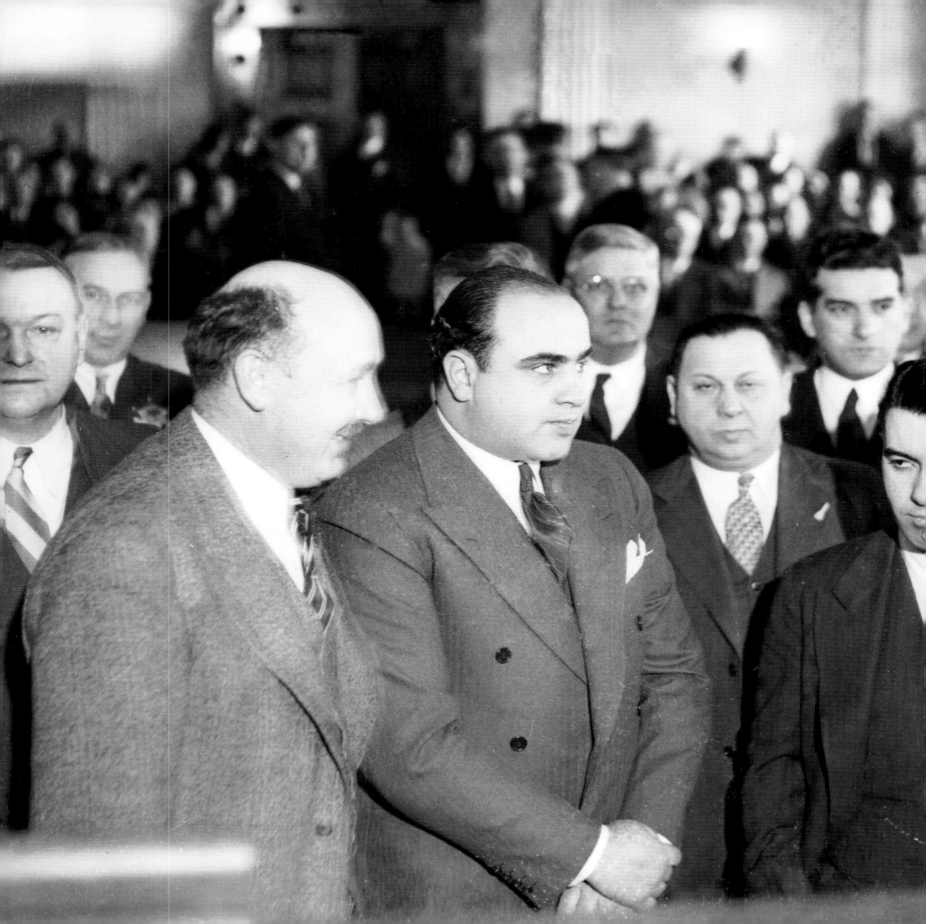

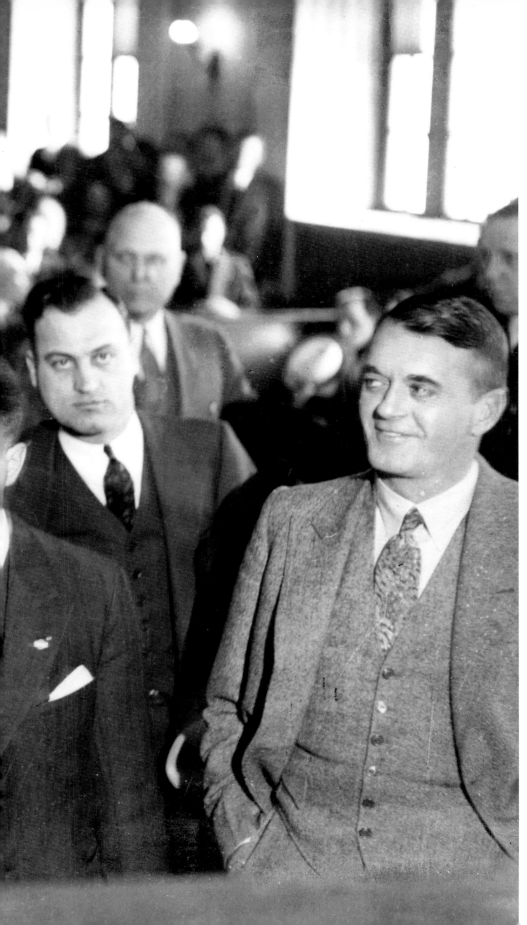

Capone was sentenced to a total of 11 years in prison, 10 years in a federal penitentiary and 1 year in the county jail. Capone was stunned by the severity of the sentence as were his lawyers and most of the reporters covering the case.

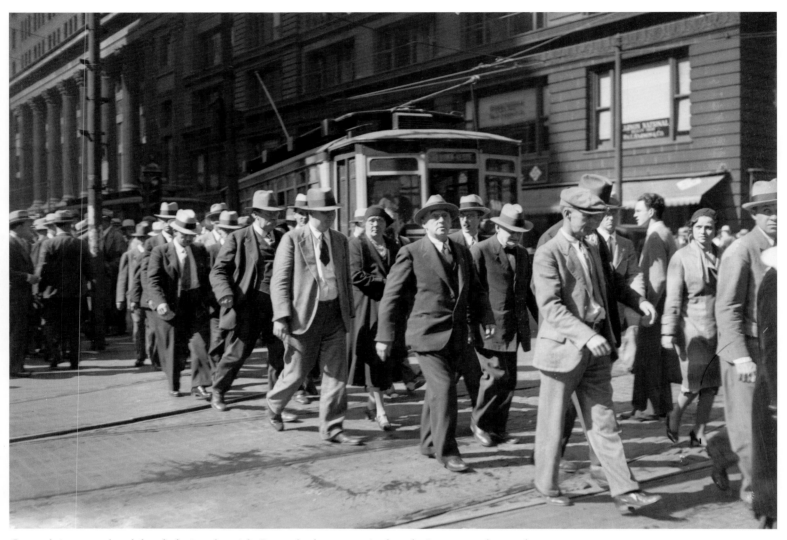

Capone's jury on a lunch break during the trial. Capone's plan to manipulate the jurors was thwarted when Judge Wilkerson swapped Capone's jury for another one impaneled to hear a different case. On October 25, 1931, the untainted twelve found Capone guilty.

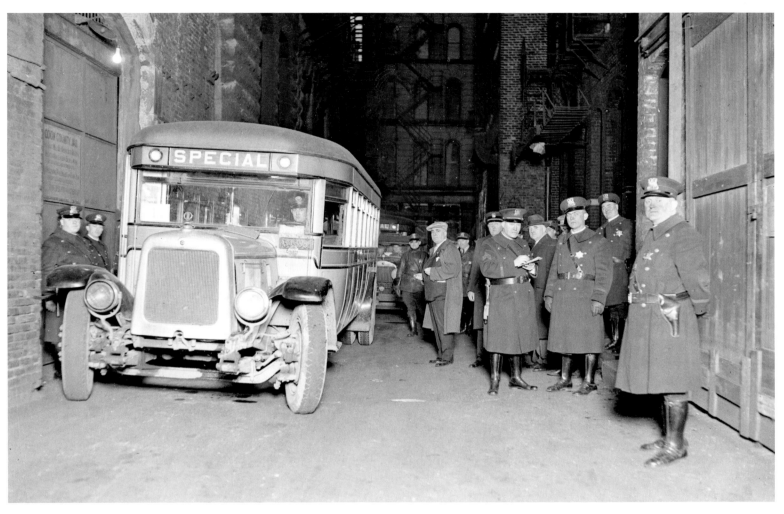

The police bus outside the Cook County Jail, where Capone would spend his
first night after being sentenced by Judge Wilkerson.

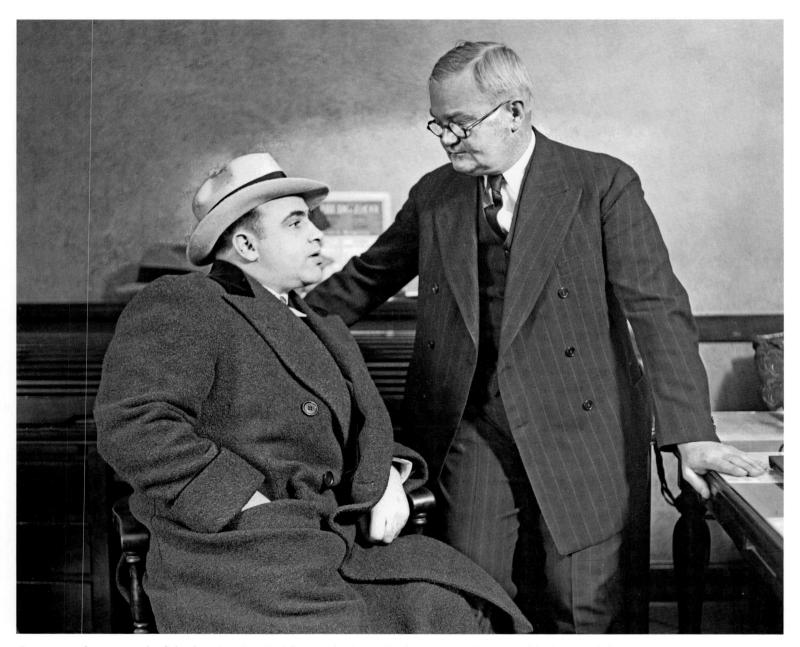

Capone was first sent to the federal penitentiary in Atlanta to begin serving his sentence. It was quickly discovered that he was obtaining special privileges and exerting influence on the prison population. He was then moved to Alcatraz to finish his term. This move effectively cut Capone off from his powerbase. He could only serve his time and hope that he would still have influence upon his release.

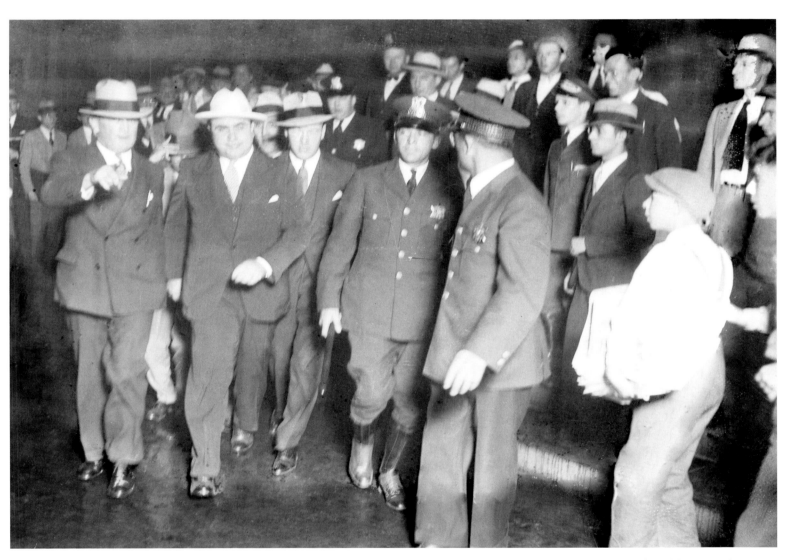

While in prison Capone's syphilitic dementia forced him into the prison hospital for the remainder of his incarceration.

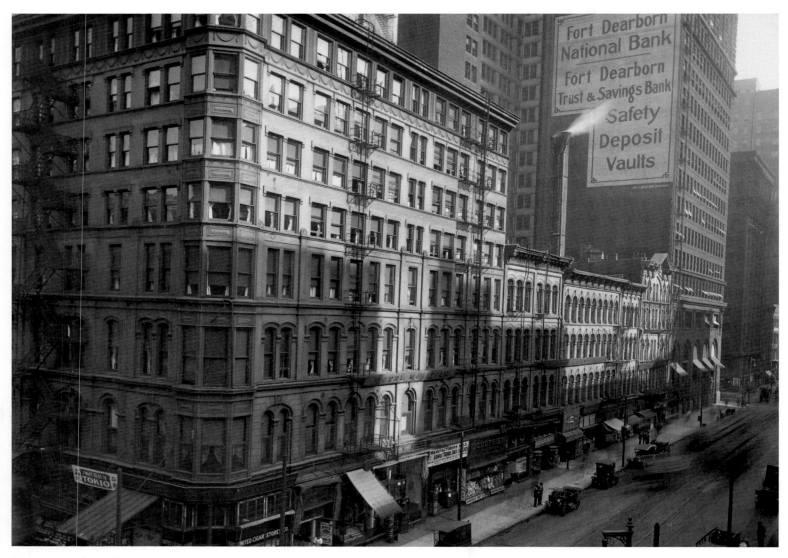

The Morrison Hotel, at Madison and Clark streets, served as the unofficial headquarters of Mayor
Anton Cermak. Shortly after Cermak was sworn in he tightened the political clampdown on
organized crime. On February 15, 1933, Cermak was shot while shaking hands with Franklin Delano
Roosevelt in Florida. He died March 6 from his wounds.

Cermak was only the second Chicago mayor to be assassinated and his funeral was well attended. Cermak was the father of Chicago's Democratic machine, and he and his successor, Edward Kelly, were strongly supported by FDR.

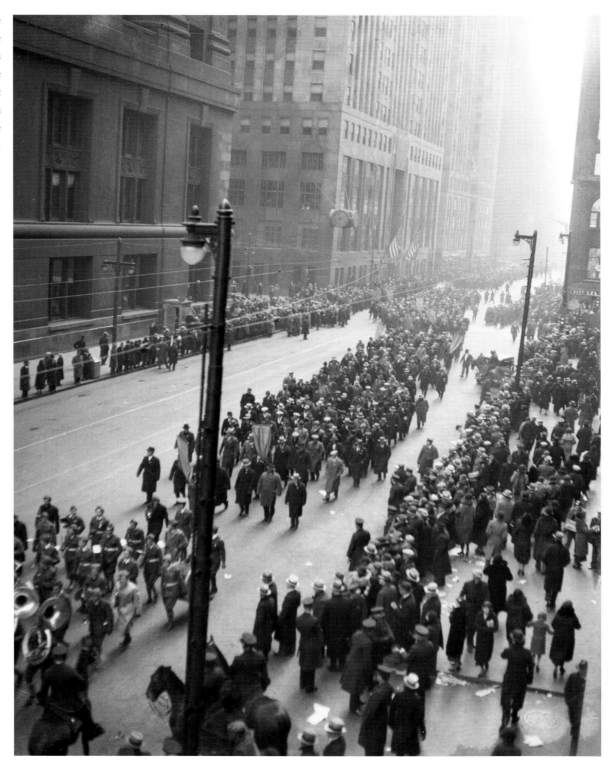

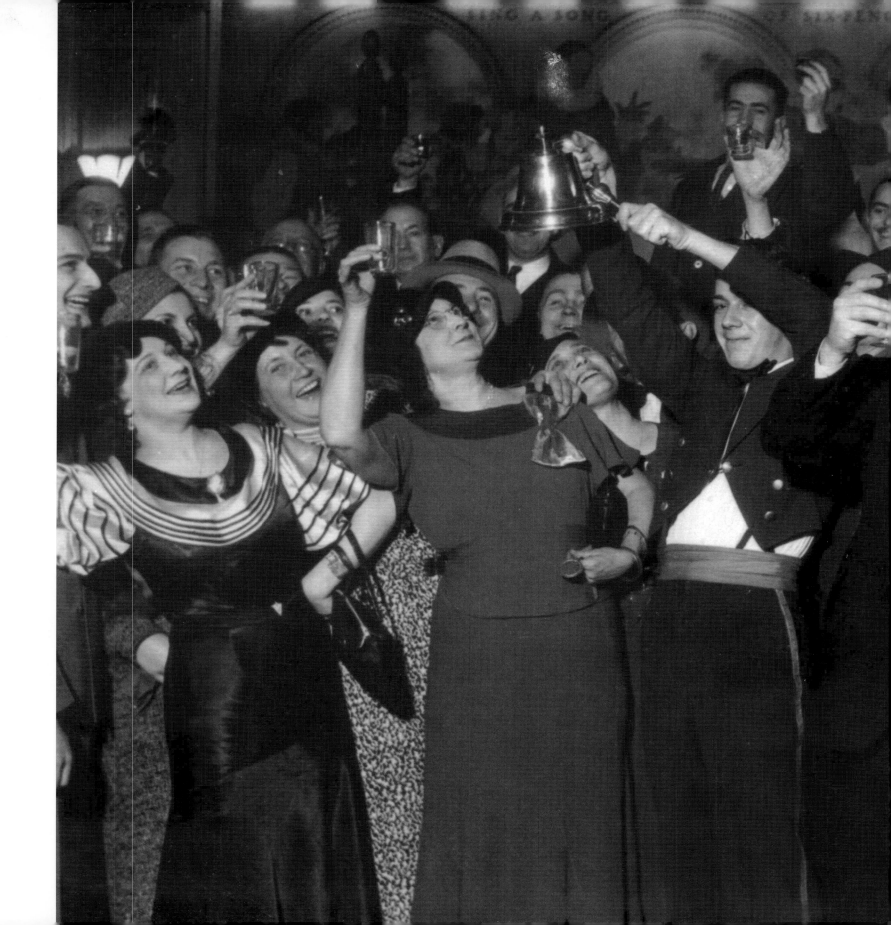

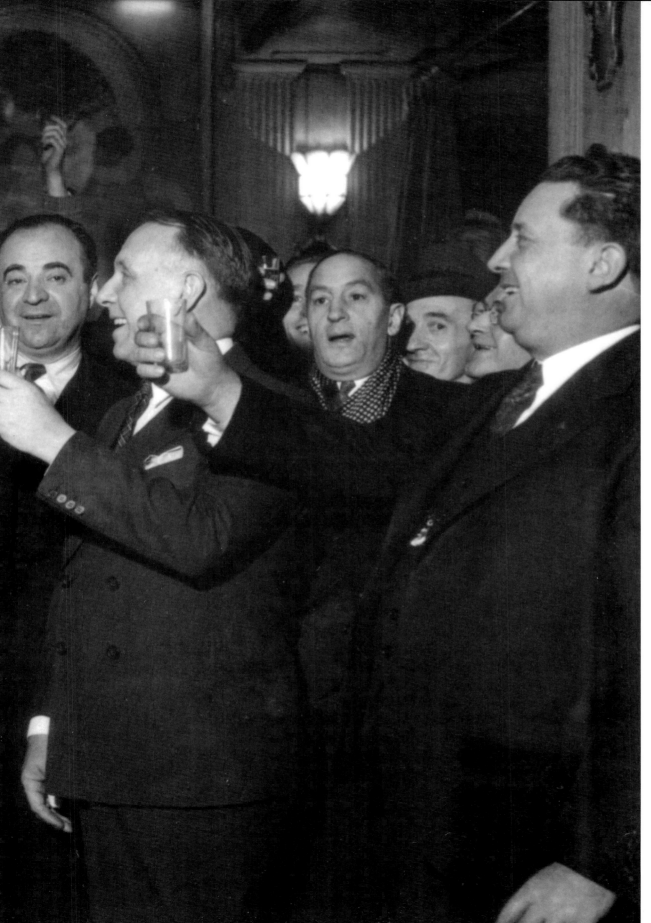

The repeal of Prohibition inspired celebration. Chicago's underworld, however, would find ways other than bootlegging to remain a potent force in the city into the 1930s and throughout the remainder of the century.

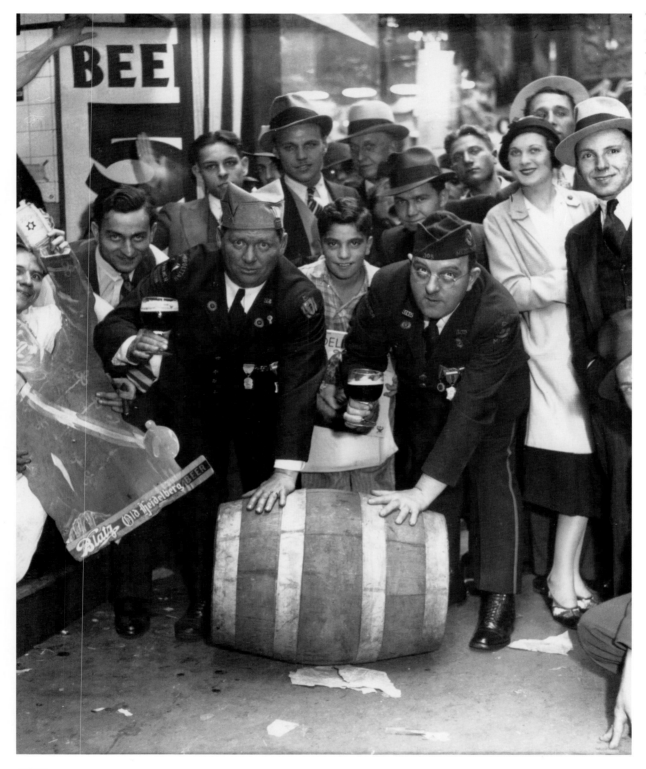

This photograph of Legionnaires celebrating was taken at the repeal of the 18th Amendment in 1933.

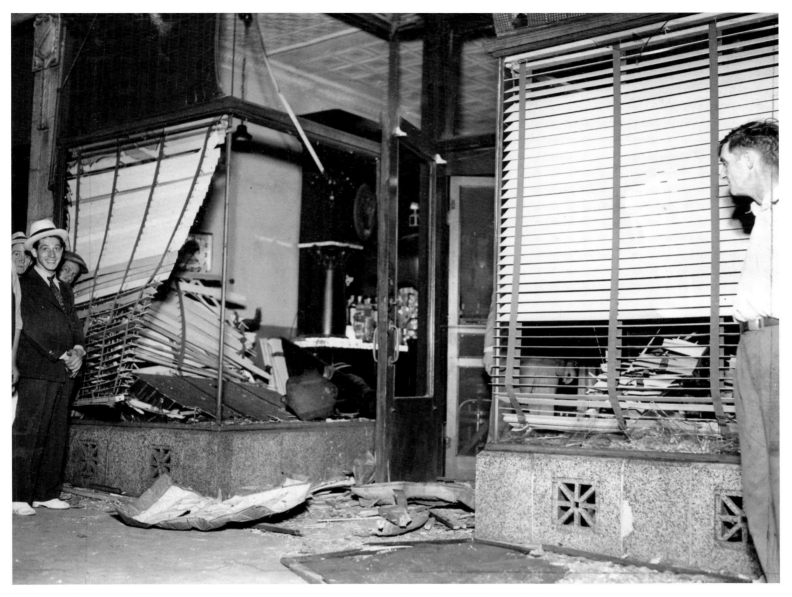

Violent attacks, such as this tavern bombing at 1206 W. Madison Street in September 1937, reminded Chicagoans that the gangs hadn't left town with Capone.

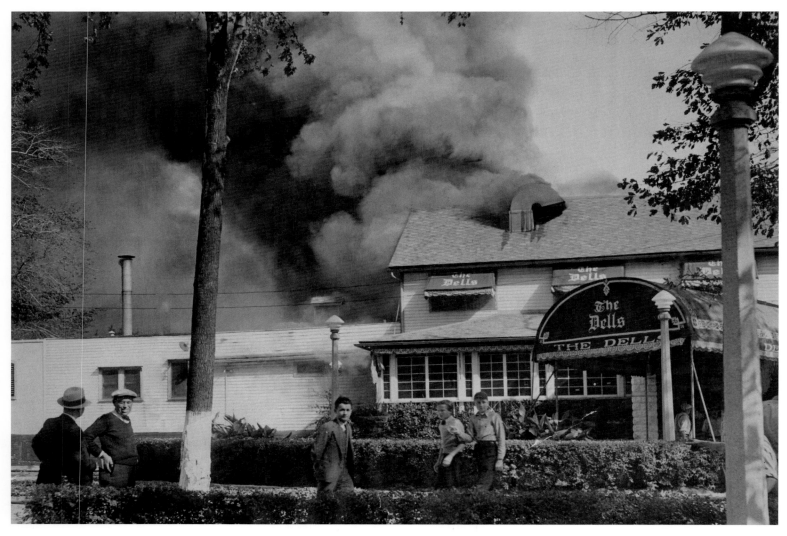

In 1934, the Dells Roadhouse in Morton Grove, a suburb of Chicago, was torched by three men with submachine guns after they kidnapped and blindfolded the caretaker.

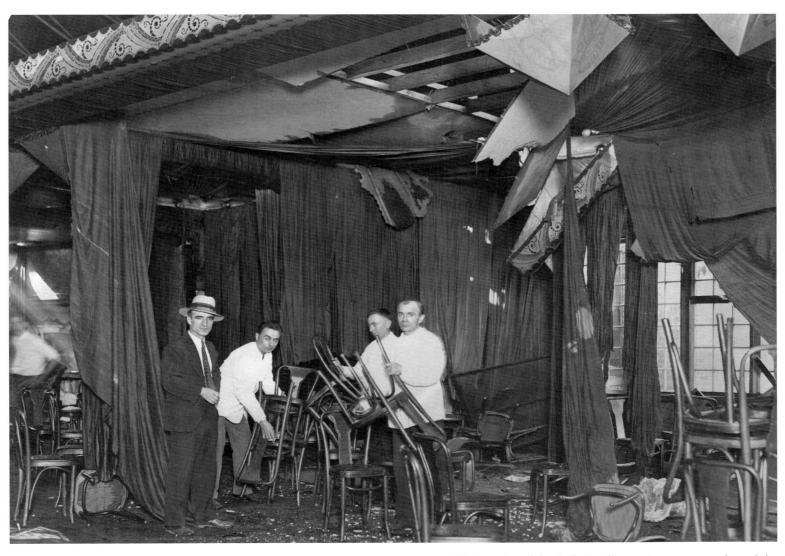

The interior of the Dells Roadhouse. Four gunmen doused the building with gasoline and set it on fire.

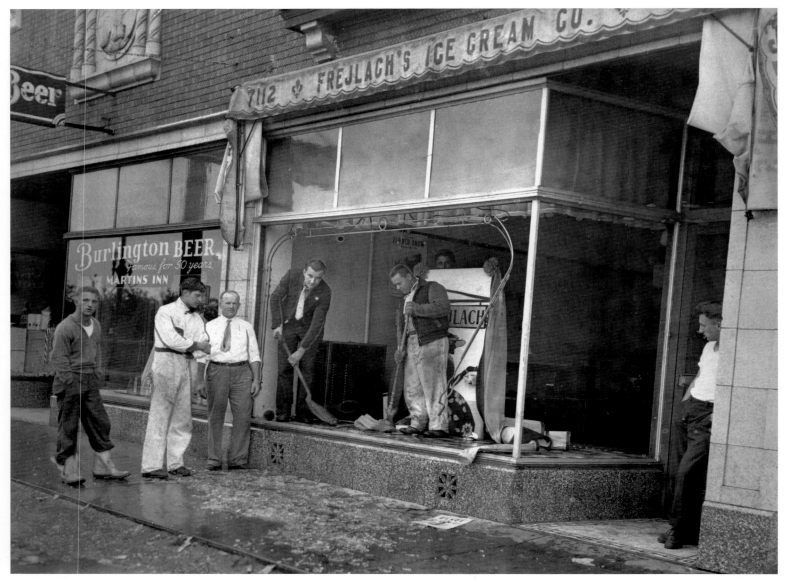

Brothers James and Lucien Frejlach sweep out their store after its bombing in 1935. The two men maintained that their ice cream company was targeted because they refused to hire union workers and for selling larger-than-usual portions of ice cream at the standard price.

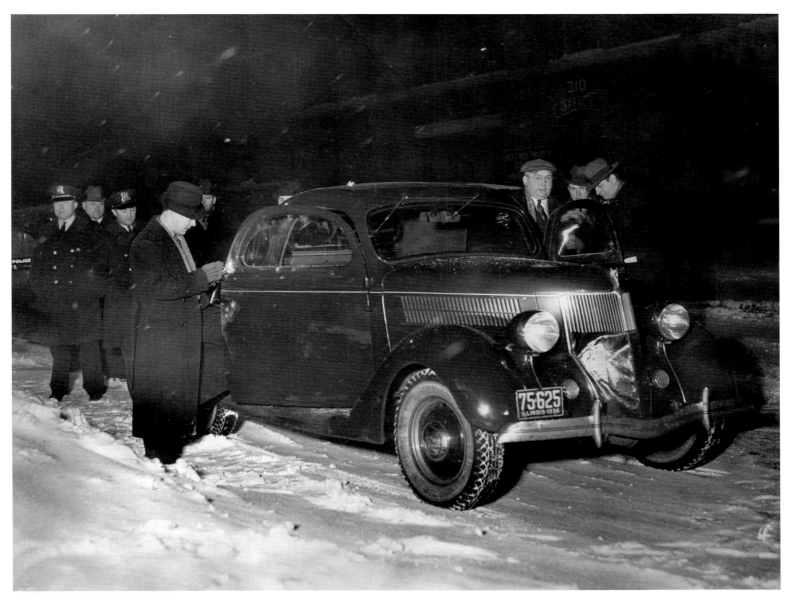

Capone's influence quickly waned, but the gangs persevered and the violence continued, eventually touching some of Capone's former cohorts. In this photograph, Chicago police search Jack McGurn's automobile for fingerprints after his murder in a bowling alley at 805 Milwaukee Avenue.

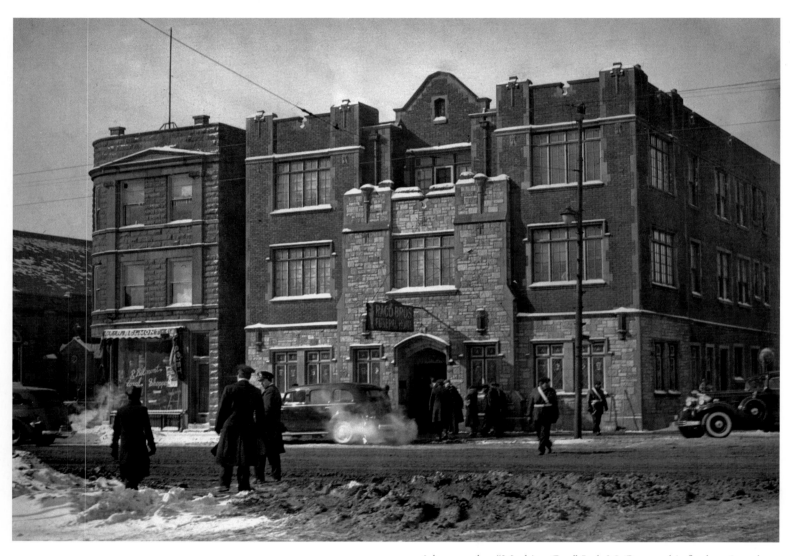

A hearse takes "Machine Gun" Jack McGurn to his final resting place.

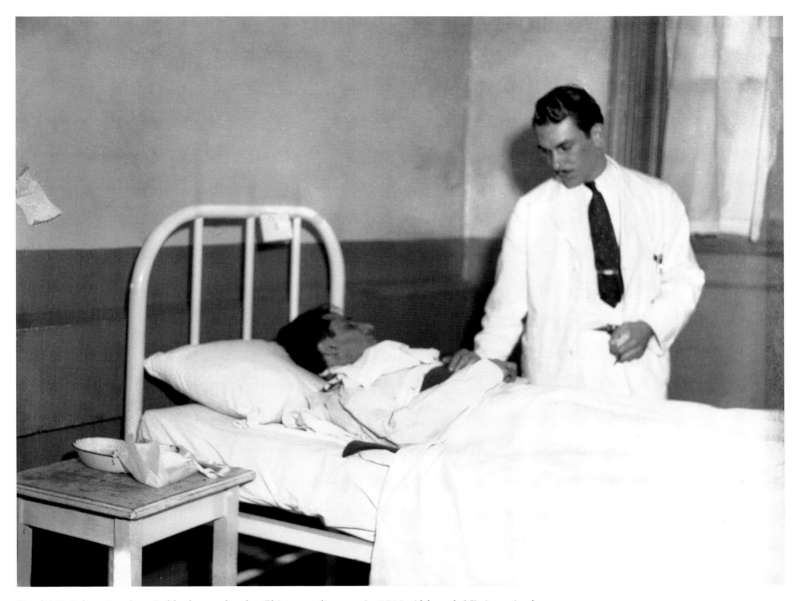

Frank Nitti, here in a hospital bed, was shot by Chicago policemen in 1932. Although Nitti survived the ordeal and managed to regain power over his organization, he was eventually indicted for extortion, along with many other gangsters, in 1943. Nitti never showed up for his day in court. Instead, he shot himself in the head the morning of his grand jury appearance.

The growth of national crime-fighting forces, aimed at destroying the well-organized urban gangs of the 1920s, resulted in high-profile arrests and convictions across the nation. The FBI manhunt to capture bank robber and escaped convict John Dillinger (pictured here in court) ended in an alley behind Chicago's Biograph Theater at 2433-43 N. Clark Street on July 22, 1934.

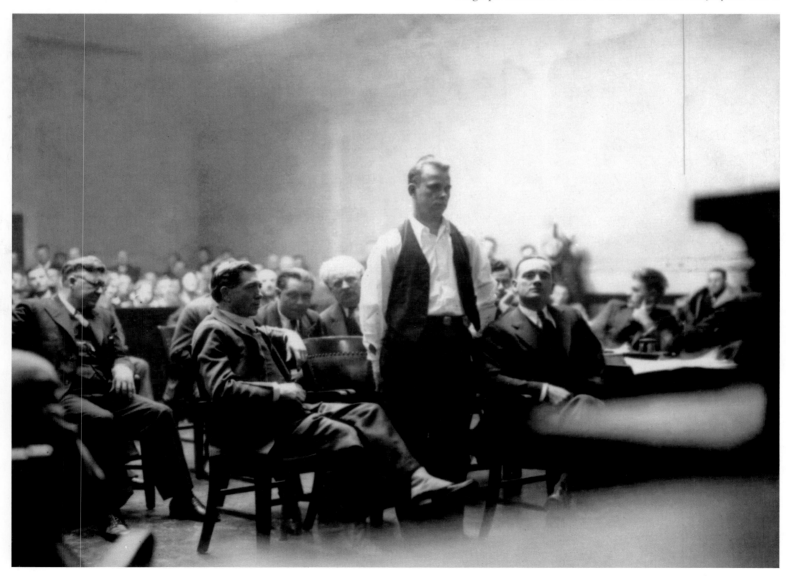

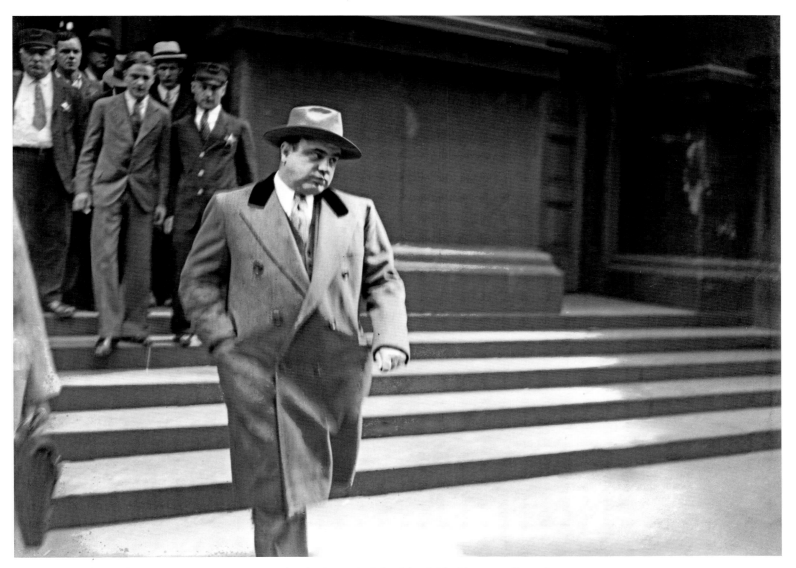

Capone was released from prison in 1939. He moved to his home in Palm Island, Florida, mentally unfit to run his criminal organization, and died of pneumonia on January 25, 1947. His body was brought back to Chicago and buried in Mount Olivet Cemetery near the graves of his father and brother. He was later moved to Mount Carmel Cemetery on Chicago's West Side.

"A Map of Chicago's gangland from authentic sources: designed to inculcate the most important principles of piety and virtue in young persons, and graphically portray the evils and sin of large cities." Issued in 1931 by cartographers Bruce-Roberts Inc., the map identifies key gang territories in the city from which the gangs controlled the distribution and sale of liquor during Prohibition.

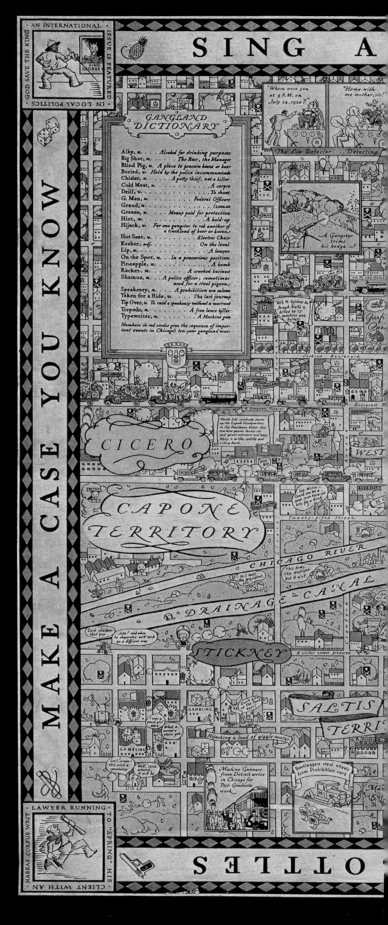

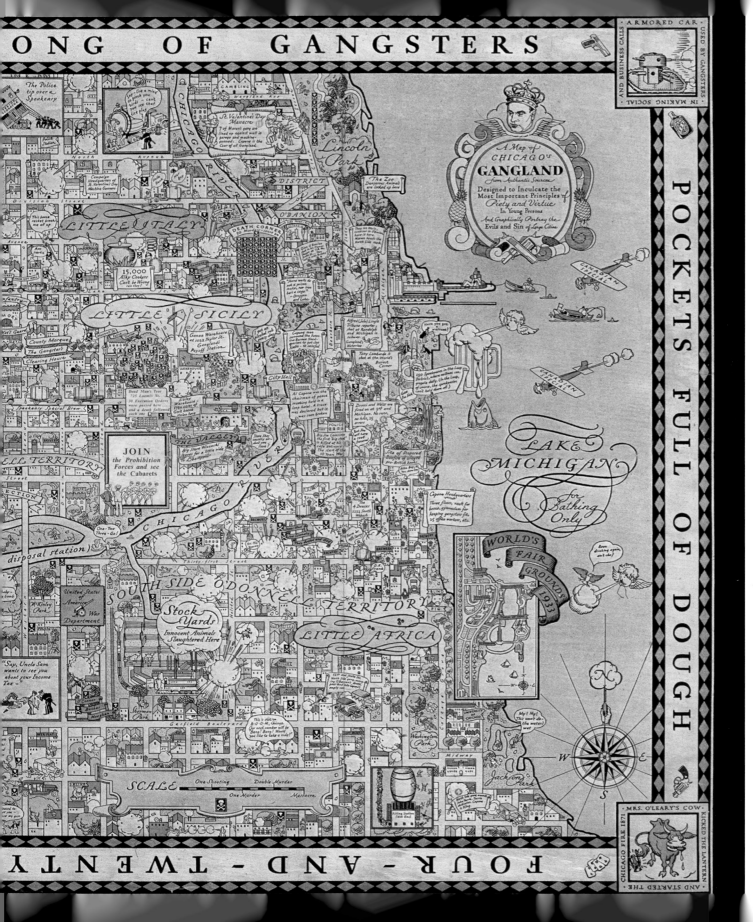

Notes on the Photographs

These notes, listed by page number, attempt to include all aspects known of the photographs. Each of the photographs is identified by the page number, photograph's title or description, photographer and collection, archive and call or box number when applicable. Although every attempt was made to collect all available data, in some cases complete data was unavailable due to the age and condition of some of the photographs and records.

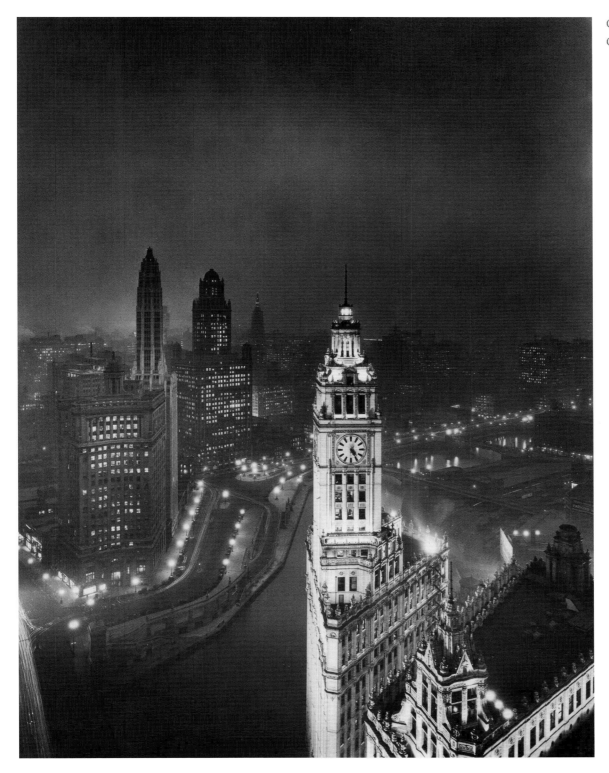

Chicago at the end of the
Capone era.